PERIPHERAL INSIDER

PERIPHERAL INSIDER
Perspectives on
Contemporary Internationalism
in Visual Culture

Edited by Khaled D. Ramadan

Museum Tusculanum Press
University of Copenhagen 2007

Peripheral Insider. Perspectives on
Contemporary Internationalism in Visual Culture

© Museum Tusculanum Press and the authors, 2007
Consultants: Anne Ring Petersen and Anders Michelsen
Copy editors: Marie Friis Kelstrup and Stina Nyks Meggele
Cover and composition by Pernille Sys Hansen
Set in Dolly
Printed in Denmark by Narayana Press, www.narayanapress.dk
ISBN 978 87 7289 967 1

Cover illustration: Poster, "Foreigners, please don't leave us
alone with the Danes" by Superflex, 2002

The article "Letters from the Turkish Bath", p. 112, is printed
with the permission from *Millenium. Journal of International
Studies.*

The book is published with financial support from
The Danish Research Council for the Humanities
The Integration Policy Division
The Nordea Denmark Foundation

Museum Tusculanum Press
Njalsgade 94
DK–2300 Copenhagen S
www.mtp.dk

FOREWORD

Peripheral Insider. Perspectives on contemporary internationalism in visual culture, which is now being published by the art historian Khaled D. Ramadan, contains a veritable treasure trove of highly competent and inspiring articles, all of which cast new light on the much discussed "question of post-colonialism or internationalism in contemporary art or art in general". Many of the rigid and flagrantly one-track minded positions that have previously tinged the debate surrounding "post-colonialism in art" are replaced in this book by subtly shaded analyses of the multiplicity of problems and new appraisals that "contemporary internationalism in visual culture" stirs up in the present day. New global visions are constantly surfacing in the various articles. In the introduction, Khaled D. Ramadan, who happens to be an expert in this area, duly refers to Kwame Anthony Appiah, who has set forth the claim that "the prefix *post* can be seen as an assertive stance vis-à-vis a compelling change of a world system that makes way for different agendas that are not an arrhythmia", but are, as he puts it, "simply a way of understanding the 'multiplication of distinctions'". Through a number of different interpretations of this fruitful and overriding standpoint, the book's central theme comes into view in a clear and distinct fashion; this theme revolves around the multi-faceted analyses of "the conditions of expatriate artists from various angles: the historical and colonial roots of the issue, positions among theorists dealing with expatriate artists in the west, the role of established art institutions, and examples of recent developments in the field".

Whereas it has been a matter of course in the last two decades that the presence of "expatriate visual artists" on the international art scene is taken for granted, it is only in a very few – and rare – instances that artists working in Denmark and the other Nordic countries have been regarded as central players on the international art scene. A number of Danish and foreign experts illuminate this set of problems, each with his/her own way of doing so, offering analyses of the situation's basic conditions and encouraging a new and more global development in contemporary art.

The texts have been divided into two sections: *discourses*, of a more theoretical and analytical nature and *positions*, where the focus is aimed at sociological, culture-political and experientially based aspects. The authors of the book's articles are art historians, anthropologists and sociologists.

Some of them are employed as university lecturers and some are working as curators or art critics. Each one possesses his/her very own but highly qualified insight about the book's main topic. Similarly, through their various activities both within and outside the institutions, each of the book's authors has gathered many kinds of experiences and has been working on promoting internationalism or globalisation in contemporary art and on expunging the dividing line between the predominant culture and the cultural minorities. Stine Høxbroe, Stine Høholt, Staffan Schmidt, Bülent Diken, Carsten Bagge Laustsen, Anders Michelsen, and Khaled D. Ramadan elucidate the book's main theme on various theoretical levels and set forth their analyses of a number of themes that are relevant to new interpretations of "the postcolonial agenda", subsuming questions about the problem of identity, curators' responsibility with respect to the "others' art", Orientalism and fundamentalism. Naseem Khan, Gavin Jantjes, Ria Lavrijsen, Y. Raj Isar and Tabish Khair are primarily absorbed in the analyses of the many impediments that expatriate artists have run up against in different countries, especially in the Nordic countries. What they correctly point out is that these hindrances have to do with the fact that the question of multiculturalism is something of an untilled field in Denmark and the other Nordic countries. All of these writers, in their own way, concur that multiculturalism is one of the greatest and most essential challenges in the new millennium.

In a deeply penetrating and most stimulating manner, the book's different articles analyse multiculturalism's requirements and stipulations. All the texts are permeated by a fervent desire to foster a better understanding of non-western artists' conditions in the Nordic countries and in many different ways, the texts serve to suggest how the Nordic countries can, to a much greater extent, integrate non-western artists into the region's art life.

Else Marie Bukdahl
DPhil, former rector of the Royal Danish Academy of Fine Arts and current head of the Department of Art History and Culturel Studies of the same

Contents

We are not about to change or transform the entire question of post-colonialism or internationalism in contemporary visual art or art in general, not in one generation or one publication at least. However, we will not be able to escape its compelling agenda either. 'Things take time', they say, but it is perhaps better to say that the post-colonial agenda consumes, eats up, time.

The time of the post-colonial agenda is a time for revision of notions of historical and social transitions – colonial transitions – such as the transition of logo- and ethnocentres of the West. This agenda is thus suspensed in the socio-historical formation of culture, whether on the side of the colonized or the colonialists. The post-colonial agenda shares with similar conjectures an implicit critique yet liaison with modernity, by showing that the workings of modernity bring forward an "intense moment of transit where space and time come cross to produce complex figures of difference and identity, past and present, inside and outside, inclusion and exclusion" (Homi K. Bhabha).

Yet it is also a straightforward wonder of the modern world, and thus a contribution to the critical and democratic impetus of modernity all over the world. As Kwame Anthony Appiah indicates in *In My Fathers House*,[1] the prefix "post" can be seen as an assertive stance vis-à-vis compelling change of a world system which makes way for different agendas that are *neither* a negation of the modern systemic *nor* an affirmation of alleged postmodern arrhythmia but is as he puts it, simply a way of understanding the "multiplication of distinctions":

> ... Modernism saw the economization of the world as the triumph of reason; postmodernism rejects that claim, allowing in the realm of theory the same multiplication of distinctions we see in the cultures it seeks to understand.[2]

In "coming to terms with what it means to be modern", African and Western intellectuals have interests they should share, Appiah adds. Thus, we may add, it becomes possible to view the post-colonial agenda as a critical impetus making way for different distinctions, yet also as an emphatic attempt at understanding social and historical formations of cultures within modernity, that is, as something we all have to deal with.

From a viewpoint closer to the actual debates – the 'sturm und drang' of an intellectual discourse in the making – one quickly finds that the no-

tion and subject of the post-colonial agenda are rather old to professionals in the UK and the US, in a wider sense to anybody who wants to reflect on the fate and phenomenon of colonialism. Robert Young's recent account of post-colonialism maps the phenomenon – and the agenda – back to the movements of decolonization after WW2, and further back to mass movements beyond the West in the 20th century.[3] Appiah finds 'roots' in black intellectuals' debates in the 19th century.

Scandinavia – the North – however, remains a newcomer in this domain and is still lagging behind on many fronts. In particular artists subscribing to a post-colonial agenda here find themselves following in the footsteps of artists and activists like Rasheed Araeen and Gavin Jantjes and their achievements in the UK and elsewhere for the past twenty years. This may make up for a first benchmark of this book. The publication is not aiming at repeating the patterns witnessed elsewhere but rather at contributing to a consideration of previous results in the field.

When I, as an artist and architect, first set up the outline of this book back in 1997, I found myself alone. The title was supposed to be 'ambitious step', and my aim was to focus on expatriate visual artists and monitor their development in the Danish landscape in order to come up with a practical publication that might help these artists understand the restless postmodern nature of Danish art practice. I then decided to give the topic time in order for it to crystallize, exactly because expatriate art is a new subject in Danish visual culture.

During the last three to five years remarkable changes have taken place within this field. After a number of conferences and international contacts, especially with organizations like The British Arts Council and inIVA, different approaches towards others' art and cultures have started to appear. This is not because Denmark is particularly fast at learning from the achievements of other nations. Rather, it has to do with the fact that the Nordic region is eager to embrace the globalization of culture, by now inescapable in big events such as *Documenta* 11, though ironically opposed in substantial parts of the Danish public at the very same time. The Danes aim at consuming time while escaping it. This is in fact yet another example of the alleged paradoxes of the postmodern world.[4]

In the Nordic region, contemporary visual art practice relies in this respect more on import than on export. As a periphery within the art centre, the Nordic region has followed the example of European art centres by engaging in the discussion of others' art. The exhibition ARS 2001 at

KIASMA Museum of Contemporary Art, Helsinki, is a good example of this.[5] As a demonstration of the new internationalism in visual art, it reflected the global tendencies and their effects on the Nordic visual culture. Besides this, the region needed to reflect its new geographic and ethnographic image.

Several years after the opening of the New Tate Gallery for international art at the riverbank of London where hybrid and trans-national artists, among others, display their work, Denmark closed its first national conference on the subject in October 2000.[6] The conference was designed by The Intercultural Network and commissioned by the Ministry of Culture and was meant to stimulate Danish cultural institutions to expand their horizon and include expatriate artists in their future planning.

A year later, the conference Under Construction took place in Helsinki in 2001. This conference was initiated by the Nordic Institute for Contemporary Art (NIFCA) and was also designed to stimulate mainstream art institutions and question their position in a changeable and rather challenging Nordic landscape.[7]

This tells us that the Nordic sphere as a whole is facing the same cultural development. At the Under Construction conference, two of the main speakers were Professor Thomas McEvilley and artist and theorist Rasheed Araeen. Both argued that till now we did not succeed in abolishing the boundaries between centre and periphery because no one attempts to address the fundamental issue of the question, which lies in the fact that countries like the UK and the US are still marked by notions of western hegemony.[8]

In the Nordic region in general and in Denmark in particular, it is still quite early to say whether change is on its way, but things are in progress. Dealing with multiculturalism is a difficult task and the attitudes towards losing and gaining are not very clear. Therefore this particular era is puzzling every observer, from academics over artists to politicians, and this is bound to reflect on the socio-cultural position of expatriate visual artists who live and work in this country.

My expectation was that improving the conditions for expatriate artists would be the result of the artists' own efforts, as it happened in the UK. I was wrong. This was not the way it was going to happen in Denmark or elsewhere in the North. Ironically, the initiative came from the very art establishment which used to shun the kind of art practiced by expatriate artists.

Some mainstream institutions are getting more curious and some are

quicker than others to recognize the changes and act accordingly. One of them is Vejle Art Museum in its decision to host the travelling exhibition *Clockwise*.[9] Another step pointing in the same direction was taken when the Nordic Institute for Contemporary Art decided to work out several books, exhibitions and conferences addressing the subject in order to establish more solid contact between the mainstream discourse and mobile expatriate artists.[10] Lately also the Royal Danish Academy of Fine Arts has begun to admit more students with non-Western background into its facilities. Finally, in 2004, Aarhus became the host of the interdisciplinary art project Minority Report addressing the issue of minorities in Denmark with the participation of several non-Western artists.[11] I must admit that I am pleased to be part of these new changes, and I admire the institutions that are welcoming them.

These recent ambitious steps were taken in order to shed more light on the many expatriate artists living and working in the North, those artists who are trying hard to make their way into mainstream cultural institutions. Despite the fact that few of them have succeeded in entering the Nordic canon, many are still waiting at the edge of the 'white cube' looking for a better position.

With the increased mobility and trans-national interaction worldwide, internationalism in contemporary visual art is no longer exclusively a western issue. Contemporary visual art includes art made by expatriate artists who have settled in the west and art made by artists outside the west reflecting on everyday events in a globalized world.

This book addresses the conditions of expatriate artists from various angles: the historical and colonial roots of the issue, positions among theorists dealing with expatriate artists in the West, the role of established art institutions and examples of recent developments in the field.

In Denmark there has been a tendency to view expatriate art, not as part of current global developments but as expressions of ethnic cultures of little importance to contemporary art practice. The argument of *Peripheral Insider* is that not only does expatriate art or internationalism in visual art form part of the global art discourse. It is a phenomenon with a specific history which is closely related to colonial and post-colonial experiences. As such, it is a phenomenon related to issues of presentation, representation and self-presentation, as exemplified in the Orientalism-Occidentalism dichotomy.[12] It is also a phenomenon which has been thoroughly addressed in other European countries, involving established art insti-

tutions, theorists and expatriate artists, leading to new developments in contemporary visual art.

Whereas expatriate visual artists have been part of the international art scene for decades, expatriate art and the issues related to it are a new phenomenon in the North. For this reason, I have asked professionals from different European countries to contribute to the book with their experiences in order to shed light on the situation in the North in general and in Denmark in particular. In order to choose the most productive contributors for the book, I decided to loosen myself in the deliberate historicity which makes up such an important part of post-colonialism and invite those who had visited Denmark and the Nordic region and engaged themselves in the question of internationalism in art in Nordic symposiums and conferences. On more than one level this resulted in an extended hybridization and 'deconstruction' – somewhat 'en vogue' – in a portrait of a network in formation.

The publication is an attempt to present the art and culture in the North by its ways of receiving an art form that contains different concepts and perspectives, often inherently critical of some of the deep motivations of social and historical life in this very same North.

It is the hope that such an approach will facilitate a shift in the contemporary understanding of Nordic art practice, from being national or regional to becoming more trans-national and including non-western regions. In straighter theoretical terms: to live up to the demands and questions of the post-colonial agenda.

I thank all contributors for their participation and generosity and wish that the goodwill behind their contributions will be well received by the Danish and Nordic cultural public and institutions as a contribution not only to the reception one way or the other, of something foreign, but of something that emerges from their own development and prospects, that is, from their own future. When reading this book, it is my hope that the reader will encounter, with the words of Appiah, a vision of shared wonder.

Khaled D. Ramadan
Helsinki, Soumenlinna, summer 2004

1 Kwame Anthony Appiah: *In My Father's House*. Oxford University Press 1993.

2 Ibid, p. 3.

3 Robert J.C. Young: *Postcolonialism. A very short introduction*. Oxford University Press 2003, p. 6.

4 Hans Ulrich Gumbrecht & Michael Marrinan (eds.): *Mapping Benjamin: The Work of Art in the Digital Age*. Stanford University Press 2003, p. 26.

5 ARS 2001, KIASMA Museum of Contemporary Art, Helsinki 2001.

6 1+1=3. Cultural Diversity and the Cultural Sector. Copenhagen 2000.

7 Under Construction, Nordic Institute for Contemporary Art (NIFCA), Helsinki 2001.

8 Under Construction, NIFCA, Helsinki 2001. *Also see: Under [de]Construction. Perspectives on Cultural Diversity in Visual and Performing Arts*. NIFCA, Helsinki 2002.

9 Clockwise. New Nordic Contemporary Art. Vejle Art Museum 2002.

10 NIFCA 2002. *Also see*: www.nifca.org

11 Minority Report. An interdisciplinary exhibition project. Aarhus 2004.

12 See for instance Edward Said: *Orientalism*. 1995.

EDITORIAL NOTE

Khaled D. Ramadan

The essays in this book are concerned with expatriate art and artists, their artistic production, and how they are received by their new societies.

Expatriate visual art[1] began to appear in the West around the beginning of last century. In the last twenty years, the art of others – or "others' art"[2] as it is called – has started to appear as an art form of its own after the criticism of modernism and writings on the subject in the post-modern era.[3] Among the many writers who have addressed the subject of "others' art" is Edward Said with his book *Orientalism* from 1978.

Said's thoughts have had great influence on post-colonial studies. In his book he exposes and criticizes the set of beliefs that characterize "Orientalism" and presents the inaccuracies of the many assumptions about the Orient as various paradigms of thought, which have been accepted at individual, academic and political levels.

He holds that there is a need for dialogue about the presentation of others and argue that it is time to recognize others' art and culture.

Many have taken Said's book to be hostile to the West,[4] and when studying his political approach to the subject this might be true. However, when studying the cultural questions he puts forward, it becomes clear that the book touches upon a very topical issue. In the book, he gives examples and discusses how most western countries approach "the others" by marginalizing the culture of natives, minorities and immigrants.[5] He also shows how western countries systematically have tried to draw scientific lines between western and "other" art, which has enabled the western countries to characterize their culture as the only elite culture in the period from 1800 to 1970.

Art made by artists who were colonial and post-colonial subjects has been excluded from the established art society. During this one-sided marginalization practice, the colonial powers had the upper hand on the colonized cultures, which were stamped by the colonizers as being wrong, exotic, primitive, and lately, decorative. To a certain degree, this attitude is still present in some parts of western art life, and this is one of the topics to be discussed in this publication.

Since Said published *Orientalism*, the era of post-colonial art and the question of others' art and culture have occupied the international art discourse. In some former colonial countries this has developed into a norm, almost a trend,[6] known as art of the post-colonial era, hybrid art or transnational art.

In the beginning of the 90s this trend was referred to as the "New Internationalism". A well-known anthology edited by Jean Fisher[7] entitled

Global Visions, Towards a New Internationalism in the Visual Arts marked this era.

The new trend, however, has not manifested itself very strongly in the Nordic, and particularly not in the Danish, cultural landscape. One reason for this is that Orientalism did not flourish in the same way in the North as it did in former colonial centres such as England, France, Spain and Holland.[8] This means that contact with "others' art" in general has been somewhat limited and thus also the interest for the new internationalism.

In *Art and Otherness, Crisis in Cultural Identity* from 1992, Thomas McEvilley presents his historic controversy with the Museum of Modern Art, NY, over the 1984 exhibition Primitivism in the 20th Century Art. His book inaugurated the debate on multicultural issues which came to dominate the art discourse in the years to follow and seems likely to remain for some years to come. The concept of global art or internationalism in the visual art history was progressively articulated in his later writings assembled in *Art and Otherness* including his major essay on the exhibition *Les Magiciens de la Terre* (The Magicians of the Earth). The central point in *Art and Otherness* is that modernism and formalism are deeply wrapped up with colonialism. Therefore, charting out a postmodern and post-colonial world has become the driving passion in most of McEvilley's post magicians-of-the-earth writings.[9]

In the introduction to McEvilley's book *Art and Otherness*[10] he says:

It seems that at the beginning of the 70s era, which was called pluralism, it was possible to make art in a variety of styles and even more epochally, women began entering the canon for the first time. In the 80s it became possible to enter art history not only through a variety of styles but also from various places, but it helped if one were a white male Westerner applying for cult membership. Despite all claims of expansiveness, the 80s regionalism did not include Kinshasa or Bombay. These exclusions end in the globalism of the 90s, which is based on the recognition that art history as hitherto promulgated no longer coincides with the world we live in.

He continues:

In hopes of entering the international art discourse, a non-western artist was to repress his or her inherited identity and assume a supposedly universal one, but the 'universal' identity was just the emblem of

another tribal cult that temporarily had the upper hand. Thus, modernist internationalism was a form of imperial assertion by which non-western cultures would assimilate to Western norms.[11]

This perception is confirmed by the American art critic M.A. Greenstein who says:

> It has taken more than half a century, a few political and cultural wars, a controversial restructuring of 'global' economy, and the spawning of the internet to bring American art critical practice to its knees to reckon with the postmodern, postcolonial project of cultural relativism.[12]

The contributors to the present publication have looked upon the topic from different and more recent perspectives. Their approaches have been based on the different posts they occupy and the different geographies they find themselves attached to. In this way the subject has been discussed from different angles – that of the bureaucrat, the cultural policy maker, the empirical researcher and the academic theorist. The reason for this is the lack of knowledge about the subject on virtually all levels, especially in a country like Denmark where the subject is rather new. This calls for an introduction to the subject on several levels so that the reader gets an introduction to the historical background, the central theoretical topics discussed, examples of how the topic expresses itself in different situations and the approach to the subject by established institutions in Denmark and other countries in the northern and western European region.

The result is a publication that gives an overview of the subject on different levels, as an introduction to a subject that has not been widely recognized in the Danish field of visual culture. Furthermore, it is the hope that this publication will function as a tool for art historians and art critics when approaching this complex and highly topical subject.

The texts have been divided into two sections: positions on the one hand and discourses of more theoretical and analytical nature on the other hand.

Discourses

To elaborate on the subjects mentioned in the introduction and the editorial note, the discourses begin with my own essay. The essay is a reflection

of my study as a PhD Candidate in Art History at Copenhagen University. It includes the writings of Thomas McEvilley, Edward Said and Rasheed Araeen and focuses on the issue of value judgement and the parameters used by the western art establishment when granting access to expatriate visual artists.

In the essay, there is a discussion of the global project as a continuation of the colonial project and the 'white cube's' and the 'white world's' urge for control and fear of losing its perceived pureness and homogeneity.

Through examples from her research on contemporary Egyptian art, PhD in Cultural Anthropology at New York University, Jessica Winegar, discusses European and American assumptions about non-European art, which are often based on prejudice and limited knowledge about the countries in question, and the specific interplay between culture, religion and artistic expression. She focuses on the way expatriate artists living in the West are typically received and the way societal stereotype shape the frames through which these artists' works are analyzed, appreciated or criticized.

By including the writings of Michael Brenson and Fred Wilson, Cultural Geographer Stine Høxbroe is discussing the role and responsibility of curators when presenting 'others' art'. She writes about the impact of globalization on contemporary art and includes an interview with curator Simon Sheikh with whom she has discussed the role of curators and their influence on contemporary art practice in the North.

Former curator at ARKEN Museum of Modern Art, Stine Høholt, discusses the question of identity and self-constitution in relation to cultural meeting in a post-colonial context. She does that on a purely theoretic basis through the writings of the prominent Indian cultural researchers Homi K. Bhabha and Gayatri C. Spivak. In her essay Høholt focuses on the self-interpretation and self-representation of cultural minorities that are under direct or indirect influence of a dominant culture.

In his essay, art critic, curator and lecturer at Malmö University Staffan Schmidt shed light on the concepts and consequences of Eurocentrism and Orientalism in relation to current boundaries, physical as well as mental. By taking us on a travel back in time, he exposes some of the European representations of 'the other' in art and literature and argues that

there is a close parallel between the history of colonialism and the history of art. By including theorists such as Edward Said, Irit Rogoff, Homi Bhabha and Samir Amin, he further holds that there is a parallel between the question of art and identity in contemporary western culture and the colonial discourse of the 19th century.

Bülent Diken, lecturer at Lancaster University Department of Sociology, and Carsten Bagge Laustsen, assistant professor at Aarhus University, Department of Political Science, compare and analyze two stories of the Orient, Özpetek's film *Hamam: The Turkish Bath* and Montesquieu's *Persian Letters*. By this they expose some of the typical distinctions made between West and East. Although there is a growing awareness that these distinctions and the images they inspire are pure semblances, we keep insisting on this Orientalist view – because we enjoy it. The Orientalist image of the Orient allows us to fantasize of a hidden world of mystery and desire.

Positions

After having introduced some of the main historical and theoretical aspects of the subject, the focus shifts to sociological, cultural-political and practical aspects and how they have found expression in different situations as experienced by the contributors to this anthology.

Policy developer in the field of cultural diversity, Naseem Khan, takes the cultural policy question and inspires us concerning how to avoid mistakes and misunderstandings. She discusses the artist as a free actor but also as a responsible figure in his community, the loyalty of the artist in relation to the community and the mainstream establishment and the responsibility of the establishment and how it should plan its cultural policy towards its expatriates.

Artistic Director of Henie Onstad Art Center, Gavin Jantjes, writes about art as a translation of experience which can be used to communicate and educate. He asks whether contemporary art reflects reality and points out that if it does, then the mirrors artists hold up for us to see are fragmented, cracked and full of holes. In his essay, Jantjes shares with us his perception of the aesthetic problems that lie ahead of us and the personality of the artist of tomorrow in a world perceived as one inter-linked by geography, inter-dependant on ecology and inter-connected by economy.

Consultant on Diversity and Intercultural Affairs, Ria Lavrijsen focuses on the socio-cultural conditions and the kind of obstacles expatriate artists are facing when interacting with their new environment. Her interest lies in expatriate artists' participation in the cultural life and the kind of impact they are bringing to their new home. Lavrijsen considers multiculturalism as one of the biggest cultural challenges of the millennium.

Anthropologist and president of European Forum for the Arts and Heritage, Yudhishthir Raj Isar, draws parallels between countries like the US, the UK, Canada and Holland, which are pioneers in relation to the question of multiculturalism, while the North is quite new in this domain. He writes about a new perception of culture which does not regard cultures as homogeneous bounded wholes but rather as ways of life interrupted by cosmopolitan dispersals, migration and displacement, and the difficulty of translating this new cultural awareness into actionable policy guidelines.

Tabish Khair, PhD and Associate Professor at the Department of English at the University of Aarhus, discusses the (in)visibility of non-Western artists living in Denmark. In his view, it is often the rule that the artists' 'visibility' accrues from their 'otherness', while their art – as contemporary art with claims to individuality and difference but not to a sweeping 'otherness' – remains largely invisible. The non-Western artist can be accepted as an 'other' in many Danish circles, but not as a different contemporary artist with her own perception of art, aesthetics etc. He supports his essay with examples from Danish history and literature and argues that the 'visible invisibility' of non-Western writers and artists is a consequence of a general discourse pervading the Danish society.

1 The expressions 'expatriate artist' and 'expatriate art' refer to any artist living and working outside his or her native country and their artistic products.

2 An expression referring to non-Western art.

3 Ali Artun: "I am Another". In *I am Another*. Copenhagen: Charlottenborg Exhibition Building. 1995.

4 Edward Said: *Orientalism*. England: Penguin. First published 1978.
Republished in 1995 with a new after word.

5 Edward Said: *Orientalism*. 1995.

6 Mika Hannula. Editor of the Nordic Review NU 2001.

7 Jean Fisher is a freelance writer on contemporary art and former editor of The Third Text. She is editor of the anthology *Global Visions: Towards a New Internationalism in the Visual Arts* 1994, and *Reverberations: Tactics of Resistance, Forms of Agency* 2000. She currently teaches at Middlesex University and the Royal College of Art, London.

8 Apinan Poshyananda, in *Organizing Freedom*. Ed.: David Elliot. Moderna Museet. Stockholm 2000.

9 American book review, www.mcphersonco.com

10 McEvilley: *Art and Otherness*. 1992, pp. 9–10.

11 McEvilley: *Art and Otherness*. 1992, pp. 9–10.

12 M.A. Greenstein: *Art Planet: The pluses and minuses of cross-cultural criticism in the global age*. Art Journal 1999. Of other articles can be mentioned those written by Francesco Bonami in Flash Art 1998 and Carol Backer in Art Journal 1999. Of other writers dealing with the subject can be mentioned Marie-Noelle Ryan and Stine Høholt who contributed with two articles in the Danish magazine *Øjeblikket*. Stine Høholt and Jannie Haagemann also wrote an article with the title "Mod et nyt kunstnerisk verdenskort?" (Towards a new artistic world map?) in the book *Kunstteori. Positioner i nutidig kunstdebat*. (Art theory. Positions in contemporary art debate.) 1999.

THE EDGE OF THE WC

KHALED D. RAMADAN

One of the advantages of the last 20 years of globalization is the crucial changes on the international art scene. The dominance of New York has been definitively broken, and other centers have emerged around the world. Another advantage is the changes in the so-called 'post-colonial' age, the age which changed our appreciation of territory and history.

In 1972 when Brian O'Doherty published his book *Inside the White Cube* with an introduction by art historian Thomas McEvilley,[1] the main purpose of the book was to determine which kind of ideological space that is most suitable for art display. What should this space look like? And which kind of art must be displayed inside which space?

The 'white cube' is one of the main tropes within the discourse of modern Western visual art, and during the 20th century a lot of artists have put this specific space on display. Maria Hirvi has commented on the artists' preoccupation with the white cube, and discussed the 'purity' of the white cube, its metaphors, and the white cube as an aesthetic medium in the *Nordic Art Review* 2001.[2]

Hirvi's article, however, does not suggest anything else than a relation between cube and space, artwork and spectator, and her approach to the cube as a notion is purely aesthetic. This cannot be said about the approach of Thomas McEvilley who has written extensively about the subject, and we have every reason to expect him to write the introduction to a book carrying the title *Inside the White Cube*, as will become clear later on.

Between the ideological white cube of McEvilley and the aesthetic white cube of Hirvi lies a third white cube. The third cube is a space of non-Western art and culture mingling in the Western sphere. It is a metaphysical, post-colonial, cultural space, introduced into the Western metropolizes together with trendy slogans like *multiculturalism*, *migration* and *expatriatism*. Some Western art historians, critics and sociologists like Akbar Abbas and Frederic Jameson[3] view the third white cube as a true sign of global cultural expansion. Other theorists see the third white cube as a threat[4] to the original white cube – the white walls in Western art institutions displaying art made primarily by Western artists.

Until the 70s, most visual art shown inside the white cube belonged to the Western art tradition. In this sense, the white cube has been somewhat homogeneous, and some critics fear that letting in art made by non-Western artists may have a de-homogenizing effect. Apparently, de-homogenizing or heterogenizing the white cube threatens the legacy and identity of Western culture. Thus, widening the scope leads to fears of cultural contamination and identity cancellation.[5]

The controversy between the two positions ignited when McEvilley confronted the 1984 exhibition *Primitivism in 20th Century Art: Affinity of the Tribal and the Modern*.[6] In his criticism McEvilley undermined the old assumption of the purity, monopoly and hegemony of Western art throughout human history.[7]

The orbit of the exhibition was a brief period in early last century, beginning in the years 1907-8. Modernist artists and art enthusiasts, for the first time it seems, began to experience objects brought back by colonizing nations - from Africa, Oceania, and Native American cultures - not as curios or ethnological objects, but as aesthetic artworks.[8]

The kind of eclecticism presented at the exhibition was flourishing in the Western hemisphere in the colonial and post-colonial era. During this period, the colonized regions did not have the power to develop or maintain their cultures and heritages. Therefore, the knowledge of visual and other kinds of art was in the hands of the colonizers.[9] According to artist and theorist Rasheed Araeen, the colonizers had the upper hand on value and quality judgment of any kind of art produced within their boundaries, and they used to perceive themselves as the only sophisticated agency with the right to judge. Even in the post-colonial era the former colonizers have continued to judge others' art according to colonial standards and assumptions.[10]

In his famous essay "Here Comes Everybody" McEvilley writes:

When we look at the European art history of the last five hundred years in this way, seeing both its internal developments and its external connections with social and economic forces, the problem grows, the disturbance spreads. For what we see in the large view is that European art arose and was sustained within a matrix of two vast historical movements. The first of these movements was the colonial and imperial expansion of European societies that enabled them over a period of several hundred years to spread around the world like, as Susan Sontag once put it, 'the cancer of history', meanwhile cornering most of the wealth of the world and impoverishing almost everyone else. It is worth looking more closely at the relative chronologies of art and power in this era.[11]

Much of McEvilley's work has been related to cultural hybridization and his most distinguished writings have been about art and otherness and about others' art and cultures.[12] He has placed controversial issues in

unique perspectives in order to clarify cultural matters, in most cases at the disadvantage of post-colonialism.

In his writings, McEvilley draws parallels between the Western culture's renaissance and enlightenment and its barbarism taking place at the very same time. Generally speaking, he writes, the honourable part is included in the history while the less honourable part is excluded.

McEvilley's concern has mostly been the non-Western artists, not only those who live outside the West but also those who live and work in the West. In his book *Art and Otherness* he openly criticizes the Western art establishment by accusing it of being an exclusionist apparatus, systematically dismissing all non-Western cultural products from its cultural domain, regarding others' arts and cultures less valuable, and he argues that such behavior is inherent in the nature of the Western art establishment.[13]

McEvilley characterizes Modernism as the era of exclusion since, during this period, women and non-Western artists were rejected admission to the white cube. Similarly, he characterizes post-modernism as the era of inclusion, based on the feministic and non-Western experience during this period and their simultaneous admission into the Western art canon.

McEvilley's view on exclusion and inclusion is not shared by many theorists – Western and non-Western alike. His view is definitely not shared by a theorist like Rasheed Araeen who argues that despite the developments mentioned by McEvilley at the doorstep of the third modernity and beyond, they are not comprehensible nor are the problems underlying them fundamentally addressed.[14] Not even a mega show like *Documenta 11*, which was a grand celebration of the new internationalism, was satisfactory to Araeen, as we are to see later.

Araeen encourages non-Western artists to change or challenge the history of Western art because of its colonial and post-colonial legacy. The same legacy that established and maintained the assumption of the superiority of Western art over other kinds of art, at least till the introduction of *Documenta 11* in 2002.

Underpinning this thought Araeen launched a project a few years ago together with a group of researchers rewriting British art history in an attempt to include non-Western artists who contributed to the British art scene but for different reasons remain unknown and unrecognized.[15]

Aesthetical Barometer

Looking into non-Western artists in diaspora and their art practices, both during colonial and post-colonial time, the majority have been producing art related to their given identity. In many cases artists challenge their given identity more than they challenge the Western art institutions and their structures. Examples of this can be found in the works of Shirin Neshat, Ghada Amer and Zinab Sidera.

At the same time, these artists are Western educated and live and work in cities like New York and London. This makes them insiders and outsiders at the same time.

According to Araeen, non-Western artists are not challenging the established Western art institutions enough. However, by entering the Western art canon, they have indirectly managed to challenge one of the most significant characteristics in Western art: the predomination of art made by Western artists with Western perspectives. By such intervention the visual aesthetic of Western art has witnessed a remarkable shift, particularly with artists like the Sonning Prize winner Mona Hatoum, and Shazia Sikander, Adel Abedulsamad, Walid Ra'ad, Jayce Salloum, Houria Niati, Michal Rovner, Yasmina Bouziane, Peggy Ahwesh and Fariba Hamajdi. Thus, in order to be acknowledged, any art product must be codified, synchronized or classified in accordance with the quality standard of Western mainstream art.

Visual narratives by Hatoum and other artists in diaspora are considered unique. Such manifestations are based on specific authentic socio-cultural and political experiences, which their Western colleagues could not present. The diasporic status of these artists is different from a Danish artist moving to Berlin, or a German artist moving to the UK. Cultural identity has become central for the artistic representation of diasporic artists.

Though many non-Western artists have managed to introduce and add new aesthetical elements to Western visual art, the majority did not endeavour to change the actual rules of game. The confrontation with the Western aesthetic canon, however, comes to expression when artists like Mona Hatoum impose new visual subject matters and press for different narratives, something which was regarded by the prestigious Sonning Price committee in Denmark as an expansion of the art scene in favour of Western visual culture. The nomination of Hatoum for the prize itself marked a shift in the practise of the committee. Hatoum was the first visual artist and the first Arab woman to obtain the prize.[16]

Identity Cancellation, Mobility and Immobility

According to Neery Melkonian, mobility and movement across the world has resulted in a proliferation of individuals in diaspora with corresponding visual cultures.[17] This mobile position has led many diaspora artists to deal with unique subject matters and ways of expression, each in his/her own way, and most often on a personal level. Characteristic for these artists is the use of elements such as narratives, nostalgia, and, most importantly, the question of double identity and existence between two cultures.

McEvilley and Araeen both argue that the claim that non-Western artists living and working in the West are obsessed by their given identity and can only demonstrate authenticity by practising art in relation to that[18] has to some extend been proven right.

The obsession by the given identity has become an institutional trap which many non-Western artists are falling into. In order to find some kind of uniqueness, non-Western artists found in their given identity a safe haven which developed into a discourse. However, practicing the kind of art that should ensure their uniqueness and differentiate them from their western born colleagues, has in many cases resulted in some sort of artistic blockage making them produce monotonic art. Meanwhile, Western art agencies are happy to receive, display and support this type of art, and hope for it to stay *different*. By doing so, agencies are accomplishing their institutional need: the need to distinguish between Western and other art based on visual differences.

In his remarks on the Helsinki 2001 conference Under Construction, Rasheed Araeen argues that the description of the strategy of "cultural difference" corresponds almost literally to the problem of the "representational" role of non-Western artists. As for the dominant discourse, it is so obsessed with cultural difference and identity to the extent that it too is suffering from an intellectual blockage. The consequence of this is that it is unable to maintain its focus on the works of art themselves. In addition to this, the obsession with cultural difference is now being institutionally legitimized through the construction of the "postcolonial other" who is allowed to express itself only as long as it speaks of its own otherness.[19]

However, Araeen's argument is quite general and out of touch with contemporary art practise. Squeezing all non-Western artists into one discursive category does not automatically make his observations apply to all contemporary non-Western artists. His argument may be applied on the

pioneer generation of non-Western artists who arrived to the West around the 50s and 60s, as Araeen himself. The new generation of non-Western artists of whom some are born in the West or have lived and worked in the West from early age, however, cannot relate to this categorization.

Sadly, we did not see the *Documenta 11* exhibition in Kassel paying much attention to the new emerging expatriate artist generation. The giant show, however, was a grand celebration of the pioneer generation among the internationalists.

Post-Documenta 11

Documenta 11 attempted to put an end to the ambiguity of multiculturalism and post-coloniality in visual art. The show did not leave much for the Nordic region or Denmark other than the participation of the Danish artist Jens Haaning in the show with a sound work. The show corresponded better with major Western art metropolizes in the US, UK, France, Italy and Germany.

In the 90s we were witnesses to international stimuli in the visual art, and with *Documenta 11* we were witnesses to Western visual culture gradually entering a new epoch: a new politicization of Western visual culture.

In his press conference at the opening of *Documenta 11*, Okwui Enwezor, the chief curator and artistic director of the show, spoke of the emergence of a post-colonial identity and underlined that he and his co-curators were aiming at something much larger than an art exhibition: "… they were seeking to find out what comes after imperialism".[20]

Behind the *Documenta 11* exhibition was a diverse multicultural agenda. It was characterized as a sublime post-colonial show, which marked a new millennium and ended another. The exhibition demonstrated a desire to magnify the notion of post-coloniality by confirming and confronting it on such en extreme scale. This was done, not in order emphasize it, but rather as an endeavor to end the post-colonial legacy in visual culture and start a new epoch, which may be termed the post-Documenta 11 epoch.

Despite the efforts, the exhibition did not manage to change much in relation to post-colonial identity and all that it represented during *Documenta 11*. To some critics, the show did not even challenge anything, capitalizing on the majority of artworks selected to do the job. Perhaps what it did was raising awareness and introducing new vocabularies to the western cultural industry, underlining the general disagreements when deal-

ing with questions of difference, which will remain an issue for some time to come.[21]

Was the Kassel project in 2002 an attempt to please the new-internationalists or to confirm the formation of a new post-colonial identity? Let us have a look at how *Documenta* 11 was constructed and how the curatorial aims were defined.

Relentless, international, interdisciplinary and trans-generational in its anxiety, the broad artistic and critical scope of *Documenta* 11 was set up by Enwezor and his team of six co-curators, Carlos Basualdo, Ute Meta Bauer, Susanne Ghez, Sarat Maharaj, Mark Nash, and Octavio Zaya.

It consisted of an assemblage of five different platforms, realized in Asia, Africa, Europe and the US over a period of eighteen months, between March 2001 and September 2002. That way Enwezor substantially expanded, in spatial and temporal terms, beyond the traditional 100 days format of former documenta projects and beyond its geographical boundaries in Germany.

The first four platforms were formulated as committed, discursive, public interventions within distinct communities around topics conceived to investigate the contemporary challenges and possibilities of art practices, politics and humanity. They suggested the struggle to find new meanings in the curatorial approach of selection and display, and emphasized the problem of producing and presenting information in the field of cultural and artistic expression.[22]

In his essay, "A New World Art? Documenting Documenta 11", Stewart Martin said:

> Documenta 11 was one of the most radically conceived events in the history of postcolonial art practice. It is ideal of the influence of post-colonial discourses on critical art practice over the last twenty years in breaking profoundly with the colonial pre-suppositions of the nineteenth-century tradition of ethnographic or anthropological exhibitions of non-Western art as primitive culture.
> It exhibited contemporary art from across the globe in accordance with a profound critique of the Orientalism and neo-colonialism that this task faces, which in many respects went beyond that of previous landmark shows, such as the 1989 Magiciens de la Terre in Paris, or the 1993 Whitney Biennial in New York.
> It presents a watershed in the history of Documenta – one of the pre-

eminent exhibitions of contemporary art, held in Kassel, Germany, every five years – the first to be curated by a non-European, with an unprecedented presence of artists from outside Europe and North America, and an extensive transformation of Documenta's geographical and intellectual constitution.[23]

Here, Stewart Martin was referring to the several platforms taking place outside Germany and Europe. The Platforms were intended as a displacement of the chronology and centrality of Documenta's site in Kassel that would also actualize *Documenta 11*'s post-colonial critique of the geopolitical constitution of the historical avant-garde.

One can get an impression of the nature of the platforms from their titles and locations. Platform 1 bore the title *Democracy Unrealized* and was held in Vienna and Berlin. Platform 2 was called *Experiments with Truth: Transitional Justice and the Processes of Truth and Reconciliation* and was held in New Delhi. Platform 3 focused on *Créolité and Creolization* and was held in St. Lucia. Platform 4 with the title *Under Siege: Four African Cities: Freetown, Johannesburg, Kinshasa, Lagos* was held in Lagos. Finally, there was Platform 5, the exhibition itself in Kassel.[24]

Judging by the titles, subject matters and geographic locations of the platforms, one can to a certain degree conclude that Stewart Martin's analogy was correct when portraying *Documenta 11* as one of the most radically conceived events in the history of post-colonial art practice.

Knowledge as Art

Not surprisingly, there were other essential readings over *Documenta 11*, views I find crucial to introduce. One of the critical voices was that of Michael Salcman.

In his article "Documenta 11, The Artist as Detective; Knowledge as Art", Michael Salcman, a physician, brain scientist and essayist on the visual arts wrote:

If you're thinking of going to Kassel, there's nothing new about art to be seen at the latest installment of Documenta. Furthermore, its chief curator, Okwui Enwezor, a Nigerian-born globe-trotter who lives in the United States, is the only undisputed star of his own show. He has managed to gather a multicultural array of 116 artists who share his

predictably liberal and earnest view of post-colonial society and glo-
bal capitalism but fails to anger or even surprise you because very lit-
tle of the art is strident or energetic enough to do so. The faces on the
videos are browner and blacker than before but the shrill anti-Ameri-
canism of Catherine David's Documenta X is gone.[25]

With such interventions by Michael Salcman and others we find ourselves
back in Araeen's claim that the former colonial powers continue to have
the upper hand and insist on their superiority to judge.

The question of cultural difference has been institutionally mistreat-
ed throughout the construction of the 'post-colonial other' era. Not only
that. The construction still appears to be both popular and contempo-
rary, despite the ambitious motives of the Documenta 11 curators to alter
the post-colonial agenda. The voices disregarding or disqualifying such a
mega show in a globalized world show that the motives behind the exhi-
bition were not sufficient. Also on international scale Documenta 11 was re-
ceived with ambivalence because it touched upon responsive matters like
globalization, multiculturalism and post-coloniality. Not only did it ap-
proach these subjects with a critical perspective, it was done in the criti-
cal post 9-11 period.

Let us see how Documenta 11 was received on a regional scale, in the
Nordic region and in Denmark in particular.

The Danish Connection

In order to articulate contemporary diasporic aesthetic, particularly here
in the Nordic region, one must shade some light on the multicultural de-
bate and how it has been progressing so far.

The question of multiculturalism has been shrouded in ambivalence
ever since its birth. Western countries hosting people of different cultures
have attempted to introduce and implement the idea, and apparently with
good intent. Aims and ideas, however, are one thing. Putting them in
synch with reality is something else. When studying the actual behaviour
of the supposedly multicultural Western societies, it seems that a new age
of Eurocentrism is on the march.

Social, cultural, economic, geographic and anthropologic policies all
seem to move in one direction: towards praising the advantages of West-
ern culture and civilization.

In Araeen's words, "The so-called post-colonialism has been transformed into neo-colonialism, which now exists in Western metropolizes with large populations of non-Western people, the so-called immigrants, expatriates, labour workers and refugees".[26]

Unlike colonialism, which is supposed to take place on foreign soil, many leading figures studying the field of neo-colonialism, such as Rasheed Araeen, Edward Said and Gayatri Spivak, hold that the present wave of immigration is the unfinished project of colonialism: a new experimental piece of human engineering taking place inside the lab rather than in the field. Immigration is supposed to be the frame, multiculturalism is supposed to be the aim. The question is where multiculturalism stands today, with the 9-11 events as a new demarcation line.

In Northern Europe, a region that has become well known for its reservations towards aliens,[27] expatriate art is still an issue because of the region's ongoing experience with expatriatism.

How does Denmark fit into all this? Well it does not. Denmark is reviewing its cultural identity in order to preserve it or what is left of it. Though completely aware of the American impact on its culture, Denmark focuses on the expatriates living in the country and accuses them of jeopardizing the Danish culture. The 2001 election proved that Denmark fears the heterogeneous culture of its 7% minorities and sees them as a potential risk to the Danish heritage.

In response to this, the interdisciplinary project Minority Report was initiated as a contextualizing attempt in a critical social and political climate.

Minority Report

In September 2004 the city of Aarhus witnessed the project AARHUS FESTIVAL OF CONTEMPORARY ART 2004. The project endeavored to address the issue of expatriatism in the country. "Minority Report: Challenging Intolerance in Contemporary Denmark" was co-curated by Trine Rytter Andersen, Kirsten Dufour, Tone O. Nielsen and Anja Raithel. It was the first time a project of this genre of such magnitude was shown in Denmark.

The following is a statement from the curators:

Minority Report: Challenging Intolerance in Contemporary Denmark is an interdisciplinary exhibition, which investigates the premises for the more outspoken intolerance towards and among ethnic minorities in Denmark during recent years. Intolerance towards ethnic minorities is not a new phenomenon in Denmark. In recent years, however, it seems to have manifested itself more powerfully and in wider circles. The gradual transformation of Denmark from a monoethnic to a multiethnic society has, similarly to a number of other European countries, been accompanied by an ever more outspoken hostility and doubt towards foreigners, both what concerns the question of refugees' and immigrants' access to Denmark as well as the presence of ethnic minorities in Danish society.

Within recent years, it seems to have become more legitimate to express one's feelings of xenophobia, both among majority- and minority groups.[28]

According to its curators, Minority Report wished to investigate the growing legitimization of prejudice and further examine its foundation, circumstances, and mechanisms. The show was critical, antagonizing the latest political developments in Denmark, which have given rise to a series of tightening immigration laws.

A number of international contemporary artists discussing the global geo-political situation participated in the show by admitting work that comment on and research alternatives to the current cultural world order, including the Danish.

Structurally and conceptually Minority Report was motivated by similar significant exhibitions like *Laboratorium* (1999), *Indiscipline* (2000), *Democracy When!?* And indeed *Documenta* 11 in Kassel (2002). These 80s and 90s exhibition projects addressed concepts like gender, identity, ethnicity, and multiculturalism.[29]

The most noticeable discourse at Minority Report challenged the regional notion of representation. Since its emergence in the late 1960s, Western models of representation have been under substantial criticism, and many artists have sought its deconstruction by challenging its Eurocentric articulation and structures.

Surprisingly, and unlike *Documenta* 11, Minority Report was not received with ambiguity but with great positivism.

Within the local and regional mayhem it still seems difficult for many expatriate artists living in Denmark to break through to the Danish white

cube. Two things are impeding the process. The first is the fear within Danish mainstream institutions, or the Danish white cube, of loosing homogeneity. The second is the artistic production of the majority of expatriate artists living and working in Denmark.

In a Danish report from 2002, the relationship between expatriate artists and the Danish art agencies and institutions is studied. In 2001, the Inter-Cultural Network at the National Museum initiated a survey undertaken by Charlotte Lee Høirup and Casper Hvenegaard Rasmussen at the Center for Cultural and Political Studies. The survey included a study of more than 30 art institutions in Denmark and revealed a generally negative attitude towards immigrant artists. The resultant report "Cultural Institutions' Contribution to Multi-Cultural Denmark" mentions that some art institutions in Denmark hide behind the 'lack-of-quality-excuse' when dealing with expatriate artists. On page 12 in the report it says that usually expatriate artists meet a WALL when approaching the art establishment which constantly require high quality. According to the report, mainstream institutions use the quality argument as a shield to deny expatriate artists access to the establishment.[30] The characteristic alibi used by the establishment is in turn often met with counter-accusations of deliberate exclusionism, and this raises rather serious questions about both positions.

Art produced by the majority of non-Danish artists is still received as ETHNIC, rather than international, by most Danish institutions. Among them is the former Development Fund (1999-2002) which had multiculturalism as one of its focus areas. The Minister of Culture at the time, Elsebeth Gerner Nielsen, wanted to push the subject forward, but although the fund did support certain art projects, the attitude towards expatriate artists and the general impression of expatriate artists did not change. The reason to this can be found in the commission body, which was supposed to facilitate change. Instead, it ended up complicating the topic by distributing money at random, which silenced non-Danish artists rather than promoted them.

Its main function was distribution of cultural funds, but the Development Fund was not the right institution for the task. Lack of serious interest and expertise in the topic was the main obstacle.[31]

The intentions of the minister were good, but the problem could not be solved simply through additional distribution of money. A more ser-

ious research on the topic is still needed in order to enlighten a new visionary, inventive and comprehensive cultural policy.

Meanwhile, the level of discussion of cultural policy in relation to expatriate art and culture goes hand in hand with the level of discussion of multiculturalism in the Danish society. The general multicultural debate continues to move in a downward spiral. The emergence of projects like Minority Report is just another confirmation of this.

The Quality Question

It is often said that in order to gain recognition, non-Danish artists need to focus on quality. In contemporary art practise, however, quality is often simply referred to as the kind of art the institutions are allowing into their premises. A central aspect of the quality game is choosing the right media to express artistically and socially interesting concepts.

Art made by artists in diaspora often has more to do with clarifying cultural identity than with aesthetic feeling, beauty, or the transcendental. In this respect diaspora art is very conceptual in nature. The everyday reality of diaspora artists, though, is different from the everyday reality of Danish artists – and hence also the subject matters of their art.

Most expatriate artists living in Denmark work outside the mainstream institutions. In addition to this, the majority of these artists are using traditional practices to produce traditional works, and this is not exactly the kind of artwork the mainstream art institutions are looking for. Only a small minority has managed to get through to established Danish art institutions. Among them are Amel Ibrahimovic (Bosnia), Eric Fajardo (Panama), Al Masson (Belgium), Colonel (France), Marco Evarestti (Chile), Lilibeth C. Rasmussen (the Philippines/Denmark), Alev Siesby (Turkey), and Hamid Nouar (Morocco).

Before questioning the attitude and behavior of mainstream art institutions towards expatriate artists and place them under critical scrutiny in search for Orientalist or Colonialist behaviors, the kind of art produced by non-Western artists in Denmark ought to be studied in order to determine the authenticity of their art practice. Still, as mentioned in the report by Høirup and Hvenegaard Rasmussen, institutions that hide behind the supposed lack of quality among immigrant artists could be Orientalist in their attitude and behavior – this can not be totally ruled out.

In connection with the Nordic exhibition *Clockwise* in Vejle 2002 or-

ganized by Nordic Institute for Contemporary Art (NIFCA) and curated by Stine Høholt and Khaled D. Ramadan, a number of local politicians from the town City Hall, rejected the exhibited installations and artifacts. Right-wing politicians raised criticism towards the exhibition and its content. Though the criticism was directed at the type of art put on display in the museum, the politicians could not hide their opposition to the fact that a few immigrant names appeared in a show in their conservative town, inside their fine museum. They demanded to see what they called 'real art'.[32]

Academy of Fine Arts – Institution under Change

It is essential to point out that various changes are taking place, despite current political and cultural developments in society. Recently, the Royal Danish Academy of Fine Arts changed its admittance policy. Four to six years ago the academy started to synchronize its policies with that of other academies by admitting a limited number of students with non-western background into the academy. Still, there is a lack of non-western tutors and lecturers at the academy, but some sort of recognition and legitimizing project is in the way.

What I have tried to highlight in this paper is the un-necessity of repeating the patterns of an old epoch, namely that of colonialism and post-colonialism, which unfolded at the doorsteps of the Nordic sphere. Postponing the legitimization process of non-Western art and culture will not be at the advantage of the host country when the rest of the art world is moving beyond this position.

What is needed is a comprehensive socio-cultural project challenging the very schemes behind the Danish attitude towards non-Western artists inside its boundaries.

1 Brian O'Doherty: *Inside the White Cube. The Ideology of the Gallery Space*. Introduction by Thomas McEvilley. The University of California Press. Orig. 1972. Expanded Edition 2000.

2 Maria Hirvi in Nordic Art Review NO.1/01.

3 Akbar Abbas: *Hong Kong: Culture and the politics of disappearance*. Hong Kong University Press 1998.
Frederic Jameson: *Postmodernism, or the cultural logic of late capitalism*. New York: Verso 1991.
"Frederick Jameson's and Akbar Abas' theories on cultural expansion disconnects the labelling process from culture theorizing. They indicate that alteration to a culture does not change a culture's perceived status, but results in an expansion of that culture. Jameson's and Abas' theories embrace change through time, and recognize all of the ingredients that make up culture. Their perception of culture is of it being dynamic and able to accept change ..."
In Ken Staples, Panel Papers from the ASAA conference – July 2000. "Hong Kong culture: hybrid, bicultural, multicultural, or a continuing renewal".

4 See for instance the writing of Jenny Sorkin: "Imagined Multiculturalism". NU. Vol. 11 No. 3-4/00.

5 Jenny Sorkin: "Imagined Multiculturalism". NU. Vol. 11 No. 3-4/00.

6 Primitivism in 20th Century Art, Affinity of the Tribal and the Modern, Museum of Modern Art, New York, 1984.

7 Igor Zabel: "We and the others". Moscow Art Magazine N° 22. 1988.

8 Thomas McEvilley in his speech at the Nordic conference Under Construction, Helsinki 2001, organized by NIFCA (www.nifca.org).

9 Igor Zabel: "We and the others". Moscow Art Magazine N° 22. 1988.

10 Rasheed Araeen: *Making Myself Visible*. London: KALA Press. 1984, p. 43.

11 Thomas McEvilley: "Here Comes Everybody" in exhibition catalogue From Beyond the Pale, Irish Museum of Modern Art, 1994. Also published in Ekbatana exhibition catalogue. Images of the World. Nikolaj Exhibition Space. Copenhagen 2000.

12 See for instance Thomas McEvilley: *Art and Otherness*. McPherson & Company. 1992, pp. 10-11.

13 Thomas McEvilley: *Art and Otherness*. McPherson & Company. 1992, pp. 10-11.

14 Rasheed Araeen in his remarks to the Nordic conference Under Construction, Helsinki 2001, organized by NIFCA (www.nifca.org).

15 Rasheed Araeen. Conversation at the Nordic conference Under Construction, Helsinki 2001.

16 Mona Hatoum was nominated for the Sonning Prize in Copenhagen 2004.

17 Neery Melkonian: "Between Heaven & Hell". Al Jadid, Vol. 3, No. 19 (June 1997). Also published at http://www.aidainternational.nl/agenda/beeldende%20kunst/Between%20heaven%20and%20ohell.html
So far we have not witnessed a complete and comprehensive study of diasporic art-

ists in the contemporary Western society. The reason for that can be that the process is still crystallizing.

18 McEvilley: *Art and Otherness*. McPherson & Company. 1992. Rasheed Araeen in his remarks (unpublished) to the Nordic conference Under Construction, Helsinki 2001.

19 Rasheed Araeen in his remarks to the Nordic conference Under Construction, Helsinki 2001, organized by NIFCA (www.nifca.org).

20 Thomas McEvilley, FRIEZE, Issue 69, 2002, UK.

21 Kobena Mercer, FRIEZE, Issue 69, 2002, UK.

22 Introduction. Platform 5. Documenta 11. http://www.documenta12.de/data/english

23 Stewart Martin: "A new world art? Documenting Documenta 11". http://www.radicalphilosophy.com/pdf/article122.pdf

24 An overview of the platforms:
Platform 1, *Democracy Unrealized*, Vienna 15–20 April 2001, and Berlin 9–30 October 2001.
Platform 2, *Experiments with Truth: Transitional Justice and the Processes of Truth and Reconciliation*, New Delhi 7–21 May 2001.
Platform 3, *Créolité and Creolization*, St. Lucia 13-15 January 2002.
Platform 4, *Under Siege: Four African Cities: Freetown, Johannesburg, Kinshasa, Lagos*, Lagos 16–20 March 2002.
Platform 5, *Exhibition*, Kassel 2002.

25 Michael Salcman: "Documenta 11, The Artist as Detective; Knowledge as Art". http://www.critiquing.net/art/documenta110702.html
http://www.peekreview.net/archives/documenta_ms.html

26 Rasheed Araeen in his remarks to the Nordic conference Under Construction, Helsinki 2001, organized by NIFCA (www.nifca.org).

27 See http://www.rff.dk/uknyhedsbrev/dec2002e.pdf.

28 http://www.minority-report.dk/english/tekster/statement.html

29 Ibid.

30 Casper Hvenegaard Rasmussen & Charlotte Lee Høirup: *Kulturinstitutionernes bidrag til det kulturelt mangfoldige Danmark - en undersøgelse af kunst- og kulturformidlingsinstitutionernes tilbud til og inddragelse af de etniske minoriteter*. København: Det Interkulturelle Netværk. 2001, p. 37.

31 Based on my PhD research project and part of my own analysis of the fund's activities in connection with my role as a consultant on the topic of mobile artists.

32 Kurt Tværkær: "Kunstværk?" ("Artwork?") Vejle Amt Dagblad, 29. juli 2002. Local right-wing politicians criticized the authenticity of artworks by artists Colonel and Marco Evaristti during the Clockwise exhibition summer 2002 and demanded to see Rembrandt instead.

FRAMING EGYPTIAN ART
Western Audiences and
Contemporary Artists from Egypt

Jessica Winegar

"Good for you", several curators and critics said in a patronizing manner to a successful Egyptian artist working in Paris. This same artist also over-heard gallery owners disparaging an artist friend of his: "He was a typical Egyptian – *C'était un Egyptien typique*". Recently another Egyptian artist, who lives in the U.S., described his interest in Sufi aesthetics to an American colleague. The American suddenly asked him with alarm, "Do you support Hamas and terrorism?" The Egyptian was confused as to what Sufi aesthetics has to do with Palestinian politics. On a studio scholarship to an art center in the Netherlands, two other Egyptian colleagues of his surprised their fellow European and American artists with images of contemporary Egyptian art. The Westerners admitted that they had no prior knowledge of Egyptian art after Pharaonic civilization.

When I tell Americans about my work on visual artists in Egypt, they often ask, "*Does* Egypt have contemporary art?" This question, like the comments of Europeans and Americans in the stories above, is usually motivated by three preconceptions: that 'real' contemporary art does not exist outside the West; that artistic production in developing countries is limited to crafts like rugs and mosaics; and that Egyptian art is synonymous with ancient Pharaonic objects such as those found in King Tut's tomb. I have found these misconceptions among people who generally consider themselves to be liberal, educated, and knowledgeable about matters of art and culture. Part of this ignorance could be attributed to U.S. parochialism, but unfortunately such erroneous ideas are found among European intellectual communities as well.

In fact, I once thought that Egypt did not have much in the way of contemporary art. Although I had always been interested in working in the Middle East, I almost changed my region of study because I thought that I would not find enough artists to work with, and did not want to focus on the traditional craft production that I assumed dominated the region. I am very grateful to Egyptian historian Omnia Shakry for convincing me that there were, indeed, artists in Cairo. The misconception that significant contemporary art movements do not exist outside the West persists, even though by now many people are familiar with the fact that in the past twenty years or so, galleries in the U.S. and Europe have taken an interest in contemporary art from non-Western places (especially Latin America). Yet even the most culturally astute people cannot seem to grasp the idea that Arabs, especially Muslim Arabs, make contemporary art. I am not talking about those few Muslim and/or Arab artists living in the West

who have garnered some acclaim in recent years. I am referring to artists living and working in the Arab world.

Once I convince people that the art world in Egypt is actually so complex that I spent 3½ years studying it, the next question is inevitably, "so the work must be religious, right?" I see no other way to interpret such a line of questioning than as implicit prejudice, which reveals an incredibly simplified understanding of Muslim religious practice and its relationship to cultural production. Not only are people unaccustomed to the idea that there are non-practicing Muslims or that Muslim religious practice varies in intensity and form, but they also assume that religion determines the cultural production of practicing and non-practicing Muslims alike.

People who know a little something about Islam also like to ask a slightly more informed question: "So they don't paint images, right?" The so-called 'ban on iconography' in Islam is actually a complex debate with historical and regional variations. The injunction against praying to false idols (shared by all of the monotheistic religions) has been interpreted by some Muslim theorists, but not all, to mean that any representational painting or sculpture is forbidden because it may become a false idol. Likewise, the injunction against portraying God or any prophets has been interpreted by some artists and theorists to prohibit any representation of human beings. Yet these particular interpretations of Islam do not mean that artists of Muslim background are necessarily bound by them. Such presuppositions about religion in places like Egypt are often related to the erroneous belief that all Muslim countries are breeding grounds for 'Islamic fundamentalists' or 'terrorists'.

The prevailing idea that 'Egyptian art' is synonymous with Pharaonic art is equally troubling on a number of levels. First, it reflects the persistent fascination of the West, rooted in colonialism, with ancient Egyptian objects. The Egyptomania that swept Europe during the 18th and 19th centuries reappears whenever there is a mammoth exhibition of these objects in places like the Metropolitan and the Louvre. While these statuettes, scarabs, and headdresses are well-deserving of our admiration, the continued fascination with Pharaonia also effectively locks Egyptian art and culture in time, negating 2000 years of subsequent material culture. The Western romance with ancient Egypt directly produces ignorance of contemporary Egyptian art, because this romance depends on a conflation of place, time, and object. 'Egypt' in this context cannot be imagined as other than the mysterious, magical land of the Pharaohs.

This essay is intended as a polemical intervention into these misconceptions. Using the case study of Egypt, I shall make a very simple point but one that nonetheless bears repeating: Artists from 'Third World' countries, and from the Middle East or the larger Muslim world in particular, are complex social actors. Their artistic production is not necessarily wholly determined by their religious belief or by the religious context in which they grew up. Nor is their work a mere 'reflection' or 'product' of their culture as this culture tends to be telescopically and stereotypically understood by Europeans and North Americans. Furthermore, artists that do see themselves as working with Islamic ideas or aesthetics in their work do so for a variety of reasons and in a multitude of ways. The tendency to lump them together under the terms 'Islamic artists' or even 'Muslim artists' does not do justice to their diverse range of artistic approaches and influences. Finally, when these artists engage with Western audiences, their artistic production takes on another layer of complexity – as they try to negotiate their artistic and cultural identities with how their work is received, and with how they are represented as artists from different religious and cultural backgrounds.

By discussing the contemporary Egyptian art world, I aim to give the reader a sense of the rich complexity of issues and influences that shape artists' lives and work in their home countries. I do this to work against the pernicious simplistic interpretations of 'Egyptian culture' or 'Islam', particularly as they relate to art. And although this essay is not about immigrant artists per se, its analysis of the Egyptian case suggests that a more sophisticated understanding of immigrant artists' cultural and religious backgrounds is sorely needed. Through my discussion of contemporary Egyptian art, I argue that continued inattention to the ways that these artists are stereotyped, and the persistent elision of the power relations that produce such stereotypes, not only denies these artists full artistic personhood, but also prevents the international art scene from attaining the vitality it needs to grow in pace with other media such as cinema and literature.

Many foreign visitors to contemporary art exhibitions in Egypt are struck by the range of themes, styles, and media that Egyptian artists use. This variety certainly defies any expectation that contemporary Egyptian art is solely a product of Pharaonic ancestry or Islamic belief. Artists explore a range of political and social issues in their paintings, video projects, and installations. Such issues include the deleterious effects of industrializa-

tion and economic liberalization on Egyptian environment and culture, the military aggression of the United States and Israel, economic disparity between Western countries and the Third World, and criticisms of the Egyptian art world bureaucracy. Many artists explore customs, traditions, and changing modes of social life as expressed in the visual culture of the country – from folk imagery to contemporary advertisements. In other work, artists explore the depths of personal expression, or, alternatively, focus on purely formal compositional problems. This sheer variety of contemporary Egyptian art reflects the diversity of Egyptian society and among artists in particular. Artists come from all social classes, from rural and urban areas all over the country, are men and women, liberal and conservative, religious and areligious, young and old. Thus they have many different perspectives on art, politics, religion, history, and culture. Nonetheless there are themes, styles, and even trends that dominate contemporary art production in Egypt, and several art writers have categorized these in different ways.[1] If there is any overarching category that can be called 'Egyptian art', it arises from artistic negotiation with the specific cultural and historical circumstances of the country in which these artists live.

Ancient Egyptian history has been an important component of the modern Egyptian nation from the early 1900s to the present day. Not only is Egypt the original site of Pharaonic temples, pyramids, and statuary that artists see on a regular basis, but 'Pharaonism' – the harkening back to a glorious Pharaonic past – continues to serve the nationalist narrative (shared by many artists) of Egypt's past and its heroic potential. For this reason and others, a great number of artists find inspiration in Pharaonic forms and composition methods. For example, painters and sculptors will sometimes include pyramids, hieroglyphs, or Pharaonic figures in their work; or they might use Pharaonic composition principles to organize paintings, sculptures, and installations. Yet stylistic treatments of such Pharaonic elements are quite different, and the meanings associated with their use are contested. Local evaluation of works that employ Pharaonic elements can be both positive and extremely negative. Indeed, the ways that Egyptian artists engage with their country's Pharaonic history reveal a more complex relationship between artistic practice and historical-cultural identity than the assumption that they are merely antecedents to the Pharaohs allows.

Many Egyptian artists view their engagement with Pharaonic visual forms and principles as a dynamic one, motivated primarily by their continued exposure to this art – for example in picnics at the Pyramids, visits to the Egyptian Museum and to the temples and tombs of Luxor, school instruction in Pharaonic history, and the proliferation of Pharaonic imagery in the national media of Egypt. While many artists throughout the history of modern Egyptian art have taken pride in Pharaonic painting and sculpture as part of their national heritage, the use of this heritage in artwork is not immune from criticism. Much of the debate has to do with whether or not Egyptian artists can rightfully be said to be the 'heirs of Pharaohs' – culturally, artistically, and even genetically. For example, artists and critics alike often find fault with what they see as their colleagues' superficial use of Pharaonic 'motifs'. In particular, painters that use ancient Egyptian hieroglyphs, human or animal figures, or the pyramid shape in their work risk being criticized for naively believing that these representations express an innate, Pharaonic, Egyptian identity. Their critics argue that thousands of years separate contemporary Egyptians from the ancients, during which Egypt experienced many social and political changes, including conquering armies and migrations. Therefore, any direct connection with the Pharaohs does not exist, even though their art is currently part of the national patrimony. My point here is not to pass judgment on the claims that contemporary Egyptian artists are or are not continuing the Pharaonic tradition, but rather to show that these claims are a matter of intense local debate. The relationship between Egypt's ancient history and its national present is complicated, and it is in part this complexity that has produced some of the most interesting artwork and artistic theory in the past decades.

Several artists have approached the problem by studying the aesthetic sensibilities of Pharaonic art, and contemplating their potential use in contemporary painting, sculpture, and installation. Adam Henein, one of Egypt's most distinguished sculptors, readily admits being in awe of Pharaonic sculpture from an early age when he was taken to the Egyptian Museum in Cairo on school trips. His admiration of this art drives his own work, in which he tries to achieve what he thinks only the ancient Egyptians were able to do: a beautiful tension between solidity and weightlessness, between hardness and suppleness. It is this tension, he argues, which gives Pharaonic sculpture its internal energy that radiates outward in grandiose power. In trying to capture this same tension, Henein has created some works that bear resemblance to Pharaonic forms. But others

do not. Indeed, he argues that he is not doing Pharaonic art. That is a thing of the past, he says, but these ancient artists gave him signs for how to express pure power in form.

Nagi Farid, a former student of Henein's, also takes a cue from Pharaonic art in his refusal to elaborate surface detail, and instead aims to make his sculptures communicate the internal energy of the form and material. Recently, he has explored the visual and sensate power emerging from the juxtaposition of granite and bronze. Unlike high modernist or conceptual attempts in the West to reduce the work of art to its self-referentiality, Farid's approach references an ancient aesthetic system that was built on the triangular relationship between the people, their pharaoh, and the authority of the gods.

One of Egypt's representatives to the 1999 Venice Biennale, Shady El-Noshokaty, has explored for several years the transference of the philosophy and compositional principles of Pharaonic art into a contemporary form. In recent work, El-Noshokaty pushes the concept of transference even further, and on multiple levels. Intrigued by the Pharaonic belief in the transformation of humans and animals to gods, and the intermediary stage of mummification, El-Noshokaty has completed a number of paintings of organic forms that appear to be in cocoons, waiting to be reborn. He describes the whole project as an exploration of the idea of a journey into the light, an idea that is originally from Pharaonic ideology.

Khaled Hafez uses Pharaonic imagery in a different way, one that does not honor or tap the aesthetic insights of the ancient Egyptians. Instead, Hafez's collage-paintings are intended as a satiric comment on consumer products *and* ancient symbols, and how they both ride the line between the sacred and the commercial in contemporary Egyptian society. For example, the Egyptian god Anubis (the jackal) is often juxtaposed with images suggesting the commodification of women and sexuality in films and advertising. Hafez plays with the contradictory sacred/iconic and commercial effects of the repetition of such imagery, often symbolized by the cutouts of 'final kiss' scenes from films, which he says reminds us that "we have seen it all". There is never a surprise in the plot. The combination of all of these images is part of the artist's interest in memory as well. The Pharaonic imagery is part of his memory growing up in Egypt, where he saw such art in its original and marketed forms for the tourist indus-

try. These images are combined with others that reference his memory of three years spent in Paris. This mixture of "visions of memory", as the artist calls them, clearly index the complicated relationship between Egyptian artists, their history, and their culture in the mass media-influenced globalizing world.

While these artists' very different engagements with Pharaonic art has received praise in Egyptian art circles, it has not been an easy task. Artists and critics are suspicious of claims to affinity with the Pharaohs or their art that seem too fabricated, forced, or naïve. Such claims are seen to manifest themselves in overt usage of Pharaonic imagery in a way that is merely panegyric. At times, the nationalist narrative of Egypt's historic glory generates considerable sarcasm, but it is also at some level a source of pride. Much like the U.S. valorization of the colonial 'pioneer spirit', which in part formed the basis for American abstract expressionism,[2] Egyptians' sense that their country was the site of one of the greatest civilizations continues to invigorate their artistic theory and aspirations. The question, then, is how to engage with this history in a way that is artistically productive and theoretically credible.

In response to accusations from Egyptians and Westerners that their work is an unsophisticated repetition of the Pharaonic, artists often retaliate that European artists, like Miro and Klee, took forms from ancient Egypt. It is now their right to reclaim them. In my opinion, critics have not paid enough attention to this potentially subversive act. Artists break down this idea of cultural property at convenient moments as well. For example, critics from Egypt, Europe, and the U.S. sometimes charge Egyptian artists with imitating Western art, or assume that contemporary Egyptian art is derivative of a Western predecessor. In response, artists argue that just as Western artists are often influenced by art from all over the formerly colonized world, Egypt included, it is their right to use elements, styles, etc. from everywhere, including Europe and the U.S.

Yet all of the simplified misconceptions that contemporary Egyptian artists are 'heirs to the Pharaohs', or produce 'Islamic art', or mimic the West, limit these artists' full inclusion in the international art scene despite their aesthetic and vocal demands. On one important occasion, however, experimentation with ancient Egyptian heritage met with considerable international success, despite (or perhaps because of) the Euro-American veneration of Pharaonic art at the expense of contemporary Egyptian art.

At the 1995 Venice Biennale, there was room for acknowledgement of the achievements of both Egypt's past and present. That year, three Egyptian artists (Hamdi Attia, Akram El-Magdoub, Medhat Shafiq) won the prize for the Best Country Pavilion at the Venice Biennale with an installation that combined the architectural principles and spirit of Pharaonic temples with those of the Islamic mosque.

The entrance to the pavilion consisted of a low-lit, high-walled steel maze through which the viewer passed. Inside the maze, contemporary music played which was based on one of the artist's voices singing an Egyptian folk song. The music was an electronic manipulation of the voice into a rhythm that recalled Sufi incantations. The dark, narrow space of this maze, filled with spiritual music, mirrored the inner sanctuary of a Pharaonic temple – the seat of the god. In these temples, a series of rooms, from large to small, from light to dark, lead to the holy inner chamber. This architectural device was also used in mosques of a certain period of Islamic architectural history (e.g. Sultan Hassan mosque in Cairo, circa 1363). In these buildings, worshippers passed through a series of chambers and corridors, decreasing in size, before they reached the open space for prayer. The experience was intended to gradually remove the pious from the exigencies of everyday life, in preparation for prayer in the pure interior space, whose focal point was the mihrab. Thus the interior space of both Pharaonic temples and some Islamic mosques was built on a kind of triangular model, with the two lines of the external walls converging in the innermost room. The artists of the Venice installation took these shared philosophical elements of Pharaonic and Islamic architectural and spiritual histories and projected them into the contemporary era. They brought the viewer from the dark interior chamber filled with spiritual music back out into a brightly lit room, thereby letting the two converging lines cross each other and radiate outward again. The bright space, then, was the architecturally symbolic manifestation of Egypt in the contemporary era. It contained a number of objects that, in their compositional and material properties, embodied not only the deep history of Egyptian material culture, but also its contemporary innovations. For example, earth colors met chemical pigments, clay and mud brick was juxtaposed with industrial metal sheeting, and forms reminiscent of rural Egyptian homes blended with the sharper geometry of new high rise urban architecture.

As these examples show, the historical visual arts of Islam, along with religious philosophy and cultural aspects, are important resources for Egyptian artists with a wide range of religious belief and practice (from Islam and Christianity to atheism) and a variety of artistic approaches. In this sense, some contemporary art productions from Egypt could be seen as part of a larger artistic trend in some majority-Muslim societies to engage with religion. Historian of Islamic Art Wijdan Ali has written widely on this topic, most recently in a book entitled *Modern Islamic Art: Development and Continuity* (Gainesville: University Press of Florida, 1997). Ali argues that the centuries-long tradition of Islamic art waned with the onset of colonialism in North Africa, the Middle East, and Iran. She writes that the decline in Islamic art patronage, the increase in industrialization, and the admiration of Western art and culture all precipitated the decline in Islamic art. Her book is based on what she views as a "revitalization" of Islamic art in a modern form in recent years, which she characterizes as the birth of a School of Calligraphy in the region.

This book, as well as Ali's earlier *Contemporary Art from the Islamic World* (London: Scorpion Publishing Ltd., 1989), are the best English-language publications documenting important works and history of modern art in various countries of the region.

But as the work of another scholar of contemporary Egyptian art suggests, "Islamic art" is not the whole story. Liliane Karnouk's historical *Modern Egyptian Art* (Cairo: AUC Press, 1998) and her later *Contemporary Art in Egypt* (Cairo: AUC Press, 1995) present a much more complicated view of art production in this purportedly 'Islamic country'. She analyzes trends from folk realism to assemblage and kitsch. Indeed the problem with Ali's work is that, in its laudable attempt to find and analyze trends, it ultimately reduces a wide range of histories and practices to a homogenizing, overarching category called 'modern Islamic art'. Because the book contains no definition of just what 'Islamic art' is, or what is meant by the term 'Islamic artist', it gives the false impression that all art produced in the region is Islamic, and that all artists identify themselves as Islamic. Of course, it is part of orthodox Muslim faith to maintain a holistic worldview that sees all things in accordance with Islam as Islamic, and I certainly do not want to detract from those artists who self-identify both themselves and their art as 'Islamic'. But there are many interpretations of the relationship between religion and artistic practice, both in the textual tradition and among contemporary artists. These variations must be taken into account, and any similarities must be carefully stated, in order

to avoid reinforcing Western stereotypes of artists from a Muslim background.

Contrary to popular belief in the West, many artists in majority-Muslim countries do not use calligraphy or abstraction because figuration is forbidden in Islam. Although there are Muslim artists who avoid figuration, others take issue with this interpretation of Islamic edict. The turn-of-the-century mufti of Al-Azhar University in Cairo, Muhammed Abduh, long ago gave his blessings to the Cairo College of Fine Arts by arguing that the ban on images applied to an earlier period in Islam when the danger of idol worship was much more imminent. Indeed, Muslim artists in different places throughout history have made art representing both people and things. Even the Prophet Muhammed is represented in some Persian illuminations, though with a white sheet over his face. While many Muslim artists across the world work in abstraction, often inspired by Arabic calligraphy or Islamic wood or stone-carving designs, not all of them do so solely because of religious limitations. For example, the reason that Egyptian artist Hussein El-Gibaly paints abstracted variations on Arabic calligraphy (much of it religious) is not because he cannot, as a pious Muslim, paint objects or people. Rather, he works with calligraphy because it is part of his cultural heritage, because he finds the forms of the letters beautiful and spiritual, and because he sees endless possibilities for meaning and composition by rearranging the forms of Arabic letters.

Again, I am not trying to delegitimize those artists who do avoid representation for religious reasons, or who make art that explicitly expresses an Islamic identity. Rather, I am arguing against the assumption that religion, particularly Islam, overly determines artistic practice. And when artists do engage with Islam in their work, they do not necessarily follow the same artistic paths. Therefore, *work made by Muslims is not necessarily Islamic, and contemporary Islamic art takes many different forms.* Just as the work of Pablo Picasso or Sol Lewitt is not described as 'Christian' or 'Jewish' art, many artists from Muslim backgrounds do not see what they do as 'Islamic', even if they deal with Islam in their work. Despite our familiarity with the critiques of Orientalism, or even the nascent realization of Western media racism towards Muslims, there is still a dangerous conflation between Islam and art. This perceived one-to-one correlation negates the complexities of being an artist who is also born a Muslim. The idea of 'Islamic art', as it is practiced in the academy and as it is popularly understood, needs to be reworked and perhaps defined more precisely. It is im-

portant to take regional and historical variation into account, as well as the personal beliefs or non-belief of the artist. It should also be remembered that there are a number of artists in majority-Muslim countries who are not Muslim.

In fact, to describe oneself as an 'Islamic artist' (*fannan islami*) or what one does as 'Islamic art' (*fann islami*) is highly unusual in Egypt. Part of this difference has to do with the specificity of the history of modern art in Egypt. Although Ali's books provide comprehensive information about the introduction of modern art institutions in each of the countries of the region, she unfortunately does not use this to speculate on any differences these varying histories might produce in local understandings of the relationship between art and artistic practice. It is extremely important to take into account the fact that countries with majority-Muslim populations have different histories of modern art, and that significant cultural and political differences exist between these societies that affect artistic production. Even the variations between Arab countries can be quite significant.

In the most obvious example, the history of conflict between Israelis and Palestinians has led many Palestinian artists to focus on oppression and the occupation in their art, and many do work that expresses their attachment to the land. In Saudi Arabia and elsewhere in the Gulf, works containing Arabic calligraphy are abundant, perhaps due to the widespread view that these countries are more purely 'Arab', and closer to the geographic center of Islam (Mecca). Ali herself speculates that the predominance of calligraphy in this area may be due to market demand, or to a desire to reassert a local Islamic identity in the face of the rapid Westernization precipitated by the discovery of oil.

In Egypt, however, modern art was defined as a secular activity from its inception. The establishment of a School of Fine Arts in 1908 by royal, but not religious, patronage set the course for the development of other institutions and artistic trends outside the religious realm.

Undoubtedly, the early Egyptian artists interacted with their European counterparts resident in Egypt, which may have contributed to their disinterest in design elements culled from historical Islamic material culture such as mosque carvings, Quranic calligraphy, and illuminations. I would also argue that the dominance in early Egyptian nationalist discourse of both folk/peasant and Pharaonic imagery led artists to explore these themes

in early and subsequent attempts to build an Egyptian artistic identity. Although most artists in Egypt cannot justifiably be included in The Calligraphic School as Ali describes it, it is interesting to note that a few notable artists started to work with calligraphy after the 1967 Arab defeat against Israel that caused many Egyptians to feel that weak faith had precipitated the loss. Sadat's subsequent encouragement of Islamic groups, the revolution in Iran, and the increasing conspicuous consumerism resulting from an open-door trade policy with the West, formed the context and perhaps the impetus for more public displays of Islamic identity in Egypt. As Karnouk (1995) argues, this was the context in which artists like Mohammed Taha Hussein and Ramzi Mostafa became interested in calligraphic abstraction and in Islamic aesthetic principles more generally.

The younger generation of Egyptian artists explores themes related to Islam in ways that do not easily fit into categories like 'The Calligraphic School' or 'Islamic art'. For the past several years, artist Sabah Naeem has been exploring the possibilities for culturally specific representations of the human body. Her work transgresses stereotypical images of the oppressed Muslim woman, as well as standard art historical representations of the female nude. She tries to find a way to reach deeper than external clothing and formal properties to understand the liberating and oppressive relationship between the female body and culture in *both* Islam and the West. For example, while non-Muslim, Euro-American women may have more freedom of sexual expression outside of marriage, this comes at the price of the visual commodification of women's bodies in mass culture. Naeem's work is unlike that of many women artists from majority-Muslim countries who have immigrated to New York, London, and Paris. Their work critiques patriarchy and oppression in Muslim countries in a way that poses an intriguing challenge to Orientalist stereotypes of silent Muslim women while simultaneously reaffirming Western judgments of Islam and Muslim men. Naeem's work successfully guards against such judgments of Islam because it does not draw on well-known images such as the veil and the beard. I would argue that such images have become so symbolically loaded in the West that it is difficult to transmit any complex understanding of Muslim practice through them.

Wael Shawqy, the grand prizewinner of the 1997 Cairo Biennale, explores the relationship between religion and culture in a very different way that also challenges stereotypes. In a 1999 work, he deals with the relationship between social class, capitalist consumerism, religion, and cli-

ché. A structure resembling the Kaaba in Mecca was built out of tarpaper and placed in a pool of liquid tar and asphalt that also had a clear visual reference to petrol. Viewers, like pilgrims to Mecca, circumambulated the structure, in essence paying homage to the global culture of contemporary capitalism, which in the Middle East is largely the result of the oil trade.

This satiric comment on the clichéd nature of religion as it intersects with capitalist consumerism is an excellent example of how young Egyptian artists are dealing with Islam in their work. They examine Islam not as a monolithic whole that determines human culture, but rather as a significant part of contemporary life, and, in some cases, vulnerable to commodification.

The stories at the beginning of this essay and others like them (there are many) indicate that Egyptian artists often face considerable ignorance when they emigrate or travel abroad. This Western ignorance is undoubtedly related to ethnocentric attitudes and the stereotyping of Arabs and Muslims in the Euro-American imaginary. Art made by Arabs and/or Muslims is thereby reduced to religion and cultural background, and this background is often understood quite simplistically. There are several potential effects of this reception of such artists in the West – effects that arguably have already been felt.

First and foremost, avenues for exhibiting their work are limited. They are often steered to galleries or shows featuring 'Arab' or 'Muslim' artists. While it is admirable for the organizers of these exhibitions to expose audiences to work they might not see in major galleries or museums, such shows ultimately run the risk of reinforcing the idea that these artists are 'different' in some essentialist way, and that their work is primarily determined by and limited to their ethnic and religious background. Thus gallery owners in Paris can continue referring to immigrant artists from Egypt as 'typical Egyptians'. Even an artist who emigrates to the U.S. or Europe and aspires to being treated with equality can be forever branded as a 'Muslim' or 'Arab' first, and an 'artist' second. Hence the terms 'Muslim artist' or 'Arab artist' instead of 'artist of Arab origin (or background.)' Writers who analyze their work then frequently use these readymade labels as keys to understanding. Thus a piece cannot be about something other than Islam or the Middle East. Indeed, societal stereotypes of Muslims/Arabs shape the frames through which these artists' work is analyzed, appreciated, or criticized.

When artists do choose to examine their religious or cultural identity in their work, then, the interpretation is set by the dominant powers of the art world. Artists have little room to promote different understandings of their identities outside of the dominant framework. An artist exploring Sufi thought, for example, is accused of Muslim fanaticism. Artists who choose a critical approach to their religious or cultural identity are in a particularly vulnerable position, because Western audiences latch on to criticism of Muslims/Arabs with the only tools they have – those from the prejudicial media and political discourse. Thus viewers read the critical messages of feminist artists from the Muslim world as applying only to Muslim women, or they may see artistic criticism of Arab political systems as justification for foreign military presence in the region. On the other hand, immigrant artists who are critical of their new societies risk being branded as ungrateful outsiders unwilling to conform. In an era when political and critical art enjoys prominence on the international art scene, such constraints on artists of Arab or Muslim origin are indeed taxing.

Arguably, very few artists in the world can exhibit where they want, do the kind of work that they want to do, and have it understood in the way that they intend. And most people agree that the international art scene is inherently restrictive and hierarchical. Yet, as this essay has suggested, immigrant artists, and those from Arab or majority-Muslim societies in particular, face rather unique obstacles in the West. In addition to obvious personal discrimination, their work is marginalized in cordoned-off areas of 'ethnic' exhibitions and catalogues. It is then subject to narrow interpretations.

The international art scene suffers because of these unsophisticated approaches to and understandings of these works. In discussion of these artists and their work, there is a remarkable lack of the useful critical discourse that once opened galleries, museums, and the artistic canon in general to non-Western artists. Although artists from Asia, Latin America, and the African diaspora have not yet gained full inclusion, at least the discussion of their exclusion as well as significant analytical consideration of their work has brought much-needed energy to the international art scene. But this project, which began in the 1970s and 1980s with the feminist, multiculturalism and postmodernism movements, needs to be continued – even if the directions and frameworks of those movements have changed. Such a project is especially timely given the recent attacks on the U.S., anti-immigrant legislation throughout the U.S. and Europe,

the resurgence of xenophobia more generally, and new developments in Western capital and cultural imperialism.

As my discussion of different Egyptian artists has shown, it is inappropriate for curators and critics to lump artists from Arab or Muslim backgrounds together under one rubric. The diversity among them, and the varied relationships between their histories, identities, and their art is too complex. Rather, curators and critics need to pay attention to the rich range of issues that these artists deal with, and the variety of ways they explore them. Furthermore, instead of relying on limited analytic templates shaped by stereotypes and ethnocentrism, curators and critics should probe how religion, history, culture, personal philosophies, and even transnational experiences shape or do not shape artistic practice among individual artists. Until then, Western art world actors' claims to be avant-garde, alternative, critical, or even democratic will truly ring hollow.

1 E.g., Liliane Karnouk, *Contemporary Egyptian Art*. Cairo: American University in Cairo Press, 1995; Rushdie Iskandar et. al., *Thamanun Sana min al-Fann*. Cairo: General Egyptian Book Organization, 1991.
2 See Serge Guilbault, *How New York Stole the Idea of Modern Art: Abstract Expressionism, Freedom and the Cold War*. Chicago: University of Chicago Press, 1983.

THE NEW CURATOR

STINE HØXBROE

In "The Curator's Moment",[1] the art critic and curator Michael Brenson describes the new role of curators who must be at once aestheticians, diplomats, economists, critics, historians, politicians, audience developers and promoters. They must be able to communicate not only with artists but also with community leaders, business executives and heads of state. As much as any artist, critic or museum director, the new curator understands and is able to articulate the ability of art to touch and mobilize people and encourage debates about spirituality, creativity, identity and the nation. The tone of the curator's voice, the voices it welcomes or excludes, and the shape of the conversation it sets in motion are essential to the perception of contemporary art.

In other words, the curator sets the frame of the exhibition, invents the theme, and decides which artists to include. If what Brenson writes is true, then the curator is a very significant and powerful figure in contemporary art. If the curator is that powerful, s/he has the means to initiate new discussions and introduce new perspectives in art.

An example of this can be found in the curatorial work of the American visual artist and curator Fred Wilson.[2] Working in various museums simultaneously has made Wilson acutely aware of how the environment in which an artwork is displayed affects the way the viewer feels about that piece of art and the artist behind it. In order to visualize his idea and present it to a wider public, he organized the exhibition *Rooms with a View: The Struggle between Culture, Content and the Context of Art* at a new gallery in South Bronx in 1987.

Rooms with a View was an exhibition of the work of emerging American artists of various backgrounds. Wilson placed the work of these artists in different settings. One looked like a contemporary gallery, the white cube. Another was redesigned to look like a small ethnographic museum, not very well appointed. The works of the artists were chosen according to how they might look in these spaces.

At the time, many artists produced art that seemed to fit in an ethnographic museum because they were working in Third World cultural idioms while other artists were working more with the history of Western art. When placing the work in the ethnographic space, a visiting curator said with surprise, "Oh, you have a collection (of primitive art)". And he had to tell another curator, "No, Valerie, that work you're staring at is by an artist who had a one-person exhibition in your gallery a month ago".

The environment changed the work. The labels simply identified the

materials not the names, as is the tradition in most ethnographic museums. In this way, the works became exotic. They looked like something made by someone you would never know, and in many instances, the works were dehumanized because of the way they were installed.

After this, he was asked to organize an exhibition anywhere in Baltimore and chose Maryland Historical Society, which was one of the most conservative environments in the city. At this occasion, he made it part of the process to speak with everybody in the museum, from the maintenance people to the executive director, to find out what they felt about the institution, about the city they were in, and the relationship between the two. According to Wilson, this approach opened up the staff of the Historical Society who had worked with art but never had a living artist in their midst.

Such an approach has even wider perspectives on the Danish art scene, as illustrated at the opening of the conference "1+1=3" at *Arken Museum of Modern Art* the year 2000. At the opening, the leader of the museum Christian Gether admitted that the number of works by non-European artists exhibited in the museum was extremely limited. If such works were included, it was because they formed part of a circulating exhibition curated by someone they trusted. The main reason to this was at first that they did not have a tradition of showing works of non-European artists, no matter how talented they might be. Secondly, they knew almost nothing about non-European artists, especially those living in Denmark. Thirdly, they did not know the culture of 'the others' because they had no contact to it.

As an example of this, he told that they had had a piece of Dali on exhibition. One day he overheard a young visitor of immigrant background saying with surprise "They have a piece by someone named Ali". Gether found it interesting and decided to ask the Turkish woman cleaning the museum if she could see anything special in that painting. She had already noticed that it said Ali and he then realized that for someone unfamiliar with the artist, it was possible to read the signature that way. Is it possible that they did not know Dali? Yes. One could find similar responses among Danish youngsters and others who do not know that much about art. They might have heard of Dali, but that does not necessarily mean that they recognize his works.

There are several conclusions to be made from this experience. At first, it shows the distance between the people in question and what is consid-

ered internationally recognized art. Secondly, it shows that the possibility that the artist might be non-European opened their eyes and interest for the piece. Thirdly, it opens up for questions about our knowledge of non-European art. Are there non-European artists of equal fame in other parts of the world whose work we would not recognize? Could their work have something to say to the Danish public?

When entering the exhibition curated by Wilson, the first thing you saw was a silver globe emblazoned with the word TRUTH. Although it was made in the 1870s, it seemed very contemporary. The intention in having the word "truth" as the first thing you saw was that the work should speak to the notion of truth, to ask if there is a truth and whose truth. One of the truths Wilson came to realize when entering upon the so-called cigar store Indians in the museum's collection was to which degree these depictions of Indians represent the society's idea of what an Indian is.

This is probably true for all exhibitions. They are representations. Representations of ourselves and those we want to identify ourselves with, and representations of 'the other', which we want to distance ourselves from. It is a reflection of the inclusion and exclusion process that takes place in all parts of society. This, in turn, leads to the suspicion that when arranging exhibitions with non-European artists, they are presented in a way as to reflect the prevalent image of 'the other'.

Wilson writes: "While general art museums house and interpret collections of work from around the globe, I find the interpretation rather narrowly focused on meanings that support a western view or relationships between cultures". This is reflected in the organization of the works in general art museums. The first galleries you visit are the Ancient World collections from Egypt, Greece and Rome. Then one proceeds through medieval, Renaissance, Baroque and Rococo art to 19th and 20th century European and American art. This gives the impression of a linear history connecting the glories of ancient Egypt and Greece with present European and American art to the point where it seems to be saying contemporary westerners are the descendants of the great Egyptians and Greeks. But, as Wilson writes, not just any Egyptians and Greeks – certainly not contemporary Egyptians and Greeks. Somehow Egyptians and Greeks are the forebears of Europeans in ancient times and the swarthy 'other' in more recent times. For museums, Egypt in ancient times was afloat somewhere in the Mediterranean until it attached itself to North Africa some time in the 19th century.

When arranging an exhibition for Seattle Art Museum, Wilson made a 20th century gallery installation. This was in his own words, "Perhaps the most disturbing to the visitors, or the most engaging". He pushed all the modernist art into one corner. On a large platform set against a dark green wall and dramatically lit, he placed a Matisse bronze in front of a marble Arp, a tall Giacometti in front of a Kooning portrait and so on. The clustering made a visually exciting and frenetic arrangement, but not one work could be seen clearly by itself. When viewers asked about the reason for this, the museum staff had to explain that this was the way African and Native American collections were displayed on the floor below.

Wilson's experiences are very useful when discussing 'others' art' on Danish soil. During the past 15 years, there have been a large number of exhibitions of non-European artists living in Denmark. The exhibitions, however, are not arranged by the established art society in Denmark. Those who have taken initiative to such exhibitions are mainly humanitarian organizations. By the nature of these organizations, those arranging the exhibitions have no significant knowledge of art. They are ordinary consumers who might accept or reject a piece of art because of its colours or likeliness: They can see what it looks like and they like the colours. That is in many cases the 'depth' of their knowledge and interest in 'others' art'.

While presenting it as genuine art exhibitions, what they do is to focus on folklorism, traditions and crafts.

The general pattern in regards to exhibitions of non-European artists is that they are expected to take place in local libraries (where only drawings of kindergarten and first grade children are exhibited) or in public workshops housing everything from traditional Danish food in the cafeteria, over folkdance, to drawing and pottery classes.

In addition to this, the selection procedure, if any, is based not on quality or thematic relevance but on national origin. Anyone who calls him- or herself an artist is accepted as such, the consequence of this being that foreign artists are grouped together in one category, regardless of experience, education, quality, recognition and art field. In this way, complete amateurs who grabbed their first painting brush yesterday are exhibited together with educated and experienced artists who were established in their homeland, but have not yet become known in Denmark. Another typical feature is that all the arts are mixed together. There might be a small exhibition of 'others' art', beside which a Peruvian band dressed in national costumes play traditional music, while there is a market of small

bags and handmade jewels, and a buffet of foreign food from numerous countries, while some belly dancer runs around the tables, deriving you of your appetite for anything on the location.

The reason why it looks this way is that such arrangements are arranged by bureaucrats who do not have a clue of what art is or of arranging any cultural or artistic event.

One of the really interesting aspects of the general approach towards 'others' art' is that we would never arrange any cultural or artistic event that way if dealing with Danish, Nordic or European artists. There would be curators selecting the artists and their artwork according to certain criteria. All the artists would be of same quality, and one would not mix for instance naturalist and colourist art, abstract art and installation, or fine art with other kinds of cultural expressions, especially not if they were of lower quality.

Another characteristic of attempts to exhibit 'others' art' in Denmark is that such exhibitions are always labelled 'ethnic art'. The artworks of non-Europeans living in Denmark are usually put in the category of exotic, traditional, ethnic art, and in the exhibition catalogues and invitations, the works are presented not as contemporary art, nor as just another art exhibition, but as the works of some of these 'others'.

The humanitarian organizations are doing more harm than good, and the only ones benefiting from their arrangements are the organizations themselves, which get more funds for such activities and justify their continued existence. Apart from making a living from it, such arrangements serve to maintain the impression of 'the other' as people who have been allowed into the country by the grace and mercy of the Danes. They are presented as people with inherited traditions but no genuine and valuable culture, and as people who might be good handicraftsmen but does not have any notion of fine art. Fine art is reserved for Europeans. They invented it, developed it, and are the only ones who are capable of producing and understanding it.

Using art to serve certain agendas is in itself problematic because the artworks tend to be installed in a context that has little or nothing to do with the intentions of the artists and their agendas. As Brenson writes, the language in which 'others' art' is being defined is still often one of representation. The focus of attention is not on what a work has to offer – poetically, thematically, psychologically, philosophically and politically – but

the cause the artist serves and the political struggle with which he or she is identified.

Unfortunately, this is almost the only presentation of 'others' art' in Denmark because the established art life is a closed world to them: The art academies, the art societies, the established art galleries and the art museums. It is very hard to make anybody in the Danish art society, from critics, over gallerists, to museum curators look at the works of non-Europeans as art alone and judge it according to the same standards as other fine art products. They are put aside in a category for themselves, which nobody takes seriously.

In the words of Wilson, "Museums are highly narcissistic institutions. They either feel most comfortable when mirroring their own values or when casting other cultures as dramatically different". This might explain the general Danish attitude towards 'others' art' and the constant efforts to make non-Europeans look different, strange, exotic, childish, and so on. Such exhibitions have nothing to do with art. Their purpose is to distinguish between us and them, the known and the unknown, the good and the bad.

I once attended an exhibition in an established gallery in Copenhagen. One of the artists had a foreign name, but the work he exhibited was to me very Nordic. It had the form of the skeleton of a stranded ship made of black, rough granite. Inside the 'ship' was a spear- or dagger-like object of shining bronze and it gave me a very Nordic feeling of something emerging from the solid mountains in the North. To me the symbolism was clear. The blackness: the dark winter and heavy sky in the North. The granite: the solid mountainous rock that is so typical for the island Bornholm in Denmark, and the rocks of Sweden and Norway. And the fine shining object looked like something precious being carried safely through the wild and cold environment. To my great disappointment, I heard other visitors saying when seeing the artwork and the name that stood with big letters underneath it, "O how strange, how foreign, how exotic. It doesn't look like anything we have seen before". I could not help thinking that if it had been labelled with a traditional Danish name like Lars Rasmussen, it would have been received as a genuine Danish artwork with strong Nordic or Scandinavian connotations. It also made me wish that another time, the identity of the artists would be hidden until people had expressed themselves about it, and then it would be revealed – to illustrate the influence of prejudices on their judgement of 'others' art'.

Michael Brenson writes that there seems to be a consensus that when art from one culture is shown in another, it cannot speak for itself. The viewers must be given sufficient clues to enable them to orient themselves to the work and to provide viewers unfamiliar with the condition in which it was made at least some sense of what it means to appreciate it on its own terms. In many cases, however, the problem is not that the viewers have not been given enough information about the artworks on display, but that their expectations are based on prejudices.

In the following, when talking about non-European artists and their works, I am thinking of contemporary artists who in many respects have experiences and thoughts that are similar to those of contemporary Western artists. They are concerned with international art tendencies, the conditions of modern life and the globalization, which seems to tie everybody on earth closer together. Therefore, their art is similar to the art of their Western colleagues. They address the same issues, use the same artistic media, express their art in similar ways – mainly through installations and video art – they, like their Western colleagues, focus on different topics and ideas rather than on the product itself. The only difference is that sometimes they look at things from a different angle – like giving a different opinion or exposing another aspect of the topic, because it affects them differently. And that is what art is all about: communication, exchange of different views, attempts to reach out and understand the world we are all part of.

In the attempt to do so, however, certain mechanisms step in. If a non-Western artist produces the same kind of art as a Western artist, one possibility is that it will not be seen as non-Western art made by a non-western artist. We have seen that many times in Denmark. When foreign and specifically non-European artists finally become known, recognized and established, they are no longer considered foreign. With one stroke they have become Danish, or the aspects that draw them closer to what it means to be Danish are emphasized so that we can somehow associate ourselves with them. When mentioning the Turkish artist Alev Siesbye to an art critic when talking about immigrant artists in Denmark, a friend of mine got the reply: "Alev Siesbye? She is not foreign. She is Danish". Fine. But she is still Turkish, has lived in France for many years and does not feel really Danish but something in between.

When non-Western artists produce art similar to that of Western artists in regards to ideas, techniques and ways of presentation, they are ei-

ther moved to the group of Western artists or accused of mimicking Western artists and thus categorized as unoriginal and unqualified. Often, even when they follow all the rules of the Western art institutions, they are presented as somewhat exotic if they make use of symbols or metaphors from their own region. They are accepted, but kind of different. They are accepted, but no one is certain for how long. How long can they keep up the pace with contemporary Western art? Were they just lucky or are they really qualified, that is, according to Western standards?

The suspicious and patronizing attitude towards non-Western artists, I think, has nothing to do with their artistic capabilities or their work. It is an automatic reaction among the vast majority of people – at least in Denmark. Gone is the objectiveness and a filter of assumptions and prejudices cover their senses. It might be true that people need a mediator when looking at non-Western art, but not as much in order to understand their specific cultural background as to make people study the work of these artists without prejudices.

In the article "Globalisering" (Globalization) from 1998, Stine Høholt writes that if one has seen just a few works of non-European artists, one will know that this is not exotic art. Rather, their work should be categorized as global or international art, which makes use of European as well as non-European elements, which takes place in a global space where cultural fusion, complex identity forms, and cultural differences become important points of departure for the artistic expression.[3]

Recognizing that the conversation they are involved in crosses national boundaries, many such artists present their work as international and global. Their work deals with diasporic, post-colonial situations and is often quite political in its concern with specific, historical situations. As pointed out by John Alan Farmer,[4] there is a growing recognition of global art on the international art scene, and international biennials in cities such as Brisbane, Cairo, Havana, Istanbul, Johannesburg, Kwangju and Taipei have made the work of African, Asian, Caribbean, Central European, Latin American, Middle Eastern and Pacific artists, including those who now live in the West, more visible to Western audiences.

The question is to which degree this also applies to Denmark. While being aware of developments on the international art scene, the Danish art scene itself is concerned with completely different matters. During the last ten years, dealing with architecture, especially that of the 1970s, has been very trendy. Artists have worked with different concepts with rela-

tion to the welfare society, the social aspects of the body, gender roles after feminism, and concepts of freedom.

In order to find out more about the Danish art scene, I had a talk with the Danish art critic and curator Simon Sheikh.[5] His interest lies in making art a platform for political discussion, because, in his view, the discussions in the political arena have ceased to be political. The discussions in the political arena are concerned with representation in a superficial sense, and not with political models and political ideas. Therefore it is his hope that art can be used to analyse and discuss political ideas.

Sheikh makes a distinction between art as symptom and art as analysis. The idea behind art as symptom is that it, consciously or unconsciously, expresses a symptom or certain psychological structures. In his view, art can go further than this and function as thought and analysis. Many of the artists he considers political artists work very structurally and much more analytically than others in an attempt to come up with counter representations in relation to the society or social context they live in.

Sheikh sees the curatorial project as a continuation of a critical project. This finds expression when he translates the constellations and analyses he makes as an art critic into the spatial reality he is dealing with as a curator. The consequence of this way of thinking is that you have to communicate directly with the artists and make them discuss certain themes and base their work on that. In this way, they are building up networks and building up their own discourse from the bottom. Instead of focusing on periods in time or groups of people, the focus is on the contents and themes, which certain artists have in common, and by bringing them together ideas develop.

During the last decade, Danish art has begun to orient itself more towards the international art scene. One of the signs of this is that almost all the exhibition titles have been in English and that is something new. According to Sheikh, this is because the artists have the idea that their public is international and that their exhibitions take place in an international context.

Denmark, however, is far behind when it comes to multiculturalism. In Sheikh's view, this is related to the fact that Denmark did not have colonies the way other countries did. The primary colonies have been the Faeroe Islands and Greenland, and people from these places have numerically been too few to build an ethnic culture in Denmark as writers, musicians

and artists. There has never been a strong presence of minorities on the Danish art scene and therefore the art establishment has not been used to thinking that different cultural points of departure was a significant factor when reading artworks.

To the Danish art life, globalization is an opportunity for Danish artists to get inspiration and knowledge abroad and an opportunity to present Danish products to others. Global art and multiculturalism is not something of interest. In that way, one can say that the Danish art life is very introvert. This is kind of paradoxical at a time when multiple cultural centres interconnected by numerous vectors such as migration, trade and new communication technologies emerge around the world.

When it comes to galleries and museums, 'others' art' is only accepted in the form of internationally touring exhibitions with internationally known artists. Although the number of such exhibitions in Denmark has been extremely limited, one could hope that there would be others, and that this would open the eyes of the Danish art life and make it realize that such artists are not confined to Britain and the US. Such artists are living among us and can be found in places like Denmark, Sweden, Norway and Germany.

At the opening of the "1+1=3" conference with the subtitle "Cultural Diversity and the Cultural Sector", county mayor Vibeke Storm Rasmussen said: "I do not believe that we in Denmark are heading towards a multicultural society. And I do not wish that either … In Denmark we have certain values, which our society is built upon, and we have to protect them … There are certain things we cannot accept".[6]

This was said at the opening of a conference that was the first official attempt in Danish history to address the question of cultural diversity and multiculturalism. What Storm Rasmussen addressed was not so much cultural diversity in art as her political opinions concerning the social development in the country. Still, this is of relevance to the discussion since, as Sheikh expresses it, the cultural scene develops in accordance with the political scene.

Storm Rasmussen's speech is an expression of what Annette Stott describes in her article "Transformative Triptychs in Multicultural America".[7] Stott writes that the popular belief in the melting pot is seriously challenged as different ethnic, racial, religious and social cultures retain

much of their uniqueness as they form a culture of diversity, reclaiming their histories and defining their identities in relation to the perceived dominant culture. Opponents of multiculturalism see this as a divisive and destructive trend and repeat the need for common verbal and cultural language in order to maintain national unity. Attempts to preserve cultural diversity, on the other hand, is a response to experiences with a majority culture that attempts to consume and destroy or at least silence minority cultures.

In his article on the era of the curator, Brenson writes that the increasing centrality of the curator has been reinforced by the emergence of installation as the standard form in which contemporary artists around the world are working. Installations often relate to the space around them and carry messages that involve writing and educating. An important aspect of installation is the context, and the curator often participates in building up this context. Brenson points out that it is the sense of curatorial mission that gives exhibitions emotional and intellectual strength. This requires not only vision but also an inexhaustible supply of belief, focus, resilience and nerve. To Brenson, this make the curators look increasingly like artists. To me, this shows the power of the curators. If it is true, that they have the ability to use the artworks and the messages they carry with them more or less as they like, then they are very powerful. Why not encourage them to use this ability and power to translate and present to the public the art it apparently finds so difficult to understand?

Although focusing on international biennials, there is no reason why the ideals he presents should not apply to curators in general. Brenson's writings on the role, ability and responsibility of the curators pose a big challenge. In his view, the curatorial work can be used to break the isolation of peoples and regions and to redefine national and international relationships.

With the increasing importance attributed to the curators and the fierce debate on globalization and multiculturalism in Denmark, one may ask why no professional art critic or curator has accepted the challenge to take the issue of 'others' art' seriously. The reason is that many art historians feel they are entering into a minefield. They have at least two things to be are afraid of. One is the public opinion, which makes it extremely difficult to get close to the subject. The other is fear of making mistakes and this makes most curators choose what is known and safe.

This raises the question as to whether they are equipped for the task.

If it is true that the curators have such an important role, then it is equally important that they get to know more about international art or global art and how it should be interpreted. Perhaps more should be read and written about how one approaches 'others' art' in a purely artistic way and regard it as artistic products. By not separating artistic production by race, ethnicity, national origin or religion, one can see connections, similarities and contrasts not otherwise apparent. The point is to focus more on the message behind the works than on the name of the artists.

Here is a job for the conscientious curator.

1 Michael Brenson: "The Curator's Moment". *Art Journal Vol. 57. No. 4.* 1998, p. 16.

2 Fred Wilson: "The Silent Message of the Museum". In Jean Fisher (ed.): *Global Visions. Towards a New Internationalism in the Visual Arts.* London: KALA Press. 1994, pp. 152–160.

3 Stine Høholt: "Globalisering". *Øjeblikket Nr. 34.* 1997, p. 29.

4 John Alan Farmer: "In this issue". *Art Journal Summer 1999,* p. 3.

5 Interview with Simon Sheikh. December 2001.

6 *Conference Report 1+1=3. Cultural Diversity and the Cultural Sector.* The Intercultural Network. 2001, p. 15.

7 Annette Stott: "Transformative Triptychs in Multicultural America". *Art Journal Summer 1999,* p. 55.

BEYOND OTHERNESS
A Critical Introduction
to the Perception of the Subject
in Post-colonial Theory

STINE HØHOLT

During recent years, the concepts of 'cultural identity' and 'cultural encounter' have been on the agenda in public debate and in interpretations of non-European art. This comes as no surprise: The two concepts touch upon some of the most important issues in relation to our definition and understanding of the cultural implications of globalization. Especially as they open up to questions about the understanding and representation of cultural minorities or 'non-hegemonic' cultures.

For the same reason, cultural identity and cultural encounter are central concepts within the branch of cultural theory designated 'post-colonial theory'. Post-colonial theory belongs to a wide, interdisciplinary cultural research area, which has been rapidly progressing for several years internationally, but is still in its making in Denmark. Since it is a field with many ramifications, I will narrow down my introduction to two figures: the two prominent Indian cultural researchers and writers, Homi K. Bhabha and Gayatri C. Spivak. Both have played a decisive role in the constitution and definition of post-colonial theory, and have had such an essential role that they, in my view, are unavoidable when dealing with the relation between the first and the third world in post-colonial perspective. Here, I will focus on Gayatri Spivak's and Homi Bhabha's reflections on (post-) colonial identity and the relation between the West and the 'third world'.

My intention is to provide a critical introduction to Bhabha's and Spivak's discussion of the post-colonial subject and her lacking possibilities for articulating a subjectivity of her own. The article is formed as a theoretic discussion, and the aim is not to apply the theory on concrete art works. Instead, I will couple post-colonial cultural theory to other theory formations originating from the cultural problems of the globalization processes that have emerged within the last two decades (cultural anthropology and 'globalization theory'), and in this way develop the theory so that it, in the long run, can serve as a remedy to understand global and post-colonial art.

The Colonized Subject in Post-Colonial Theory

The question of cultural identity and in a more narrow sense, 'the other's possibility to express herself', is one of the most important issues within post-colonial theory. Both Bhabha and Spivak reflect on 'the other's' possibility to express herself in relation to a historically existing West-

ern hegemony, and on this background they refuse a recourse to an 'authentic', 'essentialistic' otherness à la the original, native identity. Instead their project is to investigate whether and how cultures, which are or have been subject to Western judgement – and the West's hegemonic power – can 'negotiate' a subject position, which is more in accordance with their present cultural identity. For Spivak and Bhabha this often happens through analyses of the historic encounter between the British colonizers and their Indian subjects, analyses, which open up to more general considerations as to how decolonized cultures define their cultural identity after hundreds of years of suppression, misrepresentation and cultural assimilation of the value systems of the West.

In his eclectic theory, Homi Bhabha couples literary theory, cultural history and philosophy with inspiration from Sigmund Freud, Jacques Lacan, Michel Foucault and especially Jacques Derrida. The constant behind most of the statements and conclusions we meet in Bhabha seems to be poststructuralism and especially deconstructionalism – with the difference that he exchanges Derridas concept of 'metaphysics' with the concept of 'the authoritative colonial discourse'.[1] Thus one of Bhabha's credits is that he continues the deconstructionalist criticism of representation in a colonial and post-colonial context. In opposition to Saussure, deconstruction, and in continuation of it, Bhabha claims that meaning is ascribed in the repetition of the sign, which is why the pronouncement never is a direct manifestation of the linguistic system, but always added a supplement, which destabilizes the superior system, because it does not 'add up'. With the concepts 'mimicry', 'sly civility' and 'hybridity', Bhabha makes topical the deconstructionalist experience of displacement of time and the built-in sign slippage that occurs as the sign is repeated and displaced through expressions that never refer to the original content of meaning.

Here Bhabha puts forward 'the other's' possibility for presenting herself as an opportunity to 'rewrite' meaning and 'negotiate' meaning at the level of the sign. How this supplementary and subversive strategy, which 'the suppressed other' is given in the encounter with the suppressor, shall be understood, Bhabha explains with the following example:

> Its strategy of intervention is similar to what British parliamentary procedure recognizes as a supplementary question. It is a question that is supplementary to what is stated on the 'order paper' for the minister's response. Coming 'after' the original, or in 'addition to'

it, gives the supplementary question the advantage of introducing a sense of 'secondariness' or belatedness into the structure of the original demand. The supplementary strategy suggests that adding 'to' need not 'add up' but may disturb the calculation. (Bhabha, 1994: 155)

In Bhabha's post-colonial theory on the suppressed's possibility to present themselves, the exclamatory process becomes crucial as it becomes the space where the suppressed 'others' can be subjects of their own history and experience,[2] in the acquisition and continuation of the colonizer's authoritative discourse, as they have the possibility of inscribing a supplement or a difference, which destabilizes the discursive order of the colonizer.

During his authorship, Bhabha gives different names to the cultural negotiation and self-presentation he investigates – some of the most important are 'mimicry', 'sly civility' and 'hybridity'. The three concepts come from the articles "Of mimicry and man: The ambivalence of colonial discourse" (1984), "Sly civility" (1985) and "Signs taken for wonders: Questions of ambivalence and authority under a tree outside Delhi, May 1817" (1985), which are all reprinted in *The Location of Culture* (1994). The concepts are related in several ways. They are all developed in connection with analyses of the encounter between colonizer and colonized in 1800 India in which Bhabha stresses the disturbing, alienating and multiplying effect 'the other' sets in work within Western colonial discourse. Bhabha's concepts of 'mimicry', 'sly civility' and 'hybridity' depict the colonial subject as a subject that exercises local forms of 'resistance' vis-à-vis colonial superiority. What usually happens is that the colonized people turn the colonial discourse against the colonial power through half-hearted imitation, ironic assimilation and false deference to the words of the colonial master. This more or less strategic use of the colonial discourse against the colonial power, however, can not be characterized as a well-planned strategy of resistance. Rather, it should be characterized as different forms of ad hoc 'resistance', exercised in concrete situations and with concrete aims, without containing a genuine articulation of the self or a superior conscious project.

If one takes Bhabha's interpretation of the concepts 'mimicry', 'sly civility' and 'hybridity' as expressions of the colonial subject's representation of herself, it becomes clear that according to Bhabha 'the other's' subjectivity is based on negative premises.

Although the concepts are developed in relation to a concrete Indian

context, they are presented as timeless concepts from which Bhabha deduces general understanding. This postulated generality is what makes them relevant in relation to newer global and post-colonial art in the 20th century. However, at the same time it raises the question as to whether there is anything special about the colonial and in wider sense post-colonial condition if the characteristics Bhabha deduces from the colonial encounter between suppressor and suppressed can be deduced through a deconstructionalist reading of any encounter between 'the same' and 'the other'.

Like Bhabha, Gayatri Spivak deals with the historic encounter between colonizer and colonized, and with the (im)possibility of resistance and expression of the self; but, at the same time, she differentiates between different subject positions within the category 'the suppressed other'. This might be because Spivak deals with the subaltern woman, and she – as well as the India Spivak has been studying – has, historically seen, been suppressed by colonizers as well as by the native man. By connecting the imperialism's and the patriarchate's suppression of the woman, Spivak combines two related theories: Post-colonialism and feminism. These two, dealing with each their 'suppressed other', respectively the non-European and the woman, have several parallels and borrow from each other's conceptual universe. Spivak's 'post-colonial feminists'[3] attempt to mediate between a post-colonial critic, which seldom deals with the problem of gender, and different forms of Western feminism (e.g. marxist, liberal and post-structural), which do not attribute racial aspects sufficient attention, but on the contrary although in various ways hold on to feminist conceptions of general female emancipation. This combination of post-colonial and feminist criticism relates to considerations one will also find among many post-colonial female artists.

Spivak's texts, as Bhabha's, span over a wide range of theoretic disciplines: marxism, (post-) feminism, psychoanalysis and post-structuralism (Foucault and Derrida). As illustration of her view on the subaltern woman's possibility to express herself, Spivak in the article "Can the Subaltern Speak?" tells the by now well-known but also emblematic story of a young unmarried Indian woman, Bhuvaneswari Bhaduri, who hanged herself in 1926.[4] Almost 10 years later it was revealed that Bhaduri had participated in the armed fight for India's independence and in that connection had been assigned to undertake a political murder, which she was unable to carry out. At the same time, her consciousness prevented her from

resigning from the resistance. For unknown reasons, the woman saw suicide as the only solution to her situation. But she knew that her Indian family would interpret suicide as an expression of illegal pregnancy/unrequited love and inevitably would see it as a prolongation of the sati, the Indian tradition of voluntary immolation whereby the widow chose to let herself be burned on the funeral pyre of her husband.[5] The Indian woman whose story Spivak reproduces by using oral traditions in the end chose to stage her own suicide so that it would be associated with a suicide according to the tradition of the sati, but at the same time could not be a sati, because the woman committed suicide while having menstruation. This ruled out the possibility of an 'illegal' pregnancy and was in conflict with the regulations of the sati.[6]

When Bhuvaneswari Bhaduri took her own life, the Hindu sati-tradition had been forbidden for about a century. The British colonialists regarded the sati as a crime, which was in conflict with the principles of humanism. They had forbidden the sati already in 1829 after a period where the number of widow immolation had increased, probably to maintain the tradition in protest of the British military and cultural supremacy.[7] According to Spivak, the British argument for forbidding the sati and the Indians' use of the sati were based on different perceptions of freedom for the subaltern woman: for the British it was to be freed from this criminal assault, while for the Indian man it was to participate in a ritual or a kind of martyrdom in which the woman's highest wish of being reunited with her husband in the hereafter was fulfilled. For Spivak, the attitudes towards the sati exemplify how the subaltern woman historically has been subdued opposing, although related, forms of epistemic violence, which paradoxically build on the idea of granting the woman dignity.[8] But, according to Spivak, the Hindu law on widow immolation and the British prohibition both forget to take the woman into consideration. Instead, she is the mute third party while one idea of the free will of the woman is replaced by another.[9] Therefore, Spivak characterizes the woman's subject position as double suppressed, stretched out between two opposing forms of suppression: that of tradition and that of modernization.

> Between patriarchy and imperialism, subject-constitution and object-formation, the figure of the woman disappears, not into a pristine nothingness, but into a violent shuttling which is the displaced figuration of the 'third-world woman' caught between tradition and modernization. (Spivak, 1988a: 102)

The Indian woman Bhaduri becomes an example of how the woman despite suppression and disruption is capable of avoiding the prevalent discourses, in this case primarily the sati's discourse, but in reality also that of colonialism and resistance. Bhaduri chose exactly not to die as a traditional Indian or as a modern 'Europeanized' Indian, and she also chose not to act as the nationalist resistance asked her to. This, however, does not mean that the woman is capable of giving herself identity. The subaltern woman has not to choose rather than to choose her identity. In the staged and unintelligible death, and the conscious negation of the identities, the surrounding culture ascribes her lie the seed of the subaltern woman's subject position. According to Spivak, it can only be understood as a negation – or, as Spivak writes: "the subaltern as female cannot be heard or read".[10]

The fact that Bhaduri chose death without identity is in Spivak's essay presented as proof that the wider implications of Foucault's settlement with the sovereign subject is not fully uncovered in relation to the 'third world's' women, and it is interpreted as a decisive example of the 'third world' woman's lacking possibility for expressing her own identity. The fact that Spivak chooses Bhaduri as example illustrates her radical pessimism regarding the project relating to the coloured woman's possibility to present herself. With this example she shows that the only way the subaltern woman can 'talk' is by avoiding epistemic violence, that is by making sure that she cannot be represented. The only way the woman can do this is by paying an extremely high prize – death – and this includes giving up any kind of 'self'-presentation. Later we are given Spivak's interpretation of the subaltern woman, which is our only chance to know her, and that interpretation is exactly not about who she was but about all that she, through her actions, demonstrated she was not.

Beyond Otherness:
Two Points of Criticism Relating to Post-Colonial Theory

Homi Bhabha's and Gayatri Spivak's post-colonial theories are often regarded a step forward in relation to the interpretation of the 'third world's' cultural identity and artistic expression. At the same time they – and post-colonial theory in wider sense – have also been criticized in different connections.[11] In my view, at least two objections are relevant to the subject of this article. At first, the post-colonial theory's attempt to present a gener-

al philosophy, which means it is not sufficiently capable of relating to historic change. Secondly, one has to criticize the theory's constant negative definition of the subject.

The post-colonial theory's postulated generality has as consequence that it cannot relate to historic change – and this also means to specific social, political and economic contexts. Although there is heightened awareness of power relations among post-colonial theorists, their rootedness in literary theory and French post-structuralism and the subsequent focus on epistemology and linguistic level invite to criticism from socio-economic sides for being ahistoric and not engaging themselves sufficiently in concrete economic problems of our time. Hereby is not said that post-colonial theory is blind to the meaning of context. This is contradicted by their increased awareness of power relations and discursive formations. But in its linguistically based criticism of general power structures at the level of discourse and misrepresentations of 'the subaltern other', post-colonial theory tendentially disregards economic power structures as well as more specific contexts of geographic, historic and social nature.

In this connection, one can criticize Bhabha's hybridity concept for neglecting the conflictual fight and strong opposition between colonizer and colonized, which the colonial encounter really was – not least in military and economic respects.[12] The reason why Bhabha disregards the fact that it was a conflictual fight, which the colonial masters must be said to have won, at least at the levels of *realpolitik* and economy, are probably to be found in Bhabha's general wish to present 'hybridity' as a positively valorized word in order to reconstruct the colonial encounter as a less unambiguous power relation between suppressor and suppressed.[13] However, in the efforts to show that the colonial encounter is a productive space creating hybridity and ambivalence, social and political contrasts are more or less wiped out in Bhabha's presentation. Or rather, Bhabha transfers the conflict to the colonial subject's psychological inner self and prefers to touch upon it in abstract phrases.

Also, in another sense, one can criticize post-colonial theory for suffering from lacking contextualization. As known, Bhabha and Spivak collect the majority of their examples in colonial time. They typically take off in a single anecdote or event and from these particular examples, they extrapolate general reflections about 'the suppressed other's' possibility to express herself within the Western discourse. This means that the theory

may be best at relating to the colonial situation, perhaps even more specifically to India's colonial situation.

There is, however, development in Bhabha's writing. Whereas Bhabha's analyses of the subaltern's possibility to authorize a cultural expression in the early texts collect examples in colonial time, in newer texts such as "DissemiNation: Time, narrative and the margins of the modern nation" (1990),[14] he relates to the present post- or neo-colonial age. Bhabha's analyses of the post-colonial situation, however, do not deal with the 'third world'. Instead, the focus is on immigrants in the West, and on how they bring about displacements in the national story and thereby interrupt its consistence and totality. One may wonder why Bhabha does not analyse the post-colonial situation in India, which would have been the logic consequence of his interest in the colonial encounter between Indians and Britons. This might be because Bhabha's theory is dependent on the relationship between a dominant authoritative system and a group of suppressed or excluded people who are subjugated what one, despite 'western hybridity', has to characterize as a massive pressure from the authoritative discourse, a scheme the power relation between the West and India no longer (if ever) can be meaningfully placed within. As the examples are not collected in post-colonial India, but in the West among minorities, one can doubt the theory's ability to relate to the historic change of the relationship between the West and the colonies, and to the definite post colonial situation in the 'third world'.

Bhabha's own texts actually signal that it is possible to analyse India's post-colonial situation. His examples of 'mimicry', 'sly civility' and 'hybridity' are not presented as isolated, historically situated possibilities for shaking the colonial discourse, but rather as generalizable examples. As both Benita Parry, Ania Loomba and Robert Young[15] have noted, Bhabha presents his concepts as ahistoric and universal:

> Bhabha's claims to describe the conditions of colonial discourse 'mimicry is ...', 'hybridity is ...' are always offered as static concepts, curiously anthropomorphized so that they possess their own desire, with no reference to the historical provenance of the theoretical narrative of Bhabha's own work, or to that of the cultures to which they are addressed. On each occasion Bhabha seems to imply through this timeless characterization that the concept in question constitutes the condition of colonial discourse itself and would hold good for all historical periods and contexts ... (Young, 1990: 146)

The question, however, is whether Bhabha's 'ahistoric' characterization of the ambivalent and hybrid colonial subject corresponds with the contemporary, post-colonial subject. Or if the latter's cultural identity breaks the boundaries of Bhabha's differentiated, but relatively static, subject position. In my view, the last seems to be the case and this corresponds with Arif Dirlik and Ella Shohat's more general criticism. Arif Dirlik stresses the lacking ability to relate to historic change in a formulation like this, "Post-colonial critics have engaged in valid criticism of past forms of ideological hegemony but have had little to say about its contemporary figurations".[16] And in her criticism of post-colonial theory, Ella Shohat emphasizes the lack of contextualization of concepts such as 'hybridity' in relation to the present geopolitical macro level such as neo-colonial power relations and the late capitalism's economic power structures:

> Negotiating locations, identities, and positionalities in relation to the violence of neo-colonialism is crucial if hybridity is not to become a figure for the consecration of hegemony. As a descriptive catch-all term, 'hybridity' per se fails to discriminate between the diverse modalities of hybridity, for example forced assimilation, internalized self-rejection, political co-operation, social conformism, cultural mimicry, and creative transcendence. (Shohat, 1992: 331)

If one turns from Bhabha to Spivak, one is put in front of a theorist who at least theoretically has a better eye for the meaning of context and the need to differentiate between different subject positions within the category 'the suppressed other'. Spivak's controversial conclusion in "Can the Subaltern Speak?" apparently arose because she began to include other contexts than colonialism, namely that of patriarchy and resistance. Her conclusion has given rise to a great deal of criticism, among other reasons because her thoughts not only reject all traditional forms of resistance, but also more untraditional resistance strategies, such as those presented by Bhabha.

As already mentioned, Spivak's conclusion in "Can the Subaltern Speak?" is not particular, but an expression of her general attitude towards the post-colonial woman's possibility for representing herself. In the article "A Literary Representation of The Subaltern: A Woman's Text from the Third World", which is also from 1987, Spivak makes a reading of the Indian Mahasweta Devi's post-colonial novel Stanadayini (Ammen, 1978), which in crucial points is parallel to her analysis of Bhanduris suicide.[17]

Devi's novel is based on Jashoda who becomes a suckle nurse for wealthy masters after their one child has invalidated her husband. Jashoda's repeated pregnancy and the consequent ability to give milk, supports the rest of her family, until Jashoda towards the end of the story gets breast cancer and dies. Spivak's interpretation is also in this case that the subaltern woman's subject position cannot be formulated on positive premises. Not even 'the holy motherhood' is holy for the suppressed woman. In her view, the novel illustrates that the subaltern woman's problem is very different from what western feminism imagines, since the main problem, according to Spivak, is the impossibility of making the subaltern woman subject of her own story. Devi's novel Stanadayini is, as she writes, "a text about the (im)possibility of 'making' the subaltern gender the subject of its own story ...".[18]

Although Spivak makes a theoretical differentiation between several subject positions, man/woman, colonizer/colonized, her concrete analyses contain the same tendency towards homogenization and universalization as Bhabha's.

The other significant criticism in relation to post-colonial theory is that it rules out the idea that the subject can be formulated on positive premises. Post-colonial theory is inspired by a Western post-structuralist theory that has ruled out the idea of 'subject' in advance and thereby also the idea of a genuine post-colonial presentation of the self. Bhabha and Spivak formulate the subaltern's 'subject position' in purely negative terms such as displacement and dislocation. This happens in rejection of earlier essentialistic perceptions of the subject and in continuation of the perception of the subject in Lacan, Derrida and Foucault. When Bhabha and Spivak equal the post-colonial subject with non-identity, non-existence and non-presence, they do this because the subject in their view is determined by the colonizer's external and alienating discourses. To them, it does not contain any essence, which on a more fundamental level than language and discourse keeps it consistent as subject. Thereby post-colonial theory adopts an understanding of the subject according to which it is deformed and constructed by colonial authoritative discourse. It may, therefore, have some latitude within it, but can never go beyond colonial discourse.

I am questioning this understanding of the subject. Not only from a general criticism of the Western post-structuralist 'subject', which can be criticized from sociological theories on cultural globalization, or if one wishes

to make it philosophical from phenomenology and its understanding of the subject. I am also doing this since their understanding of the subject does not correspond with the post-colonial subject positions articulated within contemporary global and post-colonial art.

The post-colonial theorists' prioritization of the discursive subject, hybridity, deconstruction, and a very general cultural analysis based on the colonial relationship between suppressor and suppressed should, in other words, be put into wider and more contemporary perspective. One has to include the cultural and economic implications of the last 20–30 years' globalization processes and not in advance rule out the idea of one kind of subjectivity, which is defined as something other and more than pure negativity. If, in the long term, the goal is to make the theory usable in relation to contemporary visual art, one should also include the specific artistic, cultural and institutional conditions of each artist in question.

Globalization Theory

A broader and more contemporary perspective, which has power to revise and enrich post-colonial theory, can be found in theories on cultural globalization. Here one finds a broad spectre of methods and conceptual apparatuses. The majority of the theories are founded in sociology and anthropology and their prime concern is the implications of the current cultural exchange.

Post-colonial theory and theories on cultural globalization are not essentially different. The two theoretical directions share a range of problems – to the degree that one can claim that post-colonial theory arises from the analysis of a specific aspect of cultural globalization, namely cultural encounter and cultural exchange between colonizer and colonized, the first and the third world.

The emphasis on the homogenizing effect of cultural globalization, i.e. the technological, commercial and cultural synchronization of the West – McDonaldization and cultural imperialism – characterized the debate of especially the social sciences until the 1980s. After this there has been increased focus on those aspects of globalization, which seem to actively counteract the unification of the world after western model. This often happens with a post-modern cultural sociological approach towards globalization. The theorists within the field, among them Jan Nederveen Pieterse, Ulf Hannerz, Mike Featherstone, Scott Lash and Roland Robert-

son, emphasize that a significant consequence of the global development is the appearance of the local, i.e. the heterogeneity and increased cultural hybridization that has emerged simultaneously with the 'compression' of the world. They do that on basis of the last decades' accelerating globalization and the fact that ethnic culture in big cities in the West and cultural production in the 'periphery' have become increasingly visible. The emphasis on growing cultural hybridization and heterogeneity is thus used to dismiss the argument that globalization is identical with western cultural imperialism. Instead, globalization is seen as partially undermining the cultural dominance of the West. Two interesting figures within this extensive area are the sociologists Ulf Hannerz and Roland Robertson. Hannerz' considerations on 'cultural flow' and 'local interpretation' and Robertson's concepts of 'glocalization' and 'global consciousness' complement the post-colonial theory's mainly negative definition of the encounter between the cultures of the West and 'the periphery'.

In the book *Cultural Complexity* (1992), the point of departure for Ulf Hannerz is that the power relation between 'centre' and 'periphery' may be asymmetric, but the prevalent perception of the relationship between 'centre' and 'periphery', which lies behind the idea of cultural imperialism, draws a simplistic image of global development. While theories on cultural imperialism claim that there is one prior culture, which with unrestrained urge for power spreads over all other cultures, Hannerz questions that the exchange between the West and the 'third world' automatically leads to homogenization in accordance with western principles. In short, he reacts against the idea that the 'third world' does nothing more than 'copy' Western culture and social conditions. The prevalent 'centre'- 'periphery' dichotomy is inadequate for several reasons. Among these is the fact that the parts of 'the periphery' that receive vast cultural influences (e.g. the big cities) with time become new regional centres for their own 'periphery', and that the peripheries today 'talk back' and influence the West. As examples of cultural currents moving in the other direction influencing the West, Hannerz has mentioned the reggae music and the Latin American novels. Instead of stabilizing power relations between 'centre' and 'periphery', these cultural counter currents, which Hannerz thinks will accelerate in the future, produce diversity, mixing and creolization. At the same time, however, he includes the lack of freedom and the conflict that is still part of the exchange, "Yet desirable as one might find it to be able to speak of world culture in terms of a more equal ex-

change, the conclusion can at present hardly be avoided that asymmetry rules".[19]

Although in Hannerz' view asymmetry rules, in the sense that most cultural ideas and forms flow from USA, England, France and other cultural centres in the West to the cultures of 'the periphery', this does not mean that the flow has a solely homogenizing effect. The various influences are always locally adapted whereby the cultural influences from 'the centre' are given new meanings. As Hannerz writes: "The meaning of the transnational flow is in the eye of the beholder: what he sees, we generally know little about".[20] For Hannerz it is important that local perspectives result from a constant exchange of local and foreign perspectives – and, as I emphasized in connection with Spivak and Bhabha, that the local should never be understood in any essential or authentic way, as centuries of cultural encounter and exchange have already hybridized the local cultural scene.

Ulf Hannerz' thoughts about cultural globalization are fruitful since he relates to the present cultural exchange of meaning from a hermeneutic perspective, which focuses on local interpretations of global influences. In my view, the most interesting is exactly Hannerz' emphasis of the fact that local interpretation always takes place, plus his attempt to combine cultural flow and global power structure and thereby maintain that cultural exchange takes place within what is basically an asymmetric 'centre'-'periphery' structure.

In Ulf Hannerz' writings, the local is just as important an aspect of the present globalization processes as the global is. Thereby the West is given another role than in post-colonial theory, which perceives the West as massive cultural hegemony. In other words, the West is viewed as something that is mixed with – but never fully dominates – the cultures of 'the periphery'. At the same time, this changes the perception of the subaltern individual whose interpretation of Western influences is not – as with Bhabha and Spivak – negatively defined, e.g. understood as displacements that happen within a Western discursive order, which has been imposed on the subaltern individual, but rather positively conceived as a mixture of two – asymmetric, but ontologically coordinated cultures. The local interpretations therefore give rise to cultural variation, difference, complexity, 'creole systems of meanings', or as Hannerz writes: "The cultural processes of creolization are not simply a matter of a constant pressure from the centre toward the periphery, but a much more creative interplay".[21]

Ulf Hannerz' reflections on the increased cultural complexity are related to Roland Robertson's concept of 'glocalization' and his definition of globalization, which is tied to his idea of global consciousness. According to Robertson, the compression of the world leads to cultural reflexivity whereby one becomes aware of oneself as one among several cultures, thereby incorporating what can be termed a global consciousness. This cultural reflexivity is not something that arises by the end of the 20th century and the beginning of the 21st, but it is intensifying the same way globalization has been accelerating from the 60s and on. The existence of a global consciousness is to Robertson a proof that globalization has intensified compared to earlier and has reached the cultural level in society. For instance, the increased interest in international human rights, which has characterized the last decades, is a time related phenomenon. The interest is a proof that, although individuals (and national governments) are placed in each their local context, a wish for sharing global values has emerged and actually, as in the case of human rights, these global humanistic values seem to weigh heavier than national sovereignty.[22] If one is to believe Robertson's optimistic interpretation of the implications of cultural globalization, it is an ongoing process resulting in a global discourse where general values are shared across borders and groupings.

Although Robertson advocates that we have reached a global level of consciousness, he does not mean that the local is disappearing, on the contrary. In globalization lies the local, the anti-global, resistance and traditionalism; and globalization thus in several cases has the opposite effect of what one could expect, if globalization is primarily perceived as homogenization, westernization and americanization:

> Contemporary globalization has produced a global circumstance in which civilizations, regions, nation-states, nations within or cutting across states, and indigenous peoples, are increasingly constrained to construct their own histories and identities – or, at least, *reappropriate selectively their own traditions.* (Robertson & Khondker, 1998: 29–30. My emphasis)

Different phenomena such as ethnic, nationalistic conflicts, the Islamic fundamentalism of the Middle East, but also more peaceful examples of the appearance of the local such as the new biennials in the 'third world', restaurants for traditional Danish food and the like, suggest that globalization results in increased interest for traditions. Consciousness of global

condition leads to greater awareness of the particularity of the local. As Robertson formulates it:

> My own argument involves the attempt to preserve direct attention both to particularity and difference and to universality and homogeneity. It rests largely on the thesis that we are, in the late twentieth century, witnesses to and participants in a massive, twofold process involving the interpenetration of the universalization of particularism and the particularization of universalism ...[23]

For Robertson the question is not whether both factors exist, but rather what kind of coexistence exists between the local and the global, between particularism and universalism.

The new biennials outside the West in Havana, São Paulo, Curitiba, Porto Algre, Istanbul, Johannesburg and Kwangju are concrete examples of how 'glocalization' manifests itself within the culture of globalization. From a geographic point of view, the biennials illustrate the beginning transformation of the contemporary international art scene, which has also contributed to the increased international attention during the last 5–10 years towards a 'periphery' such as Scandinavia. The biennial phenomenon is a proof as to how a local cultural event aims at becoming a global manifestation of a local particularity and at the same time in case of the biennials can maintain a position of relative independence vis-à-vis the traditional art circuit or at least be critically concerned with Western art history and art institutions. Although the biennial phenomenon may originate in the West, non-Western biennials have renewed the concept and added to it a different seriousness, which future European biennials will probably attempt to 'copy' in order to achieve greater dynamic.

Glocalization contradicts the kinds of analyses one finds in the writings of post-colonial critics such as Ella Shohat and Anne McClintock. They claim that the West possesses a hegemonic position in the world and in prolongation of this see the present post-colonial or global era as westernization, imperialism and colonialism in new disguises.[24] But like Hannerz' idea of local interpretation, also the concept of 'glocalization' seems to supplement post-colonial theory, which generally focuses on how the 'third world' is dominated by Western cultural patterns. Within post-colonial theory, the West is perceived as an imperialistic or culturally hegemonic power, which is literally preventing the subaltern from articulating herself and forcing her to express herself according to Western schemes.

Therefore, the only (and negative) possibility for subjectivity is, as we saw in Bhabha, to put the western categories at play in order to displace them. The theories of cultural globalization present a different image of the relationship between the West and the 'third world'. In sociological perspective, the 'third world's' individuals are considered contaminated by the cultural patterns of the West, but they are not considered victims without possibilities to express themselves, exercise their own interpretations, and influence the West. Although cultural globalization theories do not explicitly reflect on their own perception of the subject, it is obvious – and in my view very fruitful – that the starting point is a subject that is not purely negatively defined.

Economic Recentralization

One probably imagines that the intensified cultural globalization, which Hannerz and Robertson describe, takes place parallel with an accelerating economic globalization in which national economy is becoming part of a worldwide marketplace marked by trade and investment flow. This image of a highly globalized economy erases the hierarchy between 'centre' (North America, Europe and Japan) and 'periphery' (Africa, Latin America and Asia). Within this perspective, economic globalization seems unavoidable and scary for the highly developed western nations, which see the stable economic wealth and power of the post-war period slipping out of their hands because of the capital's new mobility, transnational companies' possibilities to move their production to areas with low wages, and the world economy's 'flow' of investments and finance from 'the centre' to 'the periphery'. This view on globalization assumes that we are placed in a situation dictated by autonomous market forces and unpredictable economic relations, where national sovereignty and control no longer is possible, and where imminent thorough changes in the world economy lead to greater insecurity.

This form for economic globalization, however, is not the real counterpart to cultural globalization and cultural destabilization of the power relation between the West and the 'third world'. At least, this view on global economy has been subject to essential criticism in Ankie Hoogvelt's book *Globalization and the Post-colonial World. The New Political Economy of Development* from 1997.

Hoogvelt's point differs from that of other theorists, who have sug-

gested that the idea of increased economic globalization is a myth.[25] Hoogvelt thinks that the economic globalization has increased, but holds that it has a different character than traditionally assumed. And according to Ankie Hoogvelt, the highly internationalized economy has had its predecessors, especially in the period from 1870–1914, where the global economy in some respects was more open than it is today, "The level of integration, interdependence, and openness, of national economies in the present is not unprecedented", as she writes.[26]

Hoogvelt does not object to the saying that today we experience a radical shift in the historic development of capitalism. But rather than economic openness and expansion, Hoogvelt claims, the opposite is happening: implosion; "By 'implosion' I understand an intensification of trade and capital linkages within the core of the capitalist system, and a relative, selective, withdrawal of such linkages from the periphery".[27] The development from expansion to the kind of 'capital implosion' Hoogvelt describes has, in her view, brought about an exclusion policy that stands in stark contrast to the world capitalism's earlier incorporation policy. The capital and the world trade have retreated from 'the periphery' and intensified its trade and investment within 'the centre', for as she writes: "What is a both new and consistent feature of post-war foreign direct investment flows is the geographic redirection of such flows away from the periphery and into the core of the system".[28] Under the colonial era from 1800–1950 (especially between 1870–1914) and up till the 1960s, the development countries received a far greater part of the world trade's investments than today, claims Hoogvelt.[29] Compared to earlier, the 'periphery' has thus become further excluded, which results in increased income differences and consequently increasing asymmetry between rich and poor countries. In this way, the gap between 'centre' and 'periphery' has become deeper, an observation important to include, when reflecting on the post-colonial era and cultural globalization.

What is also characteristic for globalization is that 'the periphery' today is drawn into 'the centre' via telecommunication and information technology. In broad outlines, the situation seems to be that the 'centre'-'periphery' dichotomy is dissolving geographically and culturally, while socially and even more than before a polarization between 'periphery' and 'centre' is taking place. Taking Hoogvelt's economic discussion of globalization as point of departure, one may claim that the 'centre'-'periphery' division within world economy, which was formerly known as a geographic hierarchy between the nations of the world, has developed into a

social hierarchy or a social polarization of the world, which transgresses territorial borders and geographic regions but still takes place within a 'centre'-'periphery' division. The paradox is that while we, as Robertson claims, might have reached a level of 'global consciousness' where we no longer feel a division between 'centre' and 'periphery', this division – in economic sense – has become even more pronounced than before.

In brief, one can say that the globalization of the economic sphere has had as result that wealth has become mobile while poverty has not. The economic globalization thus takes place in the West and on the West's premises, while the cultural globalization takes place 'globally'. Hoogvelt's analysis of the economic globalization argues that a social recentralization is taking place in the West. This indicates an asymmetry between the globalization's economic and cultural processes that seems to nuance the post-colonial theory as well as the culturally oriented theories of globalization with their focus on hybridity and cultural exchange.

The asymmetry within the economic sphere is an integral part of the present global society. This is not unfolded here. I have, however, found it worthwhile to include Hoogvelt's perception of the economic globalization as an – albeit short – emphasis of the fact that one should also consider the general social structures, such as the present influence of the economic development on the cultural sphere, if one wishes to understand the complex discussion of the possibility for the post-colonial subject to construct her own meaning.

With this article, I have wished to give a critical introduction to the perception of the subject in post-colonial theory. Bhabha's and Spivak's reflections on subjectivity, cultural identity and 'the other' have resulted in theoretical and epistemological precision concerning the relationship between colonizer and colonized, which is important since it calls attention to the basic ambivalence of both Western and 'third world' 'discourses'. However, with their rootedness in the post-structuralism's epistemological project, both lock themselves in reductionist positions. Their descriptions of the encounter between two cultures do not open up to broader discussions of 'the post-colonial subject's possibility to express herself, as they are based on a criticism of traditional perceptions of 'the subject' as a metaphysically anchored thing, and therefore do not contain any possibility that 'the other' can articulate her own identity. The perception of the subject, which post-colonial theory advocates, is, in other words, too deconstructivist/post-structuralist oriented compared with the post-coloni-

al subjectivity we find in contemporary global art. Combined with Bhabha's and Spivak's use of the historic encounter between colonizer and colonized as a basic matrix in their analyses of the colonial and post-colonial subject as well as their conviction that they, from a very general and ahistoric position, are able to capture the diversity that constitutes the global 'periphery', their theories can be criticized from the position of social sciences for not sufficiently including more contemporary – that is genuinely post-colonial – social and cultural factors. By this is meant an already ongoing cultural transformation of the relationship between 'suppressor' and 'suppressed', 'centre' and 'periphery' as a consequence of the dynamics of globalization, as described by the sociologists Ulf Hannerz and Roland Robertson, and the economic implications of globalization: the late capitalism's neo-colonial power structures and the recentralization of the global economy in the West.

In its origin, post-colonial theory is unavoidable in as much as it proposes a more differentiated cultural understanding and is one of the areas within the Humanities, which most consequently has gone carefully into the relationship between the West and the 'third world'. Unfortunately, the theorists do not reach beyond 'otherness' or beyond the dichotomy between colonizer/colonized, which is incorporated in the traditional Western understanding of encounters with foreign cultures. This becomes problematic when one wishes to apply the theory on newer post-colonial art, which is made within a global field that is more complex – and opens up to more possibilities – than the reflections of post-colonial critics manage to describe.

Translation: Stine Høxbroe

1 For the sake of clarity, I allow myself to simplify the points of deconstruction. Bhabha's own reasoning is a little different than mine although related: "My growing conviction has been that the encounters and negotiations of differential meanings and values within 'colonial' textuality, its governmental discourses and cultural practices, have anticipated, avant la lettre, many of the problematics of signification and judgement that have become current in contemporary theory – aporia, ambivalence, indeterminacy, the question of discursive closure, the threat to agency, the status of intentionality, the challenge to 'totalizing' concepts, to name but a few". Homi K. Bhabha, *The Location of Culture*. London & New York: Routledge, 1994:173

2 Homi K. Bhabha, *The Location of Culture*. London & New York: Routledge, 1994: 178.

3 Compare with: Ann Jones, "Writing the Body: Towards an Understanding of l'écriture feminine" in *Feminist Studies 7*, Summer 1981; Hazel Carby, "White Woman Listen! Black Feminism and the Boundaries of Sisterhood" in *The Empire Strikes Back: Race and Racism in 70s Britain*, London: Hudchinson, Centre for Contemporary Cultural Studies, 1982 and Chandra T. Mohanty, "Under Western Eyes: Feminist Scholarship and Colonial Discourses" in *Feminist Review 30*, Autumn 1988.

4 Gayatry Chakravorti Spivak, "Can the Subaltern Speak?" (orig. in L. Crossberg & C. Nelson *Marxism and the Interpretation of Culture*) in P. Williams & C. Chrisman (ed.), *Colonial Discourse and Post-Colonial Theory*. New York: Harvester Wheatsheaf, 1993/1988a:103.

5 The sati holds a central role in post-colonial theory, which partly is due to Spivak's inclusion of the sati in this essay. Compare Lata Mani, "Contentious Traditions: The Debate on Sati in Colonial India" in K. Sangari & S. Vaid (eds.), *Recasting Women*. New Delhi: Kali for Women, 1989, Rosalind O'Hanlon, *A Comparison Between Men and Women: Tarabai Shinde and the Critique of Gender Relations in Colonial India*. Madras: Oxford University Press, 1994 and Ania Loomba, "Dead Women Tell No Tales: Issues on Female Subjectivity, Subaltern Agency and Tradition in Colonial and Post-Colonial Writings on Widow Immolation in India" in *History Workshop Journal*, No. 36, 1993.

6 Spivak, 1988a:104.

7 Loomba, 1998:168ff. Whether the strategy of resistance, which the sati can be interpreted as, is an example of the woman becoming a tool in the native man's protest against the colonial power's elimination of Indian traditions, or whether it is an example of the Indian women actually trying to resist the colonial power, is difficult to ascertain. Such a settlement would under all circumstances depend on whether widow immolation was enforced by the men and thus murder (presented as suicide) or whether it was 'self-chosen' suicides.

8 Spivak, 1988a:97.

9 Spivak, 1988a:96.

10 Spivak, 1988a:104.

11 Abdul R. JanMohamed, "The Economy of Manichean allegory: the function of racial difference in colonialist literature" in *Critical Inquiry* 12, 1985; Benita Parry, "Problems in current theories of colonial discourse" in *Oxford Literary Review* 9, 1987; Robert Young, *White Mythologies*, London & New York: Routledge, 1990; Ella Shohat, "Notes on the 'Post-Colonial'", 1992, in P. Mongia (ed.), *Contemporary Post-Colonial Theory*, London: Arnold, 1996; Anne McClintock, "The Angel of Progress: Pitfalls of the Term 'Post-colonialism'" in P. Williams & L. Chrisman, *Colonial and Post-Colonial Theory*, New York: Harvester Wheatsheaf, 1993; Ania Loomba, "Overworlding the 'Third World'" in P. Williams & L. Chrisman, *Colonial and Post-Colonial Theory*, New York: Harvester Wheatsheaf, 1993; Arif Dirlik, "The Post-colonial Aura: Third World Criticism in the Age of Global Capitalism", 1994, in P. Mongia (ed.), *Contemporary Post-Colonial Theory*, London: Arnold, 1996 and Aijaz Ahmad, "The Politics of Literary Post-coloniality", 1995, in P. Mongia (ed.), *Contemporary Post-Colonial Theory*, London: Arnold, 1996. Plus Arun P. Mukherjee, "A Second Wave in Post-Colonial Studies" and Arif Dirlik, "How the Grinch Hijacked Radicalism: Further Thoughts on the Post-Colonial", both lectures held at Copenhagen Colonial and Post-Colonial Studies' opening symposium, Copenhagen University Amager, April 15 1999.

12 Compare: Abdul R. JanMohamed, "The Economy of Manichean allegory: the function of racial difference in colonialist literature" in *Critical Inquiry* 12, 1985, Benita Parry, "Problems in current theories of colonial discourse" in *Oxford Literary Review* 9, 1987, and Ania Loomba, "Overworlding the 'Third World'" in P. Williams & L. Chrisman, *Colonial and Post-Colonial Theory*, New York: Harvester Wheatsheaf, 1993.

13 Compare, "In colonial days 'hybridity' was a term of abuse, signifying the lowest possible form of human life: mixed breeds who were 'white but not quite'. In post-colonial discourse, by contrast, hybridity is celebrated and privileged as a kind of superior cultural intelligence owing to the advantage of 'in-betweenness', the straddling of two cultures and the consequent ability to 'negotiate the difference'." Ankie Hoogvelt, *Globalization and the Post-Colonial World. The New Political Economy of Development*, Macmillan Press, 1997:158.

14 Reprinted in Homi Bhabha, *The Location of Culture*, London & New York: Routledge, 1994.

15 Benita Parry, "Problems in current theories of colonial discourse" in *Oxford Literary Review* 9, 1987, Ania Loomba, "Overworlding the 'Third World'" in P. Williams & L. Chrisman, *Colonial and Post-Colonial Theory*, 1993, and Robert Young, *White Mythologies*, 1990.

16 Arif Dirlik, "The Post-colonial Aura: Third World Criticism in the Age of Global Capitalism", 1994:315 in P. Mongia (ed.), *Contemporary Post-Colonial Theory*, London: Arnold, 1996.

17 In Gayatri C. Spivak, *In Other Worlds. Essays in Cultural Politics*, New York & London: Routledge, 1988b. The article and the parallel between the two analyses also show that Spivak does not distinguish sharply between the interpretation of historic events and aesthetic expressions, compare: "Those who read or write literature

can claim as little of subaltern status as those who read or write history. The difference is that the subaltern as object is supposed to be imagined in one case and real in another. I am suggesting that it is a bit of both in both cases". 1988b:244.

18 Spivak, 1988b:246.

19 Ulf Hannerz, *Cultural Complexity*, New York: Columbia University Press, 1992:222.

20 Hannerz, 1992:243.

21 Hannerz, 1992:264, 265. My emphasis.

22 Compare with Saskia Sassen's reflections over human rights as an 'international regime' in the book *Losing Control? Sovereignty in an Age of Globalization*, New York: Columbia University Press, 1996.

23 Roland Robertson, *Globalization*, London: Sage, 1992:100.

24 Ella Shohat, "Notes on the 'Post-Colonial'", 1992, in P. Mongia (ed.), *Contemporary Post-Colonial Theory*, London: Arnold, 1996, and Anne McClintock, "The Angel of Progress: Pitfalls of the Term 'Post-colonialism'" in P. Williams & L. Chrisman, *Colonial and Post-Colonial Theory*, New York: Harvester Wheatsheaf, 1993.

25 For instance Paul Hirst & Grahame Thompson in the book *Globalization in Question*, Oxford: Polity Press, 1996.

26 Ankie Hoogvelt, *Globalization and the Post-Colonial World. The New Political Economy of Development*, MacMillan Press, 1997: 115. My emphasis.

27 Hoogvelt, 1997:84.

28 Hoogvelt, 1997:77. Compare with Saskia Sassen in "Whose City Is It? Globalization and the Formation of New Claims", 1996, in O. Enwezor (ed.), *Trade Routes, 2nd Johannesburg Biennale*, Johannesburg, 1997, and "The Topoi of E-Space: Global Cities and Global Value Chains" in *Politics*, Kassel: Cantz Verlag, Documenta, 1997. In relation to big global cities, Sassen describes how economic globalization results in new forms of centralism and in 'upper' and 'lower' circuits, which, according to her, shows that globalization does not only produce hybridity and dispersal, but also asymmetry and injustice.

29 Until 1960, the 'third world' thus received 1/2 of the total investment flow, in 1966 it had fallen to 1/3, in 1974 to 1/4, while it in 1988/89 had fallen to 16,9 %, whereof half went to regions i east-, south- and south/east- Asia. Hoogvelt's sources, which I have not had possibility to verify, are as follows: for 1960: M. Barratt Brown, *The Economics of Imperialism*, London: Penguin, 1974:206–7, for 1966: L.B. Pearson, *Partners in Development*, London: Pall Mall Press, 1970:100, for 1974: *Transnational Corporations in World Development*, note 13 and table III, p. 242 and for 1988/9: UNCTC, *World Investment Report*, New York: UN, 1991, table 4, p. 11. (Hoogvelt, 1997:77).

WELCOME HOME MISS AOUDA

STAFFAN SCHMIDT

Henri Lefebvre has extended the idea of uneven development so as to characterize everyday life as a lagging sector, out of joint with the historical but not completely cut off from it. I think that one could go so far as to term this level of everyday life a colonized sector. We know that underdevelopment and colonization are interrelated on the level of global economy. Everything suggests that the same thing apply at the level of socio-economic structure, at the level of praxis.

Guy Debord, 1961

In Jules Verne's book *Le tour du monde en quatre-vingts jours*, Around the World in Eighty Days (1873), the French novelist gives his readers perhaps the best introduction around to Orientalism. Not the concept, but, just as important, to the praxis and consequences of its worldview. The setting for the initial discussion on modern communication and the bet of 20.000 pounds that is accepted by the hero of the story, Phileas Fogg, and the dramatic end takes place at the Reform Club. All the action, until the very last near catastrophic moment, takes place under the auspices of GMT. Every scene in the novel could be related to the objective tick tack from the clock in the Reform Club in the industrialized heartland of the colonial West, London City.

Some things are within, others are outside and few things uphold themselves at the borders. The things that we can believe in are almost always the same. Part of a repetition that ends up saying the same thing over and over again. The true, but somewhat claustrophobic and thin-air meaning of semantic meaning is, as Wittgenstein has shown, the tautology. The outside of abstract reasoning is therefore always the source of intelligible meaning. The identity of the world is taken as understandable first and foremost through repetition, tautology and the triviality of borders defended against the unknown. The identity-scavengers are doing their job. Since the renaissance and the forfeit of the scholastic charta (which was always, as with the Islamic tradition, displaying the garden of paradise as its conceptual centre), mapping has been an obsessive occupation in the history of Western civilization. The following text moves along the parallel between colonialism, colonial thinking and border making, and the (limited) concept of art developed in the 19th century.

In the 1670s depictions by Vermeer, you can easily spot the prosperous link between the exotic fruits, seldom flowers and oriental rugs dressing the tables, and maps hanging from the walls. That which can be brought

95

to us at a high prize is always beneficial, but that which slips over our thresholds without either permission or paying its tributes to the established order of things is decisively treated as a threat. The Roman Empire, for all its difference, put enormous effort to make safe routes for transportation, and the British Empire understood its value, as do the rulers of contemporary identity-distribution. But the British Empire struggling to make its ideological identity a Victorian combination of history and industrialism was no doubt modern in that it recognized, as made clear by Verne's novel, that speed was a key to success in its explorations and conquering missions. *Around the World in Eighty Days* makes it perfectly clear that the speed of transportation was the highest in areas on the globe secured by Europeans and their auxiliaries with shared technique. Borders, as time- and speed limits, are defined in technical terms and are there to be surpassed – and this proves to be a potentially lucrative business.

The turmoil of the story, as for the ethnographic collections, and the Picassos of the Les Demoiselles d'Avignon-period in the art museums, is of cause the entertainment varieties and bedtime readers of imperial warfare and its enforcement of Western power in Africa and in Asia. It is similar to the difference between a train in an industrial landscape and a roller coaster at an amusement park. The ideological misrepresentation of the practice of the real world is all beautifully wrapped up in the scene where the Indian widow of a raja, destined to traditional sacrifice on the stake and saved by Fogg, accepts the heroes proposal. The author comments this by noting: "Miss Aouda looked at him with the firm, sincere and mild eyes of a woman, who dears to sacrifice everything to the one who she owes everything". Miss Aouda is still present as the idealized refugee at our borders, and thanks to national and transnational media, cameras go looking for the reward in form of eyes expressing silent gratitude.

In early colonial studies, such as the writings of Frantz Fanon, there is a need for a clear political statement. Fanon's texts are transparent to the rage as in the short but breathtaking *The Fact of Blackness*, a widely published excerpt from the book *Black Skin, White Masks* (1967). Fanon's own experience of the forces forming his identity from the prerequisite mould of colonial power takes the shape of a white child's cry: "Mama, see the Negro! I'm frightened!" He could hear his destiny in those words, hit by his own colour as the sufficient and final description of his individuality, and caught by this wrong colour as the eternal sentence to the outside of society and the prejudice opinions of others, as by a splattered paintball.

Fanon supported a direct combat against the colonizer, as did for instance the black-painted and Zimbabwe's soon-to-be-ousted Robert Mugabe.

The questions raised in later studies, such as the epochal scholarly effort, Edward Said's *Orientalism* (1978), are not so much in need of pointing out the wrongdoer, as they are involved in understanding what *cultural dominance* is. Said defines Orientalism as a cluster of restrictions and obstacles rather than a positive doctrine. The core of Orientalism, and Said makes this clear enough, is the idea of Western superiority and oriental inferiority. It is possible to see how Orientalism has its framework prefabricated in the Western metaphysical tradition: the wish to distinguish patterns hidden underneath the mundane that have had such success in the modern technical control over nature. Orientalism makes the point that west is idea and east is nature. The reader has no other intellectually honourable option than to recognize that this pattern established by philosophic idealism and force still constructs the basic tenets of American and other Western countries, including Israel policies. Two thinkers in particular, who inform this essay, have studied Said and Fanon: Irit Rogoff and Homi K. Bhabha. They are both involved with and have substantially contributed to a conceptually oriented critique of the politics of difference. Political independence and the idea of freedom have markedly lost its former and very positive *national* meaning. The ideas of nationalism, derived from a European heritage, have lost themselves in a whirlpool of more or less 'adapted' democratic handling with internal and external antagonisms.

From the actual skin to the representation of difference, from freedom on national terms to the complicity of contemporary market economics, from naming and managing a distinct culture to the image of culture splintered in east and west in a political geography, and north and south in an economical one. The postcolonial critique offers a perspective where the topics of cultural difference – social authority, political discrimination, development on biased economic terms – opens up to a discourse on the contradictions and ambivalence that come as a result of the demands from global rationalization. Lack of meaning in everyday life is neither an exclusive problem for the privileged nor a problem for the underprivileged, but why is it a common ground?

In general terms, the analysis of post-colonialism says something about the facts of life throughout the post-industrial world, which can be recognized by large groups in society: The feeling of emptiness, of being meaningless, of isolation, of uncertainty and ambivalence is widely

spread. The global economy produces the constantly renewable identity for the rapidly re-forming consumer individual. The forces of production, the commercial culture, as well as the policymakers of the world and their experts and universities, produce identities based on modular-like and through media stereotyped representations. Seen from this post-colonial perspective, culture develops in the Western societies as a product that can and must be rationalized. It must be formed in the supply-demand and forces-of-production mould. But if we recognize culture as resistance, based on the right to social survival, does it take part in the globalized world? Or, even, in the *national* concepts of culture, supported by the welfare states of northern Europe? I do not think so. If you see the world of economic rationality as an invader in cultural terms, then the questions raised by the postcolonial discourse are bound to bring your immigrant neighbours closer to you. Closer than you have ever imagined.

There are two examples developed by the post-colonial thinking that should be made in this essay. One is based on the assumption that culture is an echo chamber where the first years of the industrial and capitalistic expansion of colonialism from northern Europe, which took over from the former slave based mercantile colonialism of Spain and Portugal, are noted. Due to the industrial developments and the industrialization of war methods, this change is parallel to the forming of the concept of Art, which is my second example. Colonialism and Art can be viewed through the same critical concept. This parallel must be understood within the context of the debates within the Visual Culture discourse.

The industrialists of the north were looking to prospect for useful minerals, labour force to exploit, promising markets, and production for inter-colonial export. At the same time, the artists of the first decades of the 19th century were looking for the exotic trace left by Vermeer, though in a strictly visceral way. This nationalistic and colonial period found its perfect match in the French painter Eugène Delacroix. Picture yourself in an art museum and in front of two of his most famous works: *The Death of Sardanapal* (1827/28) and *The Massacre at Chios* (1824). What is there to be learned? The paintings display the dark side of Oriental power; its cruelty, vanity and sensuality, all at once. The modest Greeks were fighting the terrible Turks, at dwindling odds. And think of Delacroix explicit opponent over the bourgeois public, the classicist painter Ingres, and his pictures of "Oriental" odalisques and harem baths. The differences in esthetical terms are obvious, but less interesting to me than their concordant

view of the Oriental woman. The cultural reception, however, was indeed different just a century earlier, when the immediate threat to Vienna was diverted. Mozart used music and props *a la turque* in a positive manner in his operas.

The interest taken from Western countries in the Greek struggle for liberation from the Ottomans, as displayed by Delacroix (as with, for instance, the romantic pathos of Byron and Keats longing for Greek antiquity, but also the 'classical' influence on Wegewoods early porcelain) was a struggle over cultural identity and the concept of beauty (which by that time was changing from a naked man to a naked woman). Classical Greece formed so to speak the o-meridian of Art, and, to strengthen the close parallel in time and space, the Elgin Marbles can be said to establish the GMT of art: the closer you get, the better. The travels that Phileas Fogg undertakes are all structured within the abstract space-grid formed by the GMT, and the Mercator projection map that has its place already in Vermeer's paintings, and in the end it is what turns his restless travel into a success. Art and the world are measured by the same logic from the centre of the imperial world and capitalist interests.

To accept this you must agree that there is no need for separate discourses on art, culture and immigration. To make this clearer, I will use the term Eurocentrism, which is firmly placed in the context of Marxist discourse by, among others, the Egyptian historian Samir Amin. Amin's thesis, that Eurocentrism could be seen as a late fruit on the colonial tree, derives from a historical analysis in which the early capitalism, the enlightenment and the French revolution play a significant part.

Before the universal ideas of the revolution of 1789, there were no clear cut examples of nationalist regimes in a modern and frightening sense of the word. One result of the political revolution of the bourgeoisie was that it made the ongoing industrial revolution explicit. Modern society that severs every tie with the past and its traditional ways of life has to live with a deficit of meaning – the *nation* filled in the gap with more ease than the revolutionary cult of pure rationality. Great Britain and France adopted a state-nationalism, where the state played the leading role making very sure that everyone living in the realms of the empire or in *le monde francophone* without exception, and without regard to religious or ethnic background, would be integrated and ensured the same rights as a subject of the state. There are rational reasons to see the nation-system as a provider of political control for industrialists, serving the capitalism of those days

well, but it is not enough. It is obvious within the colonial rule of England and France that there was a paternal gift linked to the mythology of that particular nation that was easily forgotten. Something universal, as Liberté, Egalité, Fraternité, or perfected timetables that were given to the colonized territory and a certain respect for capital style individuality and precision that sweetened occupation. Amin points to the fact that, in the past, local populations seldom had any clear ideas of where they were living in terms of nationality or nurturing national ambitions. The notion of the nation is one of the *arrives* in history, it is an integral part of the enlightenment and it came with the development of nationwide school programmes and better communication by road and by media.

Amin likens this to a revival and a rehabilitation of European conquering through the assertment of universal – albeit only palpable trough a European perspective – principles. In the years since the fall of the 'Evil Empire' of communism, these forms of Eurocentrism have come to fully dominate world politics. We are told on a regular basis that capitalism is the only system known to man that leads to prosperity, social responsibility and individual freedom. But first things need to get worse. With the closed gates in Fortress Europe, there are only slight chances for an exportation of the 'surplus' population to save the benefits of industrialization of agriculture and other forms of production, as Europe did in 1800s-1930s. Today, immigrants from Africa are stranded on the shores of Southwest Spain, and refugees from Asia are arriving at the Salentino peninsula and in the harbours of Britain in ghostships. Only through making the world thoroughly European (as it is right now) can it become a better place! It is not hard to find arguments for the notion that the borders of the empires, Roman or British alike, never really ceased to exist, at least not in the minds of the political élite of Europe.

The art historian and one of the initiators of the Visual Culture discourse, Irit Rogoff, also puts the 1789 proclamation of the human rights under discussion. In her book *Terra Infirma/Geography's Visual Culture* (2000), Rogoff doubts the possibilities of translating the three grand liberties of the French revolution and proposes that an adaptation always has to be made. What do freedom, equality and brotherhood mean seen by the colonized in a colonial perspective? Her method is much inspired by the notion of deconstruction: she scrutinizes sign systems and rhetorical codes and favours an art that acts as a counter-system, a discursive art that refreshes stiffened views and opinions.

Mona Hatoum is one of the artists presented in the book. When interviewed about her video *Measures of Distance* (1988), Hatoum made a statement saying that she was tired of the presentation of Oriental women in western media as either silent and curbed by their men or hysterically weeping over the corpse of a dead husband or son. In the video, she took photographs of her mother in the shower, and at the same time, she reads letters from her in a straightforward, non-emotional way, describing the life in a town under siege in a civil war. Hatoum is Palestinian and lives in London, and has, in more recent works, made several overtly political references to the situation under which the Palestinians live in the region. In the Oslo agreement, Rogoff reminds us, 55% of the Palestinian population was left out of the document and she refers to Edward Said fierce attacks on the unjust concept of peace for the ones selected by those protected by borders. The geographical freedom, the scattered patches of land granted the Palestinians by the Oslo process were visualized by Hatoum, in an exhibition held in Jerusalem's old town, in olive oil soap. Map, body and smell formed an unprecedented whole, but also produced an unforeseen difference. Palestinians entered the gallery and recognized the sweet smell of homeland, whereas the Israeli visitors were forced by the same smell to reflect over another history in the direction of disaster, death, void; the monstrous RIF soup made by the Nazis out of murdered Jews.

Many of the examples in Rogoff's book deal with borders and geography in the negotiations between Israel and the Palestinians that are never possible to treat as neutral concepts. The situation is a stark reminder and at the same time the actual representation of power relations, just as in the heydays of colonialism. The idea that by drawing a thin line on a map you can organize the future of some people and ignore the future of others seems completely absurd. Who needs states and borders? The most probable answer is: The weaker part. The argument against an all-out liberal stance on national territories and borders is that there is a more significant risk that financially powerful groups will dump wages and the rights of workers. A border closed for national or super-national social reasons is, on the other hand, inhumane. Borders are always organized from a centre of power. The terrain is made transparent through language and education, through symbols and songs for the people who are born and brought up within its limits. This follows the scheme of the French revolution, and so does the finger that points towards any enemy of this 'natural' order.

Rogoff divides borders into four categories that somewhat overlaps:

1, A theory that links knowledge and recognition to a geographical entity, as a concept for classification. 2, A way of placing events and individuals within a geographical entity. 3, A geographical entity for national, cultural and other forms of narration, and finally 4, A conceptual tool for a state apparatus with which to homogenize territories. After the analytical distinctions, she moves on to disjunction the idea of borders as a unifying concept all together. By involving borders in the heterogenic discourse of Gilles Deleuze and Felix Guattari's text *Politics/On the line*, Rogoff dodges the unilateral way of having borders safeguard a known and predictable world of regularities. A border in your life does not necessarily have anything to do with a physical change or movement from one spot to another.

In the first category you will find people sharing their joy over a goal scored by their national soccer team. This is the minimum level required to become a subject, this, and the basic national understanding, which, if you are a man, is supposed to make your military training worthwhile. Common to Rogoff's four ways of understanding borders within a national frame is the need for the territory on the other side of the border, a different place, the foreigner, the potential enemy and/or the potential misfit. One of the most tantalizing and clear-cut contributions to Manifesta 3 in Ljubljana 2000 was the video *Performing the Border* by the Swiss artist Ursula Biemann. Biemann follows the traces of the trans-national companies, across the American-Mexican border at El Paso/Ciudad Juarez, to the factories where young Mexican women work under conditions that would not be accepted just a few hundred meters away into the United States. The video is a complex economic, social, sexual and political narration, which also connects to other genre-based films where the border is the difference between right and wrong, order and chaos. Films such as Quentin Tarantino's *From Dusk till Dawn* and Steven Soderbergh's *Traffic*, not to mention gangster movies and western classics. Rogoff's own example is the Israeli artist Michal Rovner's *Border* (1997), a film in which the artist keeps asking military personnel at the former occupied zone in Southern Lebanon "Is it dangerous here?" while looking out on a pastoral landscape with flocks of sheep and small farms and villages.

Borders compel us to do away with individuality, to make people fit into neat pre-considered packages and think in stereotyped and nationalized ways. Hatoum's, Biemann's and Rovner's videos and films are good examples of the critical activity in contemporary art that focuses on a low

pitched and more or less silent process of reclaiming lived experience through renaming. Pre-meditated ideas are questioned not by applying the signs and metaphors of an alternative power structure, but rather by placing an individual and everyday like view at the place held by the institutional order of signification. But, to visualize this observation, you have to be in some way detached and not too closely related to an existing conflict. You have to address the situation without the heavy-handed investment in real politics. Hatoum lives in London, Rovner in New York and Biemann in Switzerland, the most neutral of all countries in the world, but they all carry within them the virus of nations and borders.

In Homi K. Bhabha's *The Location of Culture* (1994), the concept of ambivalence stands for a new phase in post-colonial studies, where the decolonization process and the pointing out unequal power relations are dependent upon an assessment of the play of power and resistance within the colonized and colonizer. Bhabha is in no way trying to undermine the tragedy caused by the dependency on both sides of the Oriental pre-text. He is denouncing the Kipling mirrors and "fixities" of the discourse – on one hand an eternal Orient and on the other chaos, violence and corruption – as clear as Fanon and Said once did. But, there are important differences in the approach. The thinking of Michel Foucault has a firm grip of Said's notion of Orientalism as the depiction of the colonized in terms of institutions and institutional behaviour. Orientals are to be estimated, described and portrayed, Orientals are something you judge and discipline, and ultimately something you put on display. The master plan, according to Foucault, is domination through the construction, immediate naturalizing and internalization of a distinction that no one (ideally ever) could cross over. Here, once again, the alarming recognition of the beginning of the Western concept of art, a question I will return to in the final remarks.

If there is nothing to criticize in the master plan, where are the differences? Bhabha first takes on the stereotypes. He makes the readers notice that the stereotypes – the Asian copy-cat and the African alley-cat – live on due to the surplus of meaning in relation to what could be shown as 'facts'. Bhabha goes then on to say that searching for the 'truth' of Asians and Africans for some special kind of essential and pre-colonial consciousness would in fact only strengthen ideologies such as Orientalism. Bhabha questions those dogmatic moral positions that spell out the 'reason' for oppression and discrimination, as Foucault did. The analysis should instead adjust its focus on condemnation of the processes that creates sub-

jects, i.e. study the ways in which individuals accept their pre-meditated roles and in the way in which they find them agreeable.

Bhabha stresses that to analyse this it is paramount to understand the strength of the *pictures* produced to form the dominators and the dominated. If you follow the traces left by the mediation of idealized pictures of power and resistance, dominant and dependent you will find a strange fruit: The 'truth' of the colonizers systemic thought. The moment of articulation, Bhabha says, is also the opening towards a theoretical momentum: The assignment of certain identities and knowledge to certain appearances, sexes and their places of origin can never obscure the lack of an original identity. This operation is followed by distribution of clear links between constructed identities and between pleasure and dissatisfaction. The description is never sufficient thanks to the open-ended structure of signification. This observation points to the everyday experience and practice, i.e. beyond philosophy's conceptual discourse. It is also much to the point when it comes to contemporary art: the 'art' value has no tangible core and is always in a state of flux, but as a structure, the dichotomy of inside and outside, the borders of the 'art' concept, underpin and uphold institutional hierarchies.

The dissemination of stereotypes that no longer bear hard currency enables pictures to enter the psychic realm where identities, needs, desires and lackings are constantly compared to the structure and particularities of the surrounding situation. The spread of the stereotype is indeed a success story! Bhabha urges his reader to move from a semiotic activity to an interpretation of other cultural and discursive systems. Semiotics has the status of a reliable metaphoric device, which can be used in the deconstruction of culture. The language model gives us the possibility to make relative the relation between power and imposed and detectable order, where subjects are identical and isomorphic to the exercise of power as in the writings of Foucault (up until the *History of Sexuality* one must add). Dreams, fantasies, myths and obsessions are legitimate parts in the construction of the other and the linking of this world of phantasmagoria to races, sexes, geography and the ideology of origin. The ever-present reservoir of dreams and desires corresponds to a latent and unconscious Orientalism, and the actions by the agents in the history of the colonialism correspond to manifest Orientalism.

If the sign rather than the process of signification is the problem, then we are in real trouble. If the sign is more than a flat and primordially void marker in a game of signs, and indeed the base of reality, then the fixation

of language equals the fixation of identities. Bhabha avoids this situation by introducing the Freudian 'fable' of the fetish (the Marxist notion of the fetish has, as a close parallel, been widely used in the field of Visual Culture). It means that black skin is no more only a sign in the colonial vocabulary, but more so an example of false consciousness given as a 'picture' in a Lacanian sense: the reflection of colonial subjectivity that is only present provided the onlookers' stereotyped dreams. The fetish gives access to power and pleasure, but is at the same instant the sign for fear of deprivation. This constructs a narcissistic subject in front of the colonial mirror, looking for the pleasure in the repetition of the (almost) identical. The subject, however, is in a state of constant jeopardy since the reality keeps peeking through the deviations. Bhabha argues that there is a functional link between Freud's fetish and the racist stereotype. If everyone but the other is white, and white being the good thing to be, why are others non-white, and what are they missing? Could it happen to me? That is why the kid in Fanon's story is so upset: "Look, a Negro... Mama, see the Negro! I'm frightened".

The other, deviant individual threatens the idea of ideal origin. That humankind was born in Africa, that Athena of Acropolis was a black goddess, that the Elgin Marbles had not always been white, are examples of western taboos of the 19th century. There is no doubt that universal ideas of the French revolution were applied in the USA, which, at a time had an agricultural economy based on slave labour. Even the noble savages, Indians of the East Coast, were slave owners. If the differences outside the frame of colonial mirrors contradict the idea of every man being equal, then a strange pattern is established in which there is no possible way for the other ever to be adopted and to fit in. On the one hand, the colonized is fixed in his/her body by racism. On the other, to become 'white' means to empty yourself and accept a new 'genius' into your body.

It may be an expression of Nordic naïvité to look for changes in culture in the wake of postcolonial knowledge. It is nothing less than the survival of a vital culture based on human rights that is at stake in the West. If we consider the depiction of the world outside the realms of the news agencies' political, i.e. national, interests, the world is presented in familiar colonial terms of friends and foes. Western democratic order or eastern/southern despotic and/or corrupted chaos, Western productivity or uncontrollable natural disasters. In most of the media, this story is seldom questioned. We are offered the choice of stereotypes, which in turn gives

the impression that societies live in a perfectly balanced order that never change, as some kind of 'zombies from hell'.

Once again, at this point in Bhabha's line of argument you can pick up the importance of ambivalence. If classic colonial studies recommended that the tables be turned in a Christian Second Coming, The First shall be The Last-style, then the idea of culture is once again stereotyped, fixed and turned into a zombie. There is no parallel between the aspirations of an institutionalized nationalistic art, which made it possible for the prominent Swedish art critic Lars O. Eriksson recently to refer to a group of artists as the Swedish 'nationals' in contemporary art, and the culture of immigrants and refugees. The problem has to do with the gap between culture as a struggle for social survival, and culture as style and institutional career opportunities in a welfare state perspective. The national culture model has been defunct by the flow of immigrants. Bhabha insists that the privileged position of nations must be questioned on behalf of those individuals living on the fringes of Western societies without any reassurance from a nation that will readily expel them without notice. In my eyes, this adds proof to the suspicion that there is no such thing as neutral national cultures.

Finally, we must return to semiotics or, in more general terms, to language's status as a reliable metaphoric device that can be used to deconstruct representation. Representation is broadly understood from a sedentary cultural perspective. Mr. Eriksson's reference to art as a game of soccer between a brotherhood of nations is not completely void, and it qualifies the writer for Rogoff's basic understanding (and production) of borders. However, if we consider the fluent and unmotivated sign-signified relation, the unsteady and shattered subject, the impossibility to finally determine texts, do we not sit with relativism as a powerful argument against tolerance and multiculturalism in our hands? And does this argument really point in another direction than the fixation of culture? The question of cultural difference and cultural domination that the postcolonial discourse has been trying to analyse and answer thrives in the shadows of monolithic, national and/or state culture. The guardians of universal doctrine vacuum-clean discursive space to eliminate dialogue and contradictions. If there is culture, it must be created so that it reflects a unitary and original power. The royal societies for dance, music, theatre and art in Europe are examples of this notion. The critique of the formation of identities and cultures is therefore not achieved through a series of

epistemologically oriented discussions, as it is a struggle for culture outside the institutions.

Art is a colonized part of human expression, its borders are fiercely defended and they exist in a colonial rather than a global way within the art scene itself. Art, it has been said, is a discrete realm separated from other fields of human knowledge (only informed by its fruits in a serene and mysterious way). The politically introduced acceptance of borders – acceptance of the affirmative sameness only – was immediately assimilated by art historians of the past. The linesmen claimed that art was to be defined by visual, individual and aesthetic properties distinct from discursive practices. This limitation to the discussion has led to the current situation where there is no firm consensus of what art is and how to identify either a work of art or the proper means in a discussion on art. By using concepts from several other fields of knowledge except for traditional art history, mostly from the discussions in Visual Theory, I hope for an understanding on the part of the reader that these concepts are needed when getting to grips with contemporary art. The resources to handle these matters have, as I see it, already been developed within the post-colonial discourse.

This text was originally written almost two years ago,* the changes in art, from aesthetics to discourse, are all evident in the *Documenta 11*, which is shown this summer of 2002 in Kassel, Germany. The uniqueness of contemporary art is the extent of discursive openness for which its uncertain definition and discussion allows. In a way, this leaves the resources of this text well known and trodden in the practices of many important artists. It is a great thing that what I see as a colonial tenet of art is bound to crumble. For a while, this will cause considerable alienation in the broad public who enters the doors of art institutions to see what is beautiful and serene and not to read about what is mundane. Discussions over national culture will be left on a discursive scene dominated by politics until a world culture will form. Exclusion will only last for as long as the nationally based colonial argumentation has a grip over the media and the institutions, until it is clear to everybody that the discursive concept of art is about everyday experiences. Art and the colonial discourse of the 19th century were both construed as fetish reflections, as mirrors for princes. The con-

* The first part of the article was written in 2000 while the last section was added in spring 2002.

struction of art needs to be deconstructed in the same way, and much for the same reasons, as the colonial subject. Since there is no value *per se* in a separate language, separate value codes, and a separate discussion of art, ideas of social creativity forwarded by art have to escape the trappings of traditional expectations. The discursive concept of art does not, as the colonial, see exclusion as an integrated part of its self-affirmation. It recognizes art and aesthetics only as a social interface.

By an extensive discussion on the concepts of colonialism and borders in this text, I have tried to make plausible that there exists a close parallel between the history of colonialism and the history of art. Art has been treated either as a problem of form or one of content. The main contents of discussion were established prior to 1840 by historians forming themselves as historians of art, at the same time as they were trying to identify and list works of art within a European tradition according to their 'art' quality. To begin with there where pictures, forms and meaning that were not recognized a place in the Canon either because they did not fit into the parameters of 'art' quality or could not be interpreted as forerunners to Western art, or as unoriginal expressions of decadence and decline. Greek antiquity was to become the never to be surpassed pinnacle of Art. This is how Indian culture gained wide respect when the Buddhist-Hellenistic Gandhara sculptures were found and brought to European museums. This is how the people of the Indian subcontinent, through William Jones' concept of Indo-European languages (that was spread in a package with the romantic plea for the fragment – of antiquity – and a prerogative of Art drawn from theology across Europe by A.W. Schlegel), were to become our long lost 'brathras'.

Today, research is reluctant to make references to the central importance of the Greek status in art history, as was the case in the 19th century. In Honour & Fleming's *A World History of Art* (first published in 1982), you can see the development of an extra-European interest, stretching out to merge Africa and Asia into the world Canon. However, the point is that the concept of art, once it has established itself and given birth to its institutions, as much as colonialism and in the same intricate ways, makes people talk in a different language, upholding values of its own and its own reasons for inclusion or expulsion.

The Hungarian writer Peter Eszterhazy said recently in an interview that the concept of culture in a world unified under a post-industrial and neo-capitalist flag is bound to raise new changes in the social and political effects of culture as well as in economical terms. Eszterhazy pre-

dicted tensions and unforeseen problems when gaps widen between na-tionalized, market-oriented and resistant cultural efforts. In my ears, his question echoes the debate that followed the breakdown of the cultural policy of the 1970s in Sweden. Culture became accepted as a commodity that reflects the owner's economical resources and social ambitions. You get what you pay for, no more, no less. American cultural influence be-comes acknowledged as a part of the 'folk' culture, an opinion that made the art museums through the works of the Swedish artist Ernst Billgren and others in the 1980s.

Admitting to the relevance of a post-colonial critique would mean that the present-day culture is conceived as being under siege, threat-ened by the forces that equal economic rationality with universal values. First, you have to identify the economical rationality as a force that ex-pands with only feign and secondary relations to development beyond its own limits, as an invader without a cause. Loyal to the ideas of the social state, I have argued that it would be a mistake to identify every notion of national cultural policy as counterproductive and introverted. There are arguments to support this idea of a global rationalization of culture, but the forces of production, including education and knowledge, inform all of them, making them hard to swallow. The truth is that the immigrants and refugees living in our part of the world, resisting our cultural habits through culture and resisting the position of miss Aouda, have exposed the colonial system and made it visible in a way that no one is able to sur-pass.

Literature

Amin, Samir (1989) *Eurocentrism*, New York

Bhabha, Homi K. (1994) *The Location of Culture*, London

Bhabha, Homi K. (1998) "Culture's in between", in Bennet, David (ed.) *Multicultural states: rethinking difference and identity*, London

De Certeau, Michel (2000) *Heterologies discourse on the other*, Minneapolis

Deleuze, Gilles (1994) *On the Line*, New York

Documenta 11_Platform 5: Exhibition (2002) *Catalogue*, Ostfildern-Ruit

Ericsson, Lars O (2001) *I den frusna passionens heta skugga*, Stockholm

Fanon, Franz (1965) *Studies in a Dying Colonialism, or A Dying Colonialism*, New York

Fanon, Franz (1967) *Black Skin White Masks*, New York

Foucault, Michel (1991) *Discipline and Punish*, London

Foucault, Michel (2000) *The Order of Things*, London

Honour, H & Fleming, J (1991) *A World History of Art*, London

Lacan, Jacques (1989) *Écrits*, Borås

Laclau, Ernesto & Mouffe, Chantal (1985) *Hegemony & socialist strategy. Towards a radical democratic politics*, London

Manifesta 3 (2000) *Borderline Syndrome: Energies of Defence*, Ljubljana

Marx, Karl (1974) *Capital,* volume 1, London

Rogoff, Irit (2000) *Terra Infirma/Geography's Visual Culture*, London

Verne, Jules (1981) *Jorden runt på 80 dagar*, Stockholm

LETTERS FROM THE TURKISH BATH
A Lacanian Approach to Orientalism*

BÜLENT DIKEN & CARSTEN BAGGE LAUSTSEN

* Millenium: Journal of International Studies. This article
first appeared in Millenium, [Vol. 17, no. 3, Winter 1988],
and is reproduced with the permission of the publisher

Istanbul is what I was searching for. I have been here a week and it has taken my breath away, my slumber. How much time I wasted before reaching here! I have the feeling it was waiting for me, silently, while I chased for a life, as tiring as it was useless. Here things flow more slowly and soft, this light breeze dissolves your worries and vibrates your body. I finally feel that I can start again.

The above quotation is from a letter from the Orient, written by Madame Anita, a fictive character in the film *Hamam*.[1] Madame travels from Rome to Istanbul just after the Second World War and never returns. In her letters back to Rome she describes her life in Istanbul as "one long holiday": transgressing the borderline between work and leisure, her life is light and joyful. In Istanbul she marries a local businessman, the owner of a series of coffeehouses, yet the marriage lasts only a few months. With the money she is entitled to after the divorce, Madame Anita buys a decaying Turkish bath, a hamam. She restores it and runs it for many years, until hamams start losing their popularity in Istanbul.

In *Hamam*, we do not meet Madame in person. The film opens with her death and we are informed about her life only through the letters she wrote to her sister in Rome. When Madame passes away, her only remaining Italian relative, her nephew Francesco, inherits her possessions. Francesco is the owner of a successful business (an interior design office) in Rome together with his wife, Marta, and their associate, Paolo. The film depicts none of these people as charming or warm: their habitus is characterized by a stressful, image-conscious and career-orientated lifestyle. The Italian personae of the film condense everything associated with the Orientalist image of the cold and rational Westerner. And then of course, Istanbul, in stark contrast to Rome, stands in for the ancient, tantalizing, erotic allure and idleness of the Orient. The film seeks to reveal the secrets of the old, labyrinth-like, narrow and intimate Istanbul streets, the feasts of circumcision, the sensuous atmosphere of the hamam and other excessive ways of bodily enjoyment. The Turkish bath itself is depicted as a house of pleasure and tranquillity, and it clearly symbolizes Europe's 'other'.

One could of course criticize *Hamam* for arranging everything in clean-cut, dichotomous terms: the West versus the East; Rome versus Istanbul; Francesco and Marta versus Madame Anita and Turks in her neighbourhood. But such a critique, which focuses on the juxtaposition of the self and the other, misses something essential regarding Orientalism. Some-

thing has to mediate between the two poles, letters, persons and objects, allowing for substitutions and metamorphoses. *Hamam* is also about mediators that bridge the West and the East, a mediation inscribed in travel narratives on the strange and the exotic. In this respect, *Hamam* is a post-1968 version of Montesquieu's *Persian Letters*.[2] As in Montesquieu's work, *Hamam* allows the West and the East to be compared with a view to moralistic lessons. Both works are organized around letters. However, the letters in the film do not address the Orient to introduce it to the world of knowledge, rationality and reason as is the case with Montesquieu's letters; rather, they inversely address European travellers longing for escape from their stressful life constrained by social rules and prescriptions. In other words, the Orientalist dichotomy remains the same, while the positively valorized pole is changed; relaxation and enjoyment now beat rationality and wealth.

Let us now open up our question: how are we to read these postal economies? Are Montesquieu's *Persian Letters* and Madame Anita's letters to be interpreted as merely variations on the same (Orientalism)? Accordingly, how are we to read the distinction between West and East, Europe and the Orient? If we are dealing with one and the same postal economy, then how can this remarkable sameness between *Hamam*'s and Montesquieu's letters be explained? And finally, how can our reading inform the way the self and the other are juxtaposed? To answer such questions, we first deal with an interrogation of Montesquieu's *Persian Letters* and *Hamam*. Second, we discuss the texture of Orientalism in general terms. Then, by counter posing two different critical styles of reading Orientalism – a discourse analytical reading that focuses on the construction of binary distinctions and a psychoanalytic reading that focuses on the construction of the Orient as a fantasy space – we want to stress the advantages of the latter. After discussing narratives (in *Hamam* and *Persian Letters*), the theme (Orientalism) and methodology (discourse analysis and deconstruction versus psychoanalysis), we end with our considerations on the question of critique: is there an ethical, or, a genuinely critical way of reading the Orient? In this context, we offer three different readings of the final scene of the *Hamam*, which are organized according to the Lacanian distinction between imaginary, symbolic and the real.

Hamam

Which images and narratives are deployed in *Hamam*? And is it justified to see them as representative of Orientalism? To begin with, let us interpret these images and narratives as elements of a distinction between West and East, masculine and feminine, or the normal and the pervert, a distinction that, as a rule, privileges the first term. By doing this, we read Orientalism in the way cultural studies usually does: by focusing on the construction of the self and the other and the accompanying strategies of stereotyping, devaluing and disqualifying the other.[3]

The first letter of *Hamam* is informing Francesco about Madame Anita's death. Indeed, the longest sequence of the film, following the initial scene in which we are informed about her death, is based on the movements of this letter. We see the letter posted in Istanbul, stamped at several Turkish offices, sorted and finally delivered to Francesco in Rome. This might be seen as merely an introductory scene. However, as the film unfolds, it becomes clear that *Hamam* is in fact structured around the very circulation of letters, which is why the initial scene is especially significant. Most often these letters are read by the characters while they cross the Bosphorus that (dis)connects the two continents. Hence the significance of postal economies in relation to *Hamam*: they effectively mediate between East and West.

The first letter urges Francesco to go to Istanbul to sell what he later discovers to be a Turkish bath. Yet the sale is continuously delayed: everything is in slow motion in the Orient. Finally, however, Francesco is ready to sign the sale contract with a greedy speculator. Yet he refuses to do so, because he is, by mistake, told that the company wants to demolish the area to build parking places, hotels, tennis courts, and so on. Francesco warns the poor neighbourhood against the company's plans. Enlightened against the cold, calculating Western modernity, the people in the neighbourhood now follow his example and refuse to sell their homes. Once again the same old Orientalist image surfaces: in the West people hardly know their neighbours; in the Orient you just need to open your window for an intense communication with others; everybody knows each other, news travel fast. *Hamam* focuses on a very specific area of Istanbul, presenting it as everything urbanism has destroyed in the West, as a big village untouched by modernity.

When modernity is brought to the Orient unreflectively, it gets awkward effects; what is needed is therefore more Western involvement. It is hence Francesco, the European hero, who saves the primitive and back-

ward Oriental subjects from themselves (in this case from the speculator).[4] Istanbul is a beautifully decaying ruin waiting to be restored by entrepreneurial Europeans; first Madame, then Francesco and finally Marta. In a multi-culturalist manner, the hamam remains a beautiful and exotic place thanks to the West![5]

Enlightening the Orient and saving its cultural heritage is however only one side of the encounter. Francesco himself changes too. One of the reasons for his prolonged stay in Istanbul is his homosexual relationship to a Turk, Mehmet, who lives in the same neighbourhood together with his family, obviously Madame's closest neighbours. Homosexuality is an important element in that the Orient, particularly the Turkish bath, is depicted as a site of perversion.[6] Whereas the West is entrapped in rigid rules and stiffened customs, desires flow smoothly in the Orient: "[l]ike a light breeze that vibrates your body". The homosexuality of Mehmet and Francesco is perverted in the sense of transgressing the Western, heterosexual norm. This element of perversion is further underlined through Francesco, Mehmet and Madame's practice of spying naked bodies from the roof of the hamam. This gaze is perverted not because it sustains a forbidden eroticism, but especially in relation to enjoying the multitude, just as the Sultan previously had enjoyed not just the female body but the multitude of harem women.[7]

Marta, who, suspicious of Francesco's excuses for being away, travels to Istanbul in order to see him, makes the next move. During her first night, she discovers the relationship between the two men when she sees them passionately making love in the hamam. In intense relaxation, they enjoy each other's body while smoking together. This glimpse of the Oriental hothouse of desire is an updated vision of the Harem: a space of limitless and intense enjoyment. Water, steam and heat are all symbols of relaxation and smooth movement. Intense ethnic music with fast drumbeats underpins this atmosphere of corporeal passion. The Oriental body has been heated and relaxed since Montesquieu developed his infamous climate theory.

The next day, Marta and Francesco agree on divorce. Marta decides to leave Istanbul. On the same day, the Mafia murders Francesco; the building company arranges a contract hire murder. The Turkish mafia serves here as an updated version of despotic power (just as the hamam refers to the harem). What unites the Despot and the mafia is the omnipotent power characterized by a complete disrespect for human life. The Mafioso is now the absolute master: the neighbourhood is terrorized just as

the Oriental subject was terrified of the Sultan's power.[8] One does not go against the will of the Despot. In this respect, Francesco seems to remain a European: stubborn as he is, he goes against the rules of the game, which an effeminate, Oriental subject, motivated by fear rather than courage and individual will, would never do. The price paid for his stubbornness is life itself.

After Francesco's death, Marta returns to Istanbul. As his wife, she receives Francesco's wedding ring (she had given her own to a poor lady after she discovered his betrayal). This reconciliation is significant since Marta, in the final scene, decides to run the hamam. However, the reconciliation is not only with Francesco but also with the repressed, 'Orientalized', side of her own personality. Hence Marta is in the final scene depicted smoking with Madame's cigarette holder, while the narrator reads her letter, remarkably similar to Madame Anita's letters. She writes to Mehmet, who has left Istanbul after Francesco's death, to say that the hamam is now completely renovated:

> Sometimes at sunset I get melancholy, but then suddenly this cold breeze raises and takes it far away. It is a strange breeze, like no other I have ever felt. A light breeze and it loves me.

One could say that Madame Anita's letters *did* reach their destination, that their true addressee was Marta, allowing her to take her position and realize her latent 'Orientalism'. Marta becomes the new Madame, and Francesco is thus reduced to a vanishing mediator. In this context, too, letters play a significant role: they allow the metamorphosis of the characters to be completed and their 'fate' to be realized. 'Lost' letters finally reach their destination, even though they were initially returned to the sender.

Writing Persian Letters

It is no coincidence that Montesquieu's *Persian Letters*, perhaps the most famous Orientalist piece, and Özpetek's *Hamam* have the form of postal economies. Why? The letter of course has a mediating function; it unites home and abroad. This, however, is not the only reason. When Montesquieu wrote his *Persian Letters*, the choice of form was well considered. Whereas *The Spirit of the Laws* is written as a *tractatus* proceeding according to the logic of reason, the *Persian Letters* is deliberately excessive in

style.[9] The *Persian Letters* are not just *about* the Orient, they are also written in an 'Oriental' style:[10] their composition does not follow a logic and the story is not told as a linear narrative; rather, they give body to a polyphony of voices.[11] There is not one narrative or one topic, but many. The letters shift from serious political business to reflections on ways of dressing. Sometimes a moralistic tone is applied while other letters are intended to be funny. The most important aspect is the way the letters are selected: we are left with the impression that some are lost, others lack a sender or some parts of their contents. Sometimes it is as if we have obscure letters within letters. In a similar way, we have in *Hamam* the returned letters of Madame Anita that later are included in Francesco's and Marta's narratives. Why this form? And why this consistent attempt to describe the Orient according to a characteristic *lack of form?*

To answer this question, a short detour to Jacques Derrida's *The Post Card: From Socrates to Freud and Beyond* is useful.[12] Derrida's book is, among other things, an ironic critique of the teleological underpinning of many of Jacques Lacan's concepts. Derrida argues that, no matter how enigmatic meaning is, for Lacan it is always ready to be interpreted: everything fits into the psychoanalytic scheme. Once, in a commentary on Edgar Allan Poe's the *Purloined Letter*, Lacan even argued that the letter always reaches its destination.[13] To illustrate the role of the performative misfire through the economy of lost letters is hence well done. Derrida further claims that this teleological structure, which is present in all of Lacan's concepts, is deeply mistaken. Hence, he has written some unfinished and undelivered letters, some postcards, in order to subvert Lacan's teleology.

Thus, Lacan is for Derrida a representative of Western tradition's falling prey to 'logocentrism'. Logocentrism has many faces: the privileging of writing over speech, teleology over dissemination through time, the masculine over the feminine, the West over the East, and so on. Everybody falls prey to such a logocentrism, except Derrida of course, who is capable of uncovering through his impressive work, the 'other' of this tradition (speech, woman, the hyperbolic, etc.). This is literally shown in Derrida's overwhelmingly difficult book, *Glas*.[14] In *Glas*, all pages are divided into two parts. The left part of the page is stuffed with quotes from Hegel, the Western logocentric philosopher *per se*, while the right part primarily contains references to the French author, Jean Genet. Genet was a homosexual living on the margins of society, and Derrida takes his voice as a genuine other that subverts Hegel's text. While the *Postcard* can be read as written in an 'Oriental' style, the two columns in *Glas* can be read as refer-

ring to 'Western' and 'Eastern' ways of writing and being. The West is logo-centric, rational, orderly, teleological, while the East is perversely hyperbolic. Genet is subversive and perverted just as the Orient is.

The question to be posed here is how genuinely critical Derrida's project is. Is this juxtaposition of logos and hyperbole not Orientalism at its purest? Has this 'other' of reason and rationality not always, at least since modernity, been present in Orientalist fantasies? Derrida has argued that Western logocentrism has been with us since Plato and the same goes for the 'other' of this tradition, 'Orientalism'. There is nothing subversive in stressing the existence of this other voice, in doing so one mainly consolidates a Western gaze. The Orient, the existence of this other voice, is nothing but an ideological supplement to Western logocentrism: it is a fantasy. This orientalized voice is not 'other', marginal, or repressed. It does not take any deconstructive labour to uncover.[15] To clarify this point, let's return to Montesquieu's *Persian Letters*.

Montesquieu's popular book was published in ten editions within a year.[16] The place of publication was Holland, which was a normal practice when a work could risk official disapproval.[17] It was published anonymously. Montesquieu's English translator J.C. Bett characterized it as one of the main anti-Establishment works of the early eighteenth century.[18] Still, it remains one of the classical examples of Orientalist discourse. The *Persian Letters* is not, however, a singular achievement: around thirty percent of all books published in Montesquieu's time had the Orient as their theme.[19]

The most important voice in the *Persian Letters* is Usbek, a rich man travelling to Europe to be enriched. He leaves, putting his seraglio and harem under custody of the chief eunuch. In the book, we also meet another traveller from Persia, Rica. The two men are usually interpreted as the two sides of Montesquieu's own personality: Usbek is the curious man seeking enlightenment, while Rica, constrained by traditional ways of seeing, is the Orientalized figure.[20] Taken together, their narratives offer a varied commentary on contemporary affairs and allow Montesquieu to contrast West and East.

The *Persian Letters* are highly moralistic in preaching a golden rule that can apply to everything from government to sexuality. Both the complete denial of freedom that supposedly pertains to the East and the unlimited pursuit of freedom as premised in the philosophy of Thomas Hobbes are under ruthless critique.[21] The women in the harem and the eunuchs unfold their sexuality in an unnatural and too restrained way.[22] Marriage as

practiced in the West is a much better way of uniting man and woman. On the other hand, Montesquieu criticizes monastery life and the Catholic Church in general for being too strict, recommending his readers to strive for the right balance in all aspects of life.[23] This double-edged analysis is present in all of Montesquieu's concerns. His letters are both 'Persanes' and 'Parisiennes'.[24] The main focus is a critique of the Orient: through the work of reason Usbek learns to appreciate knowledge, rationality and freedom. At the same time, however, an implicit critique of the abuse of privileges in France is offered. The emperor's abuse of government in France is claimed to mirror Oriental despotism.[25] Orientalism is not just, as Said often argues, a tool used to repress the Orient,[26] it is and has always been a double-edged sword.[27]

Three themes are central in this Orientalist discourse – religion, sex and politics – enabling a distinction between Islam and Christianity, between perversion and heterosexuality, and between despotism and republicanism.[28] Islam is a fake religion based on lack of inner conviction. Mahomet is an impostor giving birth to a religion of empty rituals.[29] The image of sexuality relates to the eunuch, the harem and the fantasies of secret enjoyment: a lesbian relationships,[30] the unfulfilled sexual desires of the eunuchs, and so on.[31] The Sultan himself is a pervert turning his household into a house of lust and pleasures: a brothel where all women (and men) are brought in to please the Sultan. Finally, the Orient is described as a place where there is no separation of powers. Everything exists for and belongs to the Sultan; nothing has an independent existence.[32]

More than 250 years later, we find these narratives reappearing in films like *Hamam*. We have already mentioned that the mafia stands in for the Sultan (the complete disrespect of human life, the politics of fear …) and the hamam for the harem (the enjoyment of the manifold, the bodily pleasures, the illicit pleasure obtained through a hidden gaze …). As Montesquieu's *Letters*, *Hamam* is also an ambivalent narrative. It contains not only a stereotypical image of a backward East but also a critique of contemporary Western culture. False gods are now Western (design, money, or excessive materialism). Furthermore, as is the case with Montesquieu's narrative, *Hamam* is about the metamorphosis of the West and the East; hence, the importance of letters in both narratives.

It is, in this context, tempting to argue that Orientalism has remained unchanged. Indeed, this seems to be Said's conclusion in *Orientalism*.[33] A whole range of analyses have taken this idea up and mapped the different ways in which the West constructs the non-western world. Much is gained

through these analyses but one thing is always missing: scholars are not attentive to the ambivalence of the Orientalist discourse.[34] The Orient is neither near nor distant, but both, and at the same time. It is not necessarily a positively or negatively valorized social topology, but a utopia and a dystopia at the same time.

This ambivalence is clearly present in the famous concluding letter 161 of Montesquieu's *Persian Letters*.[35] Lacking the firm hand of Usbek, his seraglio and harem slowly but unavoidably disintegrates. There are indications of lesbian relationships among the harem women, and the hierarchy of power is turned upside down (power has moved from the powerful eunuchs to the manipulative harem women). Already in letter 156, Usbek's first wife reports: "[h]orror, darkness, and dread rule the seraglio: it is filled with terrible lamentation; it is subject at every moment to the unchecked rage of a tiger".[36] Later, in letter 161, things become clearer when Roxanne explains to Usbek the reasons for her suicide:

> Yes, I deceived you. I suborned your eunuchs, outwitted your jealousy, and managed to turn your terrible seraglio into a place of delightful pleasures … How could you have thought me credulous enough to imagine that I was in the world only in order to worship your caprices? That while you allowed yourself everything, you had the right to thwart all my desires? No: I may have lived in servitude, but I have always been free. I have amended your laws according to the laws of nature, and my mind has always remained independent.[37]

Like Montesquieu's whole book, this ambivalent letter can read in two different ways.

The first reading focuses more on the geographical or the geophysical. In accordance with Montesquieu's climate theory, all power constructions in the Orient are permanently corrupted. At the same time, however, the Oriental system, that is, despotism, is unnatural for it denies human freedom. How, then, is the persistence of the Oriental system explained? Obviously, it is a difficult question to answer and Montesquieu's way out is to argue that the climate makes people lazy and prone to accept domination: physical nature corrupts human nature. Accordingly, Western ideals of freedom and self-rule cannot be introduced in the Orient. If they are introduced, they will have negative effects. True freedom, as marked by the absence of Usbek, the master, is not possible in the Orient.

In a rather different, a feminist, reading, female enjoyment or fe-

male voices exist outside the reach of the Despot. His power is never total. Hence, the image of despotic power is claimed to be Orientalism at its purest. The women, (in Montesquieu's narrative: Roxane), are not completely controlled, there is always the possibility for them to take control over their own life and manipulate the sultanate. Whereas the first reading assumes the need and possibility of complete domination, hence the collapse of the Harem with Usbek's absence, this second reading stresses a dialectics of master and bondsman. Perhaps, it is the women who rule while the sultan remains tied to his role. Perhaps, the women have a secret enjoyment and a secret language. Focusing on the content of the Orientalist narrative, as we did in this section, one can conclude that Orientalist themes are both persistent and ambivalent. We started the above line of argumentation by ordering our discourse according to the distinctions between East and West, and went on to draw a more complex picture. However, something important is missing in this textual universe, which is organized according to the reifying logic of binaries. Hence the next section aims at reconstructing our analysis according to a theoretical scheme of Lacanian origin.

The Orient as a Zero-Institution

Europe's identity is defined in relation to its 'other', predominantly the Orient, and this is what cultural studies commonly argue. Identity is not given through references to intrinsic qualities of objects, places, or people, but rather though a relational web of differences. Accordingly, the Orient condenses what Europe is *not*: a kind of negative photographic image, which operates through the logic of oppositional differences between normality and perversion, law and despotism, mind and body, reason and desire.[38] Thus such images of the Orient – as the hothouse of desires and cradle of despotic power – tell us more about the identity of Europe itself. They are images that unfold before a Western gaze. Through a power-knowledge nexus, the Orient is frozen in Western stereotypes.

Are Montesquieu's and *Hamam*'s letters, then, to be read along the same lines, as yet another version of a well-known story? We want to resist this temptation. Since its publication in 1978, Said's *Orientalism* has become a standard approach to the topic. Yet the following year, an equally interesting but much less known book on the Orient appeared in France: Alain Grosrichard's *Structure du sérial: La fiction du despotisme Asiatique*

dans l'Occident classique.[39] Grosrichard's major source of inspiration was not Foucault but Lacan, this making a significant difference.

Our first argument is that the relationship between the West and the Orient is not merely that of a difference between two elements within the same space. Rather, the Orient signifies that which is prior to difference. In other words, difference is not that of the masculine and the feminine, but between (sexual) difference and the lack of difference. Hence, the eunuch, not the woman, is the emblem of the Orient.[40] Similarly, despotism is not merely a political form as monarchy, tyranny and democracy, but rather an a-political 'formlessness'; the Orient is defined by the lack of form as such.[41] It is constituted as a space, in which the distinction between the social and the political does not hold. The discourse on sex and power is thus intertwined: the Orient does not belong to the symbolic order; it is a narration of what is prior to or beyond the symbolic.

In Lacanian terms, the Orient is constituted as a fantasy space that both conditions and escapes the 'social'. Fantasies create objects of desire, but they create these objects as being out of reach. The law, that is, the prohibition of various activities, creates a desire to overcome constrains. The Orient is a product of such a desire to transgress. It is in this sense not a hallucination of fulfilled desire but rather an answer to the question: why this desire? Through the law, the fantasy of a beyond (and before the law) is made possible. Fantasy is not primarily sustained through semantic interventions but through investments of psychic energies, desires and drives. Fantasy stages desire, freezes it in fixed patterns and hence protects the subject by keeping enjoyment at bay. The object of desire is transposed to another space, 'Orientalized', enabling it to remain sublime, that is, unreachable. (Indeed, as we will argue later, to realize one's fantasy is often to dissolve it.)

Concomitantly, the social bond has two sides.[42] Life within the domain of the law, that is, life organized by the separation of powers (the separation of the political and the domestic, male and female ...) is sustained through fantasies of transgression. Such fantasies form the 'downside' of the social bond that guarantees the strength of its upper side. In this sense, Western rationality, reason, and morality (the upper side) and its dark, 'Orientalized' downside are parts of the same economy.[43] The downside, however. has to remain disavowed, 'Orientalized', in order to be able to function.

Against this background, Said *à la Foucault* and Grosrichard *à la Lacan* produce two different forms of critique. The first is discursive and fo-

cuses on a 'symptomal reading' of the ideological text to 'deconstruct' its meaning by showing how the text constructs a field organizing a heterogeneous set of 'floating signifiers' around certain 'nodal points' and pushing other signifiers to the margin by devaluating them. Hence, it focuses on the upper side of the social bond, on the construction of dichotomies between West and East, and on how traces of these constructions can be uncovered when reading in the margins of classical texts. This is also how we have analysed Orientalism so far. The second mode of analysis, in contrast, "aims at extracting the kernel of enjoyment, at articulating the way in which – beyond the field of meaning but at the same time internal to it – an ideology implies, manipulates, produces a pre-ideological enjoyment structured in fantasy".[44] This is how we want to proceed.

Which status does the Orient have in this second reading? To answer this question, let us initially focus on Claude Levi-Strauss' *Structural Anthropology* as discussed by Slavoj Žižek.[45] Here, Levi-Strauss describes the behaviour of the members of the Winnebago tribe. This tribe is divided into two subgroups, 'moieties'. Asked by an anthropologist to write a spatial representation of their town in the sand, the two groups draw different pictures. Whereas one group perceives the city as a circle with a central house in the middle, the other divides it into two halves. Žižek labels these two groups conservative-corporatists and revolutionary-antagonists. These two camps could likewise be labelled left and right, or man and women. The temptation to be resisted here is the straightforward claim that the West and the Orient, Rome and Istanbul …, are like moieties, like positions within the same symbolic space.[46] On the contrary, these two positions express two ways of dealing with a fundamental deadlock, they are two attempts at symbolizing a traumatic kernel, or in other words, two ways of covering a primordially given and traumatic lack:

> Lévi-Strauss' central point is that this example should in no way entice us into cultural relativism, according to which the perception of social space depends on the observer's group membership: the very splitting into the two 'relative' perceptions implies a hidden reference to a constant – not the objective, 'actual' disposition of buildings but a traumatic kernel, a fundamental antagonism the inhabitants of the village were unable to symbolize, to account for, to 'internalize', to come to terms with – an imbalance in social relations that prevented the community from stabilizing itself into a harmonious whole. The two perceptions of the ground plan are simply two mutually exclusive

endeavors to cope with this traumatic antagonism, to heal its wound via the imposition of a balanced symbolic structure.[47]

How are the two tribes brought together? Through what Levi-Strauss calls a 'zero-institution'. The zero-institution is "a kind of institutional counterpart to the famous *mana*, the empty signifier with no determinate meaning, since it signifies only the presence of meaning as such".[48] It is an institution that allows the symbolic to be installed and differences to be represented. The Orient works as a zero institution characterized by a lack of difference; it is a fantasy of the pre-social, of what precedes difference.

It is worth taking Levi-Strauss' concept of the zero-institution literally here. The Orient functions as the number zero, as that which does not have an objective counterpart. It can only be represented as a lack, as a black hole, a desert.[49] As such, however, it lays the foundation for all series of numbers (all series of differences: man versus woman, ruler versus ruled ...). Zero is involved in all rows of numbers even though it is literally not there. The Orient is the zero degree of political order. "Despotism functions as the degree zero in Montesquieu's system of ordering".[50]

Yet, this 'beyond the law', the traumatic 'Real' prior to difference, can only be represented through the symbolic. Hence, it becomes a zero-*institution*. The concept of the letter is again useful here. The letters bridge and represent the beyond, the other space where no constraints are felt. They are, as are fictions, or, imaginary simulacra. The fantasy space of *Hamam* is thus not an empirical Istanbul. Rather, it is a space constructed through Madame Anita's letters. Yet, the stuff of the letter is literally letters, signifiers; it creates difference by way of signifiers, and as such the letter belongs to the symbolic register.[51] Thus, fantasy has a double, spectral structure.[52] It is a discursive representation of a space beyond the symbolic.

The difference between the Lacanian concept of fantasy and the common understanding of ideology should be noted here. Fantasy is, as we mentioned, fundamental in staging desire. There is nothing, no truth, to be discovered behind it.[53] It only covers a traumatic abyss. There is no real Orient behind the Orient caught by the Western gaze. Said's *Orientalism* implies that there is a true Orient distorted by the European gaze. From a Lacanian perspective, the Orient could be located anywhere, everything can be 'Orientalized'. When one merely asks whether Orientalist fantasies are true or not, what one forgets is that desire, not truth, sustains ideological fantasies. Hence, the only function of the zero-institution:

is the purely negative one of signalling the presence and actuality of social institution as such, in opposition to its absence, to pre-social chaos. It is the reference to such a zero-institution that enables all members of the tribe to experience themselves as such, as members of the same tribe. Is not this zero-institution, then, *ideology* at its purest, that is, the direct embodiment of the ideological function of providing a neutral all-encompassing space in which social antagonism is obliterated, in which all members of society can recognize themselves?[54]

Fantasies and ideologies should be analysed as given in discursive practices in which signifiers are fixed. This would be the first, Foucauldian, mode of analysis mentioned above. Such operations are, however, only possible with reference to a more fundamental level. Fantasies and ideologies are sustained through desire.[55] Thus we now want to describe this interplay of desire and social taxonomies. To begin with, we take the final scene of the film as our point of departure and read the film as a meta-narrative about desire, enjoyment, drive and their social settings. Then we show a way of 'going through fantasy' that culminates in the ethical attitude of four female heroes: Marta, Antigone, Roxane and Lady Montagu.

Returned to Sender

The interpretation of Marta's position in the final scene of *Hamam* is essential, allowing for a reading that is not linear and chronological. Reading the film backwards, it becomes clear that a Hegelian cunning of reason has lead each personal story to its true conclusion. If the film is read as an updated version of an ancient Greek tragedy, the core concept in this context is fate. Due to the mediating activities of Francesco, Marta realizes her fate: through him, her transformation into Madame becomes possible. Francesco twice enables Marta's arrival in Istanbul and makes it possible for Marta to read Madame's letters. Finally, she is transformed from an addressee to a sender (the last letter of the film is, as we mentioned, sent by Marta).

In *Hamam*, we predominantly follow Francesco's actions and hence he seems to be the main figure. The final scene, however, makes it perfectly clear that Francesco is a secondary figure, whose only aim is to enable Marta to take Madame's position both socially and physically. Francesco

is what Frederick Jameson has called a vanishing mediator.[56] It is he who allows the letters to reach their destination: he is a 'postman'. In the beginning of the film, we are informed that Madame's letters to Rome were returned unopened. Yet, focusing on the characters in the film, one could say that the letters finally reach their destination and Francesco and Marta finally realise their common fate. But what is this fate? Let us begin by qualifying Lacan's claim that "the letter always reaches its destination" and by explaining the way in which letters allow for Francesco's and Marta's metamorphosis.

The reason why the letter always gets to its addressee is, firstly, with a reference to the imaginary, that everybody experiences herself or himself as an addressee.[57] A message in a bottle is the paradigmatic example. Louis Althusser's concept of interpellation describes this imaginary lure.[58] The person interpellated by a policeman shouting "hey you" is interpellated, because by turning towards the policeman, he identifies himself with the addressee of the call. This 'I', which turns around, is created through the call; it is a product of the process of interpellation. The addressee of is thus everyone who turns around recognizing the policeman as an authority. Madame's letters reach their destination because persons who happen to read them are interpellated. Furthermore, Madame's letters also have the audience of the film as their addressee. Like the person interpellated by the policeman, the audience readily turns around, confirming the banal fantasies of the Orient. The film offers a fantasy structure accepted in so far as it helps us in overcoming our 'symbolic' castration. We find a 'self' in the film and willingly accept it because it fits our fantasies.

"A letter always arrives at its destination since its destination is wherever it arrives".[59] In this sense, the success of the letter has to be explained by the fact that it offers a screen for the projection of our fantasies. In Edgar Alan Poe's story, the policeman never finds the letter of the criminal due to the fact that he has an already established image of how the letter of a criminal may look like.[60] Actually, the letter is in front of him but carries the seal of the chief police officer. That the letter always reaches its destination implies, with reference to 'the symbolic', that the letter is simply a signifier, which is interpreted according to the fantasies of its receiver. It is the police officer's image of a criminal mind that prevents him from finding the letter. The film is a chain of signifiers ready to be interpreted. Gays read the film in the context of gay liberation (the message of the film being in this case that no sexual practices can be claimed as sick or perverted: everyone has a sexuality that is just right for him or her). Commu-

nitarians read it as a narrative of cultural and social decline in the West. Some Turks take it as a celebration of Turkey's unacknowledged silent acceptance of sexual and cultural diversity, in opposition to the Western images of Eastern intolerance, while others dislike the film because of its homosexual scenes, Orientalism, and so on. Which reading to prefer, then? This question is a false one in so far as one accepts that the Orient is a fantasy space. The film can confirm all spectators' fantasies.

Now, we can investigate how the letters in *Hamam* reach their destination allowing the main characters to change. We offer three different readings of the film. The first two readings confirm the Western construction of the Orient as a fantasy space, while the third attempts to go through fantasy, breaking its spell and its power to fascinate.

From the Symbolic to the Imaginary

Smoking is a central signifier of enjoyment in the film. In the final scene, for instance, Marta smokes on the rooftop of the hamam she now owns. This is the culmination of the process in which she finds herself: she moves from a socially mediated desire (Rome) to enjoyment (Istanbul), from Marta to Madame. This would be a commonsensical reading of the scene. Marta has found what she was searching for just as Francesco and Madame had done previously. The Oriental life form is worth desiring, or better, enjoying, in contrast to the false and empty desires staged in Rome. Moving to Istanbul, both Marta and Francesco realize that this Western form of life is false and conformist: the European self is a surface self, a mask, in contrast to the Oriental self, which is based on inner truth and conviction. In this reading, the film is about finding oneself behind the mask.

However, Rome is here associated with the symbolic in a second sense. Lacan wrote that the sexual relationship is impossible and that the partners are forced to play the role of partial objects for each other's desires.[61] The image of love as unity is a mystification.[62] Life in Rome is a precise manifestation of this impossibility. In their pursuit of great love, both Marta and Francesco get caught in a game of betrayal. The desire for the sublime love only creates unhappiness, for the ideal partner is always somebody else; desire is always the other's desire. However, in Istanbul they approach the object of desire directly and accept that the socially mediated fantasy of the great love as hollow. Francesco finds true happiness by living out his denigrated love. He lives out his fantasies, accepting the

position of a pervert, falling short of the heterosexual norm. Istanbul is a way of escaping social taxonomies.

This reading, however, must be rejected too, or better, its ideological underpinnings have to be uncovered. For there is no true self to discover, there is nothing behind the mask. This reading is ideological in attempting to conceal the void on which all identities are based. In "The Mirror Stage as Formative of the Function of the I", Lacan claimed that the child misrecognizes its unity.[63] When it watches its reflection in a mirror it sees an autonomous self, existing independently of its parents. This perception is a misperception for the child crucially depends on its parents and their care. Later, Althusser gave Lacan's idea a sociological twist by claiming that the bourgeois subject, defined through the concepts of autonomy and freedom, misperceived its unity and independence. The bourgeois subject is in reality formed by ideology, just as the gaze of the parents forms the child.[64] Along the same line, Lacan stated that "the woman does not exist".[65] The basic idea is the same as in Althusser's essay on ideology: of course people of the female sex exist, but the woman as such does not exists as an independent being given outside the play of sexual difference. In short, this reading falls prey to the lure of ego psychology, whose contemporary form is according to Žižek, "Western Buddhism":

> The recourse to Taoism or Buddhism offers a way out of this predicament which definitely works better than the desperate escape into old traditions: instead of trying to cope with the accelerating rhythm of technological progress and social changes, one should rather renounce the very endeavour to retain control over what goes on, rejecting it as the expression of the modern logic of domination – one should, instead, 'let oneself go'. Drift along, while retaining an inner distance and indifference towards the mad dance of this accelerated process, a distance based on the insight that all this social and technological upheaval is ultimately just a non-substantial proliferation of semblances which do not really concern the innermost kernel of our being.[66]

Seen from this perspective, *Hamam* parallels Western Buddhism. Find your true self, give up the desire to express your self through commodities, career and prestige; let your self liquefy in the light, oriental breeze. Such Western Buddhism is a fantasy used to conceal one's fundamental castration or lack.

From the Imaginary to the Symbolic

In contrast to the illusory life in Rome, tranquillity, relaxation and social and physical proximity characterize Istanbul. Everybody seems to know one another in what is portrayed as a gigantic village untouched by modernity and capitalism. Enjoyment is not tied to individualistic aspirations as in Rome, but rather it is a matter of occupying a place within community. No conflict between the individual and the social is experienced, no class divisions. We are within the symbolic order, not in the sense of a castrating and limiting law that puts constraints onto the subject, but in the sense of a spirituality shared by all members of the community. Whereas in the first reading the focus was on finding one's self, here the focus is on finding one's place within community. Hence, the scene of circumcision in *Hamam* is significant: in the East people are properly 'castrated', their entry into a given community is properly marked and secured. As such, the film is a critique of Western individualism and materialism, a tribute to community life. The lack of symbolic castration in the West only creates anxiety and insecurity, whereas it works successfully in the East, which is why it is, with its outstanding communitarian structures, a place of tranquillity and comfort.

Again, the structure is redoubled in the relationship between Francesco and Marta. After Francesco's death, Marta and Francesco are reconciled, and their love culminates in the acceptance of each other's fantasies. The reconciliation is marked by Marta's acceptance of Francesco's wedding ring, which she is offered after his death. Francesco and Marta, so to say, 'marry' a second time, re-establishing the symbolic bond between them, and signalling the transcendence of difference. What we have here is the image of pure love, of two becoming one, just as community members become one by transcending their antagonisms.

We must, however, be critical towards this reading, too. Ernesto Laclau has stated that "society does not exist".[67] Not that Thatcher was right when she claimed "there is no such thing as society".[68] But 'society', as an image of a unity without antagonism, that is, society as one big individual continuously repeating some previously shown *aporia*, is an illusory idea; the 'social' is always already antagonistic. It is not easier to find one's place in the community than it is to find one's self.[69] The communitarian paradise is a melancholic construction.[70] It is something lost and mourned. *Hamam* mourns the loss of *Gemeinschaft* in the West. Žižek's discussion on the way Tibet (as Istanbul in *Hamam*) functions in the Western narrative is useful in highlighting this melancholia.[71]

What characterizes the European civilization is, on the contrary, precisely its ex-centered character – the notion that the ultimate pillar of Wisdom, the secret agalma, the spiritual treasure, the lost object-cause of desire, which we in the West long ago betrayed, could be recuperated out there, in the forbidden exotic place. Colonization was never simply the imposition of Western values, the assimilation of the Oriental and other Others to the European Sameness; it was always also the search for the lost spiritual innocence of OUR OWN civilization.[72]

We are again within the domain of ideology. The Orient, Istanbul or Tibet, works as a fantasy space that conceals the antagonistic character of 'society'. Fantasy enables a melancholic attitude in which a lost paradise is mourned. In a similar way, the relationship between Marta and Francesco is a failure until Francesco's death. The film repeats the grand old Hollywood cliché in which the partners are reconciled just before the death of the beloved.[73] Marta has to lose Francesco in order to realise their love as pure, as given without conflicts, cheating and perverse fantasies.

Now, having demonstrated two different readings organized around the categories of the imaginary and the symbolic, let us develop a third one by focusing on the concept of the real. Here, a central question is this: are the Orientalist fantasies of *Persian Letters* and *Hamam* really the same? Yes and no. They are the same but they work in different ways. Montesquieu's fantasy was hidden and censored; as such it reflected Montesquieu's split personality. The contemporary Orientalist fantasy is, in contrast, neither hidden nor censored. There is nothing to transgress; everything is already seen and approved. We are today not facing a strict superego bombarding us with demands and prescriptions, but rather an imperative to enjoy, as illustrated in the critique of Western Buddhism.[74]

Yet, paradoxically, the lack of censoring weakens the hold of fantasy rather than the other way around. The worst thing that can happen to fantasy is to realize it. When realizing a fantasy, what previously seemed sublime becomes just one more trash object. *Hamam* displays a nostalgic attitude that also reflects the anxiety related to loosing the Orient as a fantasmatic frame. A scene in the film is telling. Both Francesco and Marta, on different occasions, visit a ravished house in the old part of Istanbul. What is interesting is that its missing parts make a 'void' visible.[75] Focusing on this scene, one could argue that the critical twist of the film lies in

showing that behind the fantasy of the Orient there is merely a void. Let us now focus on this void by using the Lacanian concept of 'the real'.

Four Heroines

As we have seen, Francesco's death is a prerequisite for the symbolic marital bond. Ultimately Marta comes to love what she has lost. However, *Hamam* is not as melancholic as it is tragic. Indeed, Marta could be compared to a classical Greek heroine, Antigone. She seems to have gone beyond any desire. While Francesco becomes 'like a son' in the Turkish family, she remains a stranger. She comes to occupy Madame's position, which is why she, in the final scene, stands alone on the roof of the hamam. The difference between Francesco and Marta can be illustrated if we compare the two smoking scenes. Francesco and Mehmet are smoking together; Marta is alone. Francesco and Mehmet are making love in the hamam while Marta is standing on the rooftop, gazing the Oriental panorama. After being transformed into the new Madame, Marta becomes a kind of asexual being; living alone, as a stranger, embodying an a-social drive beyond the socially mediated desire.

Marta has sacrificed herself to fulfil Francesco's project. We should here distinguish between two kinds of sacrifice. The first aims at securing one's position within the symbolic: one sacrifices oneself for the good of a community and in return gets a place in it. In contrast, the second sacrifice aims at sacrificing this very place within the symbolic. It is, as such, sacrificing the sacrifice itself, accepting condemnation by and exclusion from the community. Antigone is a good example. She undertakes a mad, suicidal act burying her brother, Polyneikes, who has been condemned as an enemy of the city and hence denied burial. Antigone buries him, forcing Creon to punish her by imprisoning her in a cave with just as much food needed in order to survive. In this, Antigone comes to occupy the position of the neither dead nor alive. Is Marta a modern Antigone? She sacrifices her life in Rome in order to bury her husband and she stays in Istanbul to make sense of his heroic act, which is her sacrifice. Neither Antigone's nor Marta's space is, as in Hegel, given within the symbolic; it is not that of a 'family-ethics' but rather, they occupy a non-place, that of the real:

In Hegel, the conflict is conceived as *internal* to the socio-symbolic order, as the tragic split of the ethical substance ... Lacan, on the contrary, emphasizes how Antigone, far from standing for kinship assumes the limit-position of the very instituting gesture of the symbolic order, of the impossible *zero-level* of symbolisation, which is why she stands for death drive. While still alive, she is already dead with regard to the symbolic order, excluded form the socio-symbolic co-ordinates.[76]

The concept of drive is crucial in this context. Drive enables desire to break out from the framework of fantasy, which freezes the metonymy of desire in fixed coordinates. Thus drive is disruptive. Death drive is Freud and Lacan's prime example. Lacan states that suicide is the only successful act, as it is the only act through which the subject undergoes a radical change. Suicide here does not have to be taken literally. Death drive is the force enabling the subject to redefine oneself, to be reborn, as somebody else: 'I finally feel I can start again'. 'Suicide' is not mere *action* (conditioned by a symbolic space) but an *act* (destroying this space and the fantasy that sustains it). Accordingly, the final scene of *Hamam* is not about desire or enjoyment, but about drive. Here, to use Lacan's phrase, Marta 'goes through fantasy'. This transition is not from the symbolic to the imaginary or from the imaginary to the symbolic as indicated in the first two readings but towards the real. Marta does as Antigone did: she has a debt to be paid and she pays it with her 'life'. She uncouples herself from the symbolic and accepts a process of subjective destitution. The space beyond fantasy is a non-space, the place of death. Marta comes to occupy such an impossible position. She invites us, the audience, to repeat her gesture, going through our fantasies.[77] This reading transforms the narrative of *Hamam* to a Greek tragedy: could one think of a better way to dissolve the fantasy space of the Orient than situating it in ancient Greece?

However, we have to be precise when describing 'going through fantasy'. Crucially, the fundamental move in this respect is not to rearrange signifiers but to uncover the economy of desire and enjoyment underlying the Orientalized images. There is no way out of fantasy, no other space, for what is beyond fantasy is a void. Identity is basically about covering, hiding, this void through fantasy; hence dissolving fantasy brings with it the dissolution of the symbolic structure (and thus the identity) sustained by fantasy. Which is also to say that Europe will always have its 'Orient'. It can be situated anywhere. The critique of fantasy and ideology is therefore an

endless process; we are urged to tarry with the negative despite that it is an infinite task. Still, we have to insist on it:

> Although ideology is already at work in everything we experience as 'reality', we must none the less maintain the tension that keeps the *critique* of ideology alive. Perhaps, following Kant, we could designate this impasse the 'antinomy of critico-ideological reason': ideology is not all: it is possible to assume a place that enables us to maintain a distance from it, *but this place from which one can denounce ideology must remain empty, it cannot be occupied by any positively determines reality –* the moment we yield to this temptation, we are back in ideology.[78]

Is this impossible space also the space occupied by Marta in the final scene? Does Marta transcend the symbolic frame or does the final scene merely confirm her inscription into it? Is it Marta or, rather, the narrator who comes to occupy the impossible space of the real? To be able to read the Orientalist discourse critically, one must insist on the existence of a 'female' drive beyond the socially mediated desire, be it Marta's or the narrator's drive. It is from this place that a new, critical story can unfold, dissolving the stereotypes about Europe's others. Not to replace them with more 'true' identities, but to highlight their fantasmatic status. It is only in this sense possible to articulate a critical project through an economy of letters, that is, from within the symbolic order.

Reading *Hamam* as a Greek tragedy, one could similarly read Roxane in Montesquieu's letters as a female heroine who breaks the spell of fantasy. Such a reading is characterized by the intention of giving women a voice and insists on subverting the male-dominated power relations. Men install and control the symbolic space and the economy of letters; the female heroine is the one who challenges this monopoly.[79] Katie Trumpener writes, "[t]he women in the seraglio are punished and controlled by the interception of 'leurs paroles les plus secrètes', by enforced silence, by not being allowed to speak to one another or to write letters".[80] Following this, Usbek's "letters of instruction and command are intercepted or lost or reach the seraglio only to sit unopened and unheeded for months of time", while his wives "have begun to carry on their own correspondence with the outside world: a mysterious letter, of which the chief eunuch can guess neither the author nor the intended recipient, circulates clandestinely in the seraglio".[81]

Criticizing the dominant economy of letters that circulate between

West and East, one must search for a new economy. It will be a new because there is no way to escape the symbolic order, only a moment of death, sacrifice, and revolution. Inge E. Boer criticizes Grosrichard for merely repeating the Orientalist fantasy of the almighty sultan, the effeminate subjects, and she searches for another voice from within the harem.[82] Grosrichard's work is, concomitantly, written from the despot's point of view.[83] The point is well taken, although Boer seems to be unaware of the crucial twist at the end of Grosrichard's book where he describes the power of the subjects, their secret language and the Sultan's mother, the real ruler.

Boer mentions Lady Mary Wortley Montagu's *Turkish Embassy Letters* (1717–1718) as an example of a female narrative from within the harem. The lady stresses that the veiling of the woman protects them from being looked upon and allows for masquerade and free movement.[84] To end with, let us consider one of her letters:

> It is very easy to see that they have more liberty than we have, no woman of what rank so ever being permitted to go in the streets without two muslins, one that covers her face all but her eyes and another that hides the whole dress ... You may guess how effectively this disguises them, that there is no distinguishing the great lady form her slave, and it is impossible for the most jealous husband to know his wife when he meets her, and no man dare either touch or follow a women in the streets ... the perpetual masquerade gives them entire liberty of following their inclinations without danger of discovery.[85]

There are specific female spaces, which cannot be invaded by men, and in which women enjoy more privileges than in the West.[86] The harem "is not merely an Orientalist voyeur's fantasy of imagined female sexuality: it is also a possibility of an erotic universe in which there are no men, a site of social and sexual practices that are not organized around the phallus or a central male authority".[87] Boer mentions the braiding of hair as a countering of the Despot's gaze. The braiding of hair is a secret female way of communicating and a specific female enjoyment.[88] It is a counter institution to the coffeehouse, which serves as a male forum for discussion, information exchange and male bonding.[89] But at the same time, these practices do, as in the story of Roxanne, bear the zeal of death. It is a focus of critique, which however can only be articulated in a negative way.

Sending a Letter

We have argued that the Orientalist imagery is sustained through psychic investment. Therefore the fantasy of the Orient is not dissolved merely through critique that shows the contingency of articulation. Everybody knows that the image of the Orient is a semblance, but they still enjoy it; a cynicism is at work in Orientalism. We do know that Montesquieu's letters are only literature or that Ingres never visited the Orient. But still we insist on these images. How can we explain the moderate success of Said's intervention otherwise? Why are we still insisting on the Orientalist discourse even though Said has already shown it to be fictitious? The answer is enjoyment. The image of the Orient works as a zero-institution enabling desire to proliferate in a smooth space.

The psychoanalytic reading de-territorializes the distinction between the self and the other, between West and East. It is not a difference between two poles within the same symbolic space, but between the two sides of the social bond. The symbolic is always supported by a dark downside, by fantasies of transgression and of unlimited enjoyment, working as the image of a degree-zero of civilization. We find this downside set in motion everywhere: in popular culture, in Saddam's 'despotic' power, in the fundamentalist threat, in 'Balkan barbarism', in the political debate on immigration, foreigners, ghettoes, and so on. Likewise, the fantasy of the East is at work everywhere, in diplomacy, warfare, and intercultural exchanges: like letters.

The discourse on the self and the other within, cultural studies and other neighbouring disciplines is still caught up in a fascination of the Orient, the avoidance of which can only take place by going through fantasies. It is necessary to supplement discourse analysis and semantic interventions with an analysis of fantasies operating in them. Relating *Hamam* to other narratives of female heroines, we constructed four attempts to go beyond the zero-institution of the Orient. We read the film as a meta-narrative and as a tragedy. In doing so, we focused on drive and sacrifice.

To conclude, there is no escape from the circulation of letters, the flowering of desires and the staging of enjoyment in fantasies, but there is a responsibility to make an attempt at installing a new economy of letters less violent than the old ones.

1 The full title of the film is *Hamam: The Turkish Bath*. It occasionally carries the titles 'Steam' or 'The Turkish Bath'. The film is an Italian-Turkish-Spanish co-production by Sorpasso Film (Rome), Promete Film (Istanbul), and Asbrell Production (Madrid) in collaboration with Rai Radiotelevisione Italiana. Ferzan Özpetek has directed the film; Stefano Tummolini and Ferzan Özpetek have co-written the screenplay.

2 Charles de Secondat Montesquieu, *Persian Letters*, London: Penguin, 1973 [1721].

3 For a survey of this literature, see Iver B. Neumann, *Uses of the Other: 'The East' in European Identity Formation*, Minneapolis, MN: University of Minnesota Press, 1999, pp. 1–38.

4 This rescue fantasy – 'without the beneficial imperialism of the West, the cultural heritage of the Eastern countries would have been destroyed' – is also present in films like *Indiana Jones*, the *Mummy*-series and in the *Raiders of the Lost Ark*.

5 Compare, Slavoj Žižek, *The Ticklish Subject: The Empty Center of Political Ontology* London: Verso, 1999, pp. 215–21 and Slavoj Žižek, *On Belief*, London: Routledge, 2001, p. 69.

6 For an account of the role of sexuality in Western films on the Orient, see Ella Shohat: "Gender and Culture of Empire: Toward a Feminist Ethnography of Cinema", in *Visions of the East: Orientalism in Film*, eds. Matthew Bernstein and Gaylyn Studlaw, New Brunswick: Rutgers University Press, 1997, pp. 19–68.

7 Alain Grosrichard, *The Sultan's Court*, London: Verso, 1998, pp. 141–46.

8 Ibid., pp. 36–40.

9 Charles de Secondat Montesquieu, *The Spirit of the Laws*, Cambridge: Cambridge University Press, 1989 [1748].

10 Mary McAlpin, 'Between Men for All Eternity: Feminocentrism in Montesquieu's Lettres Persanes' in *Eighteenth-Century Life* 4, no. 1 (2000): p. 55.

11 Ibid., p. 45.

12 Jacques Derrida, *The Post Card: From Socrates to Freud and Beyond*, Chicago: University of Chicago Press, 1987 [1980].

13 This point will be qualified later. See Jacques Lacan, 'Seminar on "The Purloined Letter"', in *The Purloined Poe*, eds. John Muller and William J. Richardson, Baltimore, MD: Johns Hopkins University Press, 1988, pp. 28–54.

14 Jacques Derrida, *Glas*, Lincoln, NB: University of Nebraska Press, 1986 [1974].

15 For a deconstructive reading of Montesquieu focusing on postal politics, see Geoffrey Bentington, *Legislations. The Politics of Deconstruction*, London: Verso, 1884, pp. 240–258.

16 Betts, 'Introduction', p. 19.

17 Ibid., p. 18.

18 The book was, not unexpectedly, included in the Vatican's list of prohibited books. Ibid., pp. 18–19.

19 Kaiser, "The Evil Empire?", p. 16.

20 Mary McAlpin, "Between Men for All Eternity", p. 50.

21 The famous letter 11–14 of Montesquieu's *Persian Letters* (containing the fable of the Troglodytes) is a critique of Hobbes. The unrestrained pursuit of self-interest leads to the destruction of the whole valley. The story is intended to illustrate for the reader the contours of a virtuous life.

22 Montesquieu, *Persian Letters*, letter 114, pp. 206–08.

23 Ibid., letter 116 & 117, pp. 209–13.

24 Katie Trumpener, "Rewriting Roxane: Orientalism and Intertextuality in Montesquieu's Lettres Persanes and Defoe's The Fortunate Mistres", *Standford French Review* 11, no. 2, 1987: p. 180.

25 C.J. Betts, 'Introduction' in Montesquieu, *Persian Letters*, London: Penguin, 1973, pp. 26–27, Grosrichard: *The Sultan's Court*, pp. 26–27.

26 Edward Said, *Orientalism: Western Conceptions of the Orient*, London: Penguin, 1978.

27 Thomas Kaiser, "The Evil Empire? The Debate on Turkish Despotism in Eighteenth-Century French Political Culture", *The Journal of Modern History* 72, March, 2000: pp. 6–34.

28 Grosrichard, *The Sultan's Court*.

29 Ibid., pp. 85–119; Rebecca Joubin, "Islam and Arabs through the Eyes of the Encyclopédie: The Other as a Case of French Cultural Self-Criticism", *International Journal of Middle East Studies* 32, no. 2, 2000: pp. 197–217.

30 See letters 4 and 20, Montesquieu, *Persian Letters*.

31 See letters 79 and 96. Ibid.

32 Grosrichard, *The Sultan's Court*.

33 Said, *Orientalism*.

34 Homi Bhabha, "The Other Question", *Screen* 24, no. 6, 1972: pp. 18–36.

35 Letter 161, Montesquieu, *Persian Letters*,.

36 Letter 156, Ibid., pp. 276–77.

37 Letter 161, Ibid.

38 Iver B. Neumann and Jennifer M. Welsh, "The Other in European Self-Definition: An Addendum to the Literature on International Society", *Review of International Studies*, 17, 1991: pp. 329, 331, 334. Methodologically, most scholars map different aspects of self-other relations. Quite a few are inspired by Tzvetan Todorov's distinction between the axiological, the praxiological and the epistemic level: see, Neumann, *Uses of the Other*, 21 and Lene Hansen, *Security as Practice*, London: Routledge, 2004.

39 Grosrichard, *The Sultan's Court*.

40 Grosrichard, *The Sultan's Court* and Trumpener, "Rewriting Roxanne".

41 Grosrichard, *The Sultan's Court* and Boer, "Despotism form Under the Veil", p. 46.

42 Žižek, "The Feminine Excess", p. 93.

43 Grosrichard, *The Sultan's Court*, pp. 137–38.

44 Slavoj Žižek, *The Sublime Object of Ideology*, London: Verso, 1989, p. 125.

45 This example is discussed in Slavoj Žižek, "Class Struggle or Postmodernism? Yes Please!" in *Contingency, Hegemony, Universality. Contemporary Dialogues on the Left*, ed., Judith Butler, Ernesto Laclau and Slavoj Žižek, London: Verso, 2000, pp. 90–135 and Slavoj Žižek, "Introduction. The Spectre of Ideology" in *Mapping Ideology*, ed., Slavoj Žižek, London: Verso, 1994, pp. 25–26.

46 This temptation is of course the one that poststructuralist IR cannot resist.

47 Žižek, "Class Struggle or Postmodernism?", pp. 112–113

48 Ibid., p. 113.

49 Ibid.

50 Boer, "Despotism from Under the Veil", p. 47.

51 Jacques Lacan, *Écrits: A Selection*, London: Routledge, 1977 [1966], pp. 146–78.

52 Žižek, "Introduction: The Specter of Ideology".

53 Ibid., p. 17.

54 Žižek, "Class Struggle or Postmodernism?", p. 113.

55 A third level is a functional analysis of who or what these ideological fantasies serve, Laustsen and Wæver, "In Defence of Religion".

56 Fredric Jameson, *The Ideologies of Theory: Essays 1971–1986*, vol. 2, *Syntax of History*, Minneapolis, MN: University of Minnesota Press, 1988.

57 Slavoj Žižek, *Enjoy Your Symptom: Jacques Lacan in Hollywood and Out*, London: Routledge, 1992.

58 Louis Althusser, "Ideology and Ideological State Apparatuses: Notes Towards an Investigation", in *Lenin and Philosophy and Other Essays*, London: NLR Books.

59 Barbara Johnson, "The Frame of Reference: Poe, Lacan, and Derrida", in *The Purloined Poe: Lacan, Derrida & Psychoanalytic Reading*, eds., John P. Muller & William J. Richardson, Baltimore, MA: The John Hopkins University Press, 1988, pp. 213–251.

60 Edgar Allan Poe, "The Purloined Letter" in *The Purloined Poe*.

61 Jacques Lacan, *Le Séminaire: livre XX, Encore, 1972–73*, Paris: Seuil, 1975, p. 58.

62 Ibid.

63 Lacan, *Ècrits*, p. 1–7.

64 Althusser, "Ideology and Ideological State Apparatuses".

65 Jacques Lacan, *Télévision*, Paris, Seuil, 1973, p. 60.

66 Žižek, *On Belief*, pp. 12–13.

67 Slavoj Žižek, "Beyond Discourse-Analysis", in *New Reflections on the Revolution of Our Time*, ed., Ernesto Laclau, London: Verso, 1990, pp. 249–60.

68 Quoted from *Woman's Own*, 31 October 1987.

69 For a critique of Althusser's concept of subject position, see Mladen Dolar, "Beyond Interpellation", I *Qui Parle* 6, no. 2, 1993: pp. 75–96.

70 A common theme in Orientalist films is the search for a lost origin of the West in the East, or a search of a lost civilization prior to Western contamination. See Shohat, "Gender and Culture of Empire", pp. 25–26.

71 For a discussion of melancholia and fantasy, see Slavoj Žižek, *Did Somebody Say Totalitarianism? Five Interventions in the (Mis)Use of a Notion*, London: Verso, 2001.

72 Ibid., pp. 67–68.

73 In Žižek's narrative, the prime example is Titanic where "the iceberg catastrophe helps us to sustain the illusion that if the iceberg had not hit the ship, the couple would have lived happily ever after". Slavoj Žižek, "The Thing from Inner Space", in *Sexuation, SIC 3*, ed. Renata Salecl, Durham, NC: Duke University Press, 2000, p. 223. See also, "Hallucination as Ideology in Cinema", *Politologiske Studier* 4, no. 3, 2001: pp. 17–25.

74 Compare Bülent Diken and Carsten Bagge Laustsen, 'Enjoy your Fight! – "Fight Club" as a Symptom of the Network Society', in *Cultural Values*, 6, no. 4, 2002.

75 In other cases, the film tries to conceal this gap by focusing exclusively on the old parts of the city.

76 Žižek, "The Feminine Excess", p. 101. Italics added.

77 Thus, in the final scene, and for the first time, the camera identifies with Marta's gaze and invites the spectator to identity with it too.

78 Žižek, "Introduction: The Spectre of Ideology", p. 17.

79 Grosrichard, *The Sultan's Court*, pp. 63–67.

80 Trumpener, "Rewriting Roxane", p. 184.

81 Ibid., p. 185.

82 Boer, "Despotism From Under the Veil", pp. 51–55.

83 Ibid., p. 53.

84 Ibid., p. 56.

85 Robert Halsband, ed., *The Complete Letters of Lady Mary Wortley Montagu*, vol. 1, London, Oxford University Press, 1965, pp. 96–97.

86 Boer, "Despotism From Under the Veil", p. 57.

87 Lisa Lowe, *Critical Terrains: French and British Orientalisms*, Ithaca, NY: Cornell University Press, 1991, p. 48. Quoted in Boer, "Despotism From Under the Veil", p. 59.

88 Ibid., p. 61. Others have emphasized the role of signing as a secret way of communicating among mutes and dwarfs that escapes the gaze of the Sultan. M. Miles, "Signing in the Seraglio: Mutes, Dwarfs and Gestures at the Ottoman Court 1500–1700", *Disability and Society* 15, no. 1, 2000: pp. 115–34.

89 Boer, "Despotism From Under the Veil", p. 64.

THE PERIPHERAL INSIDER: DE-PRESENTATION?
On Antimigration Sentiments and the Crisis of Post-colonial Critique

ANDERS MICHELSEN

We live in one global environment with a huge number of ecolog-
ical, economic, social, and political pressures tearing at its only
dimly perceived, basically uninterpreted and uncomprehended
fabric. Anyone with even a vague consciousness of this whole is
alarmed at how such remorselessly selfish and narrow interests
– patriotism, chauvinism, ethnic, religious, and racial hatreds –
can in fact lead to mass destructiveness. The world simply cannot
afford this many more times.
Edward Said

1. The Peripheral Insider: De-presentation

The notion of the 'peripheral insider' points, of course, to the negotia-
tions endemic to present day globalization and its flux, migrationally and
otherwise. That is, to the idea of globalization as an encounter of an inside
with an outside by way of deterritorializations of people, matter, culture,
art etc. However, I want to ponder, in this paper, whether this notion may
imply, also – and presently a principal contestation of 'encounter' as such:
the emergence of *antimigration sentiments*. To be 'peripheral insider', that
is, to be *subjected to*, or conversely, to be the *subject of* this state may indi-
cate a dwindling of encounter, a principal weakening of conditions for *mi-
gration as such*.

The peripheral insider may be seen as an adequate term for position-
ing the flux of migration, and the implicit prospects of a thus dedicated
position within a system, whether a 'world system' or a system of meaning
in some capacity. But it is also a contradiction in terms: inscribed in the
predicament of being *inside* while being *rendered peripheral*, allowed some
meaning inside but only *from* the periphery. While this may be the condi-
tion of any form of migration – that is the condition of displacement, hy-
bridity and so forth – the "unique double vision" (Edward Said) of the mi-
grant, the peculiarities of the peripheral insider should, perhaps, be seen
less as the given regime of contestation habitually theorized in post-co-
lonial critique, and more as open to different forms of contestation. The
peripheral insider wittnesses a stranger form of limbo: this positioning
seems increasingly to be inscribed *not* in a re-definitory prospect, but in a
crisis of the regime of post-colonial critique.

In the post-colonial critique of Homi K. Bhabha the migrant position
is taken to be an interstice principally implicating a "non-synchronous,

incommensurable gap"[1] situated by way of the "beyond" of "border lives"[2] – a "double narrative movement",[3] a dis-semi-nation[4] in the narration of the Western nation conditioning "cultural contestation",[5] and emerging as a "difference". That is, a resetting of culture by way "of cultural knowledge that 'adds to' but does not 'add up' …".[6] Gayatri Spivak argues that migration, "large scale movements of people – renamed diaspora – are what defines our time".[7] To her, the diasporic migrant is a "resident alien" caught up in a heavy intertextuality of migration, which foregrounds "excentricity" as a cultural option for systemic deconstruction, that is, also, systemic change and virtuality as expressed in large scale cultural events like the art exhibition *Documenta 11*, Kassel 2002, implicating hybrid, disseminative – excentric – regimes of meaning.

Spivak emphasizes that "the new African, Asian and other 'diasporas' connect globally in unprecedented ways".[8] She reproaches Derrida for not seeing the wholly reconstitutive moment of diasporic alterity:

> Derrida has opened hospitality into teleopoiesis – a structure touching the distant other that interrupts the past in the name of the future rupture that is already inscribed in it. But his specific figurations remain named arrivant or revenant, arriving or returning. The figure of the Resident Alien is excentric to this dynamic.[9]

But one has to question whether this really adds up to the state of the migrant today. Is large scale movement of people really what characterizes current globalization? Or is the form of excentricity Spivak argues for – the "diasporas" connecting "globally in unprecedented ways" – increasingly the impetus for a polity in the reverse? Is globalization marked by attempts at curbing or restricting migration within a different systemic moment, somehow complicit with the by now broadly assumed "massive shake out" and "transformationalism" (Held et.al.)[10] of globalization? Or in a wider perspective, is the "(im)possible perspective of the native informant" Spivak builds her wider cultural theory upon,[11] rendered increasingly impossible as "reminder of alterity".[12]

In this paper antimigration sentiments – debated primarily as a problem of the West but for sure emerging in other parts of the globe as well – is taken to point to a *denial* of heightened global interdependence in Said's sense of environment, leaving the regime of post-colonial critique in an *impasse* between Western triumphalism, e.g. Francis Fukuyama's post-hegelianism, and what we may term 'fundamentalism' of a new order ne-

gotiating this heightened global interdependence. What is increasingly left out seems to be exactly the option of deconstruction, of 'sign on sign' – of signified alterity, etc. – to the advancement of something else, contesting in a wider sense the heritage of critical thought in the postwar era, in particular, perhaps, when based on 'French post-structuralism'.[13]

One may, of course, view antimigration sentiments of the West as yet another growl of the inhuman voices of our "respective ancestors" as Frantz Fanon characterized racism.[14] However, they appear to me to be quite different, even if they may relate to new forms of xenophobia.[15] In racism, to put it short, the 'racial other' must be represented in some capacity. However, current antimigration sentiments (and of course, from different perspectives and in other contexts, in other parts of the world, left out of the debate here) seem to have a simpler solution: to *deny the migrant*, to re-create the world as if migration was non-existent, to conceive the world from a position beyond the 'beyond' of post-colonial critique, that is, to dispute the very idea of a global environment. That is, denial of large scale movement, of diaspora, of native informant, by way of a reconstituted system along the lines of Samuel P. Huntington's and others' notions of cultural homeostasis *by way of* separation of civilizations:[16] to put it short, by *de-presentation* of the *resident* alien at root. This is what I find unsettling in a notion like 'peripheral insider': *not* another variation of cultural critique but, *on the contrary*, a lurking dismemberment of "interstice" to the advance of a wholly *different location* of a system.

My hypothesis of de-presentation implies a debate on the nature of signification, that is, on the nature of representational signification. Mainstream cultural studies – and much cultural critique – today teach meaning *cum* sign-system, e.g. as the enacted representational signification of meaning-generative power-knowledge regimes which may be negotiated, opposed or re-defined by "signifying practice",[17] as an introduction by Stuart Hall argues. However, I want to analyse antimigration sentiments in terms of representational signification by focusing on a possible 'antepredicative' level of signification that takes post-colonial critique into a beyond, not stipulated in the re-definitory prospect. That is, as it were, to a 'beyond' of alterity, excentricity, (im)possibility – 'decoding'– of system. From this prospect follows not only unfolding of crisis but a *different ontological perspective* on signification.

Rasheed Araeen may be right to dismiss the contestations of the assumed multicultural West – e.g. in antimigration measures – as yet another failure of the West to commit to its own enlightenment values.[18] But

I think he is missing a more revealing problem, which pervades far larger parts of the global environment, as Said envisions. In so far antimigration sentiments are more than a passing whim of postmodern constituencies, they may well be seen as the attempt at 'tearing with the global fabric', displaying a different moment of signification, in the sense of what Cornelius Castoriadis terms the "imaginary institution of society",[19] instituted as an ontologically creative form of the human *ex nihilo*, appearing antepredicatelively to representational signification, e.g. as a flux of "presentations:"[20] what Castoriadis bluntly terms "… self-creation deployed as history".[21] Thus the intersection between antimigration sentiments and self-creation may point not only to possible imports of the peripheral insider but, equally important, to new ways of understanding globalization as meaning, in some capacity.

The concern of the paper is thus to use an alleged crisis of the regime of post-colonial critique as an entry to the following thesis: (1) antimigrations sentiments is a social form of signification liaisoned with globalization by way of specific processes of de-presentation, which may moreover be defined as a new form of creativity; (2) this may be conceived of in a theoretical framework relying on Castoriadis notion of self-creation. In the following this thesis will be treated in two entries: First, "Antimigration Sentiments: Self-assertion, in Denmark". In this section, I will introduce an interpretation of antimigration sentiments by debating what I will call the cultural self-assertion of the populist Danish People's Party. Second, "Constraints: De-presentation and Presentation". Here, I take a closer look at this self-assertion as a form of de-presentation complicit with presentation, pointing to self-creation and imaginary closure as a modality of an implosive world system.

2. Antimigration Sentiments: Self-assertion, in Denmark

In a newspaper feature article from 1991, Jørgen Ørstrøm Møller, former state secretary to the Danish foreign ministry and Danish Ambassador to Singapore, Brunei Darussalam, Australia and New Zealand, suggested to counter Danish defiance of the European project by adopting culture as a *strategy*: a "Model Europe".[22] Even if Ørstrøm Møller may not see his point this way, he in fact proposed to see culture as a mitigation of the alleged economic and political realities of globalization (and regionalization).[23] No matter what e.g. the European Union might take away from

the Danes, the argument seemed to go, they would be allowed to preserve their culture. Put differently: the Danes might be allowed a cultural refugium which would cause no harm to the mandatory context of political and economic globalization.

While there may be real grounds for Danes' worry about outside pressures, for instance in relation to Danish welfare, Ørstrøm Møller's "Model Europe" has trickled down strangely to many Danes, notwithstanding the hazy implications of the term Danish *culture* for the average 'postmodern' Dane. Throughout the 90s many Danes have embraced culture as a first line of *internal* defence against a malign *external* world, whether originating in Brussels or Baghdad. To paraphrase a Danish saying after the loss of southern Denmark to Germany in the catastrophic war of 1864: 'what is lost to the outside must be gained from the inside'; i.e. what is lost to external pressures must be gained by strengthening the Danish way of life, or as it goes, 'Denmark for the Danes'. However, while the internal expansion in the 19th century was directed towards barren moors in the provinces of Jutland which were to be cultivated by large scale engineering, the target of the new 'internalism' is quite different.

Mediated by the Danish People's Party,[24] 'culturalization' of Danish defiance has produced one of the most succesfull antimigration campaigns in the West, which should be measured not only on the various attempts at curbing 'ordinary' migration – guest workers as it went in the 1970s – but by a *lurking de-commitment* to global exchange by way of separation of civilizations. While maintaining a commonsensical image, in contrast to similar parties in France and Austria, one may argue that this campaign has de facto managed to turn Huntington's "clash of civilizations" into clever everyday politics. Even if the party may be seen within the spectrum of classic political strategy, e.g. it appeals to mass sentiments, stigmatization, rally around a charismatic leader, "Pia" (Pia Kjærsgaard), the party's primary raison d'etre is culture, embedded in a *self-assertion* of life forms, customs, traditions, religion etc. of a Danish nature. In its Program of Principles the party states that "the country is build upon the Danish cultural heritage and Danish culture must therefore be preserved and strengthened",[25] and moreover, that "culture consist of the sum of the Danish people's history, experiences, faith, language, and customs".[26] In the party's "Working Program" it is stated,

> The Danish People's Party will work to increase the understanding that any society's development is determined by the total content of

its culture, and we want to counteract any attempt to create a multicultural or multiethnic society in Denmark, that is, a society where a considerable part of the population adheres to another culture than ours. To make Denmark multiethnic implies that the development of hostile and reactionary cultures will destroy our so far stable, homogeneous society.[27]

In the Summer of 2003 the Economist[28] described the antimigration policy of the new liberal gowernment secured by the party's backing as a "range of petty and illiberal rules"[29] and quotes the prime minister Anders Fogh Rasmussen for acknowledging that "in principle we have an immigration stop".[30] The paper wrote:

Mr. Fogh Rasmussen and his Liberals need the support of Ms Kjaersgaard's party in parliament, so the government has had to adopt many of her policies on immigration. Danes are less concerned about political correctness and more inclined to speak their minds than their Swedish neighbours. Many of them openly call themselves racist.[31]

In the summer of 2003 Pia Kjærsgaard, quite unprecedented in Denmark, attacked the Danish Supreme Court for making political judgments when the court ruled that it is not unlawfull to characterize her standpoints as racist in a situation where she identifies a singular migrant with the migrant community as a whole.[32] Pia Kjærsgaard argued that the ruling of the Supreme Court was "utterly wrong, utterly unjust, and utterly political",[33] and she compared the ruling to former East European totalitarianism.[34] She denounced several judges by name[35] and made clear that while she took the verdict ad notam, she refused "to take it seriously".[36] At the same time a leading strategist in the party, MP Peter Skaarup, stated his satisfaction with the silencing of views defending migration, e.g. from NGOs and human rights groups: "In comparison with earlier times, the political work has become easier because there are viewpoints which have been driven back. We can work more uninterrupted in the direction of what we want".[37]

Despite the debate provoked by Kjærsgaard's critique of the Supreme Court during the summer 2003,[38] it is fair to say that apart from scattered opposition, e.g from NGOs such as the Danish Refugee Council, the average public reaction in Denmark has been one of deception or indifference,

or *de facto* support. The centre-left Social Democratic Party has engaged further and more substantially in antimigration measures,[39] and the Danish left is more or less silent. Nevertheless, the Danish People's Party is most often seen as yet another form of passing populism, a political trend judged by the Economist as "toxic but containable".[40] Notwithstanding more than three decades persistence of similar or related political trends (a sort of predecessor party, the Progress Party appeared in 1972), the trend is still often seen as merely another repercussion of postmodern politics based on fluid and mediated 'simulacroid' constituencies. A mounting international critique of alleged Danish xenophobia and racism by among others the Council of Europe and the Centre for Research of Racism and Xenophobia has been received without much effect.[41]

Today the public debate in the country is under the influence of antimigration statements, not only from the political right but also from former left wingers.[42] Even though immigration has significantly decreased in Denmark due to measures taken over several past decades, the real predicament lies in the apparant stability of antimigration sentiments, often stirred on the basis of problems related to resident migrants, e.g. second and third generations of resident families. One example: polls in the Summer of 2003 indicated that the Danish People's Party may keep its influence as long as it nourishes antimigration sentiments,[43] that is, the party is not based on anything passing, on political spin, but on *apparantly continuous beliefs*. Winter 2003, polls indicated this trend to continue. On the question, "How – in comparison with Poul Nyrup's government [the centre-left government of the 90s A.M.] – do you think the government has handled the economic policy, unemployment, the environment, migration policy, foreign pollicy",[44] migration policy scores "better/much better" in 44% of the answers, as compared to 30% on foreign policy and 9% on unemployment: antimigration measures are seen as the government's most important achievement. Here we may discern the first contours of a crisis of a regime of post-colonial critique: the issue of immigration is increasingly unrepresentable to the Danish debate, and, not only, as Bülent Diken contends, shifting between "over-representation" and "under-representation".[45]

A paper published in 2002 by the Rockwool Foundation Research Unit[46] – one of the centers for research into issues related to immigration in Denmark – attempts to refute the foreign critique alltogether. A veteran analyst of public opinion in Denmark, Hans Jørgen Nielsen, argues that the "continuous stream of reports from international bodies criticizing

our attitudes to and treatment of foreigners"[47] critically fails to note the indication of what is *de facto* the opposite, falling hostility to foreigners among Danes. Nielsen underlines that his focus is not "the degree of tolerance in Denmark in absolute terms"[48] but a comparison between nationalities. To this end, he debates the quality of the information, methods, comparability and conclusions underlying the foreign critique under headings such as "The Problem with Data Quality" and "The Problem with Baseless Claims"[49] and argues that the problem of racism in a country like Denmark must be seen as complex.[50] He writes in conclusion:

> Xenophobia and the opposite can have different aspects, and the results from one area cannot simply be used in another. Still, conclusions can also be too cautious, and with consistent differences on mostly – if not all – questions and on most dimensions it is still possible to point at different tendencies. However, even in this perspective, the Danes are neither the most nor the the least xenophobic people in the European Union.[51]

Despite the pointed relativism of Nielsen's approach and his avowed counter-position to international critique, he is undoubtedly right in calling for caution. The question is, however, what caution? The situation in Denmark is perhaps not one of raging racism, but the question is whether, for one thing, a hypothesis of racism is the right context for an analysis at all, and, second, whether Nielsen really takes his own call for understanding "complexity" seriously. Nielsen alludes to this in some "speculations" appearing after the formal conclusion of the paper. He notes that the public debate in Denmark can be quite outspoken in comparison with other countries and in some cases biased[52] even though he argues in imprecise terms and does not detail, for instance, what it means in a wider perspective that statements made by right wing politicians in the Danish election campaign in 2001 "were rather vague"[53] (the campaign can be said to have resulted in a parliamentary breakthrough for the Danish People's Party).

Interestingly, he discusses the option of a possible "subtle" racist discourse appearing in "the reporting of events from the perspective of how they impact negatively on the host population, such as it is found in Finland and the Netherlands".[54] Nielsen finds, however, such an approach as unacceptable as the foreign critique: "With such a premise even the studies by the Rockwool foundation of the problems connected with the inte-

gration of immigrants into the labour market may be seen as having a racist flavour, and the normal political Danish debate even more so".[55]

One may say that behind Nielsen's "speculation" lies e.g. epistemological differences between empirically oriented interview-based surveys and analyses of the 'structuring' of negative "impact". Danes are perhaps not racist by stated conviction, for instance by *submitted statement* vis-a-vis a stated interviewer, they may not be racist or xenophobic by most standards, as Nielsen is right to emphasize. Nevertheless one may ask a *different* question of whether both the foreign surveys and Nielsen's critique are off the mark. Nielsen's dismissal, in "Speculations", of 'non-positivist' meaning as pertinent object for discerning racism may close the debate just as prematurely as the foreign critique does in his view. One may argue, perhaps somewhat unfair to Nielsen, that his argument is prone to a reasoning caught up in *de facto* affirmation of the Danes, for instance by an unacknowledged but shared bias of Nielsen's critical interpretation *and* the object of study.

Now, this argument may be substantiated by drawing on a political science oriented approach in one of the volumes from the research project "Magtudredningen. The Danish Democracy and Power Study", entitled *Er vi så forbeholdne? Danmark over for globaliseringen, EU og det nære* [Are we so reserved? Denmark facing globalization, EU and what is close] (2003)[56] where the problem of xenophobia and the prospect of a possible Danish fundamentalism (explicitly related to the Danish People's Party) are debated in a context of globalization termed "transnationalization".[57] The study is based on four theses of which especially thesis 3 and 4 are of interest to this paper.[58] Thesis 3 states that *"Under pressure from the historically sedimented system of norms in the population Denmark as a state has mainly chosen a defensive strategy when faced with globalization ..."*.[59] This norm system is determined by a constitutive relation between "qualitative superiority [merværd A.M.] combined with a quantitative – in terms of power – inferiority [mindreværd A.M.] which has been sedimented historically in the dominant norm system of the population".[60]

This lead to thesis 4 arguing that because of the norm system the Danish state has been forced to limit the impact of transnationalization in the Danish society, which will, consequently, suffer negative repercussions in the long term.[61]

The study's implicit commitment to the policing of "transnation-

alization" may of course be debated. Nevertheless it is an interesting attempt at dealing somehow with unquestioned imaginings of Danes and Danishness, in particular the idea of a culturally based "norm system". Cornelius Castoriadis's philosophy opts for a normative co-constitution of the "imaginary institution of society": norms of a given social and historical institution must be seen as integral part of self-creation; "it is the elaboration of a complete system of the world".[62] Thus for Castoriadis the instituting of society is *prima facie* valorized, it is impossible to conceive of society and history without norm, it is always-already normative.[63]

The imagination and the imaginary is an ontological conditioning of how "meaning", Castoriadis speaks of "signification",[64] arises for the human whether as individual or collective. Thus a historically "sedimented" norm system is constituted in the creative conditioning of the human as "strata of the real", it is the *condition*, and the *conditioning*, co-extensively. In a sense the creation of society may be compared to the creation of a poem, Castoriadis explains, even if such a comparison only serves to open the debate on a much larger and polymorph form of creativity: Stalin's camps are as creative as the Notre Dame, he adds.[65] To follow Castoriadis, "Social imaginary significations create a proper world for the society considered – in fact, they *are* this world ...".[66] He argues on this background for "ontological conversion"[67] by way of acknowledging the importance of creative imagination – the *imaginary* – hitherto mostly placed within the more or less narrow confines of the humanities, e.g. as the aesthetic, the ideological, or the psychoanalytic, or simply ignored ("occulted" in his terminology).[68] Anything that happens to be in the social and historical world, that is, shares in the "human strata of the real", is inconceivable without recourse to a 'defunctionally' defined imagination.[69]

At a principal level Castoriadis distinguishes between "two connotations" to be applied to the word "imagination", taken in the inherited sense (1) imagination as the formation of images – forms – in the most general sense, including this formation's connection with the idea of invention and creation, and (2) a "radical imagination" which is "*before* the distinction between 'real' and 'fictitious': ... it is because radical imagination exists that 'reality' exist *for us* – exists *tout court* – and exists *as* it exists".[70] On this redefinition Castoriadis builds his architecture of the "imaginary institution of society" relating to two principal issues: the psycho-somatic constitution of the imagining body and the social-historical constitution of the imaginary (and their interrelation e.g. by means of the 'subject') aligned to a number of problems, for instance thought, science, technol-

ogy and politics.[71] Most radically, by acknowledging a much extended role of the imagination and the imaginary, Castoriadis conceives of a wholly new form of organization, defined as a social and historical "magma" of significations, "a type of organization unknown until now ..." which nevertheless conditions signification. The radical imagination does not connote a constructivist theme but must be understood as a specific organization of the real, aligned with and taking its place in a larger reality. The notion of the magma serves the need to explicate the instituting of a social and historical world through creation, that is through significations that "do not correspond to, or are not exhausted by, references to 'rational' or 'real' elements because it is through a *creation* that they are posited"[72] and moreover only existing "if they are instituted and shared by an impersonal, anonymous collective":[73]

> ... the social imaginary significations in a given society present us with a type of organization unknown until now in other domains. This type is what I call a "magma". A magma contains sets – even an indefinite number of sets – but is not reducible to sets or systems, however rich and complex ...[74]

The imaginary constitution of the human world – the imaginary institution of society – thus takes the notion of creativity into a new realm. On the one hand the notion is drawing on ideas of creativity related to e.g. the imagination of the subject, which are rephrased beyond inherited notions relating variously to concept-formation, reflections of the real, suprasensoriality etc. On the other hand this redefinition of the tradition of creative imagination is used to indicate a different notion of organization, scalable within modalities of self-creation as a human strata of the real.[75] Thus the creative imaginary becomes an institution which is not *per se* systemic but is however unthinkable without instanciation of the systemic: social imaginary significations are stipulating a *sui generis* relation between creation and system. Moreover, this sui generis relation takes a multiplicity of forms, or inherits in a multiplicity of forms, thus territorializing the human strata of the real.

The articulation of a complete system of the world is related to assumptions of the 'ratio' of the world[76] and of Being[77] in two ways: by bringing ratio forward in its various modalities, as a systemic form engendered by and circumscribing a human strata on certain conditions (e.g. nature, or for that matter, evolution), and by figuring systemic forms, e.g. institu-

tions co-predicated on ratio (e.g. law and technology). Furthermore, imaginary instituting is meta-instable, given the problematic of the magma, allowing for constant perturbation, for changes to appear, also changes which in 'terms' of the systemic – e.g. 'systems theory'– may appear as wholly impertinent. Thus the systemic can neither be seen as overarching, in the sense of e.g. world systems theory, nor be relegated to a represented, epistemic (nominal) form, as in much of the cultural theory underwriting post-colonial critique. Put differently: the issue of alterity is not seen as the "(im)possibility" of something systemic, brought forward from and by margin, or "excentricity" as the limit and the limiting of the alleged systemic, *cum* differance and so forth, but as addition, that is: as *creative addendum* to the world in some capacity.[78]

On this background it becomes possible to argue that Danes relate to foreigners in a normative fashion which creatively organizes self-assertion as a wider imaginary: put differently, to follow how self-assertion appears in a psycho-somatic context and as social-historical institution. Danes may not be racist, but they constitute a *self-assertionist constellation* of superiority and inferiority, which (1) by this constitution valorizes the disappearance of transnationalization issues; (2) may, moreover, be seen to emphasize culture when it favours the superiority element, the cultural self-identification – the qualitative Danish way of life – while reducing the predicament of inferiority, i.e. the lack of power of a 'small' nation state (and related issues such as economical power, access to ressources etc.) and (3) furthermore may take the form of denial at root, *of de-presentation*, as argued above by the stipulation of the superiority-element as a strong, 'whole' way of life.

In her critique of the Supreme Court Pia Kjærsgaard emphasizes that the notion of racism is misplaced, notwithstanding the court's considerable effort at defining this term (to her a muddle of vulgarization supported by the Danish Language Council).[79] Racism is altogether different: something wholly irrelevant when dealing with a situation "(...) where you agitate against mass-immigration into Denmark and its consequences".[80] By identifying racism and agitation against mass-migration, the Supreme Court is simply rendering the Danish language invalid, she argues.[81]

Now, the point in this article is not to engage in a debate on definitions of racism in relation to antimigration. The interesting point in Kjærsgaard's argument is, for one thing, the emphatic denial of the problem of racism altogether, and, for another, most importantly, the plea for

the 'everyday' viewpoint of the Danes – culture – to be rendered as *a priori* exempt from racism: "The viewpoints I state have nothing to do with racism, of course not: on the contrary they have to do with ordinary everyday views, as most Danes state".[82]

To argue against "mass-immigration" is thus Danish, and to equal such an argument with racism is to neglect what is Danish, that is, to abolish Danishness. Conversely there is no room for, no point in, associating Danishness with racism, or, for that matter, with migration.

As *Are we so reserved?* argues, the impact of this constellation may be viewed as a strategic paralysis in an extended sense, not least when seen from a position of policing transnationalization. One obvious problem relates to the demographic development of an ageing Europe and the need for import of workforce, as often argued by for instance the EU and the OECD. To some unquestionably a reason for regarding the Danish People's Party's platform as ineffectual in the long term. However, it is important to understand that from the perspective of antimigration such ineffectuality does not hinder, or intervene with, valorization. The norm system that impacts the Danish state to take in-action, according to *Are we so reserved?*, may be reenvisioned as a wholly adequate – if not benevolent position within globalization. The policing of transnationalization may be seen as a misconception of reality, exaggerating the demise of the nation state etc., as also prefiguring in "sceptical" positions in globalization debates. Thus 'ineffectuality' does not necessarily count in the party's view. More precisely: it does not count as the superior systemic functionalism taken for granted at governmental levels in the EU and OECD.

As the Danish People's Party often displays, it is willing to deal pragmatically with transnationalization and globalization on a range of questions, e.g. when supporting Danish participation in the Coalition in Iraq in 2003 or when accepting the general implications of a globalizing market, while insisting on negative consequences for Danishness (as well as the developing world) to be mitigated, e.g. by welfare initiatives.[83] In fact, the party's popularity indicates that exactly the repeated functionalist arguments underwriting the EU-project may not count much, and the belief in systemic functionalism as underwriting scientific, legal and administrative measures per se may indeed be misplaced (one of the points of departure for Castoriadis is predicaments of functionalism).[84] Here we also find a reason for the predicaments of 'benevolent' culture envisaged by Ørstrøm Møller[85] in the early 90s but, impor-

tantly, no less of a reason for the predicaments of the post-colonial *regime of critique* investing in what remains a dedicated *functional* position, e.g. an interstice of representational signification, relying on notions of "beyond", "gap" and so forth, or, in the case of Spivak, most emphatically in her repeated argument for the dedicated positioning/expulsion of "the native informant".[86]

Nevertheless, the foreign remains elusive in the Danish People's Party's imagination. While the foreign, in a broad sense, is almost non-existent in the party's "Program of Principles",[87] issues of foreign politics, globalization, migration etc. are treated in some detail in the party's "Working Program" implying e.g. support for NATO and the UN (seen as a buffer between nations and ethnicities, to be substantially reformed, though).[88] While globalization is mostly seen as an unavoidable fact, which has to be mitigated,[89] the working program explicitly attempts to deal with the global world and its cultures in the section "Denmark and the poor world". Here one reads that poverty may lead to "hostile clashes between different cultures". The solution, however, lies not in migration from poor parts of the world to rich but in reform of poor countries:

> The Danish People's Party finds that the effort of the EU as well as most European countries to improve the conditions of the developing countries is wholly insufficient. It is of no use to inject economical ressources into these countries, because they are to a large extent wasted if the culture and whole social organization of the countries are not changed. A determined effort to change the culture of the developing countries is a precondition for the prevention of mass-immigration which the European countries cannot bear. The Danish People's Party considers a substantive planning of aid for the development of institutions, democratization and birth control an imperative necessity.[90]

Two points are interesting here: (a) the program denies any importance of the poor world beyond the level of problem: the position of, one assumes, the 'problem-free' Danish culture is the yardstick to be applied, (b) the conception of problem as well as solution is made in terms of culture: poor culture must be replaced in order to promote problem-solution. In so far as this is not a tautology, one may read it, somewhat ironically, as a suggestion of cultural export, for exporting the Danish way of life as a conditioning problem-solution for the poor. Of course, the party's view

may be seen as a depreciation of the majority of the world's cultures, but, again, it is interesting primarily for its inability to deal with cultures established externally to Danishness. In sum, the party envisions a chiasm of superiority and inferiority in terms of the assumed qualitative superiority of Danish culture. The basic prospect for the party is the culture of the Danish, Danishness at large, stipulated as cultural form, whether in peril because of migration or when seen as remedy.

While the response to the crisis of 1864 was firmly situated in the institutions of nationalism, territory and nature, positing the internal as a form of pragmatic response to the predicaments of nationalism (in turn taking on further shapes of cultural value, e.g. in peasant and worker movements emerging with capitalist industrialization towards the 20th century), self-assertive Danes want to clear their land *in terms of creativity,* by social imaginary significations. In so far "social imaginary significations create a proper world for the society considered – in fact, they *are* this world (...)",[91] the antimigration stance of the Danish People's Party apparantly wants nothing migrational in the "proper world" of the Danish. And, conversely the only world possible is the Danish; that is, the process of representing migration is a process of creative disarticulation, of de-presentation proper.

The self-assertionist constellation of superiority and inferiority, as *Are we so reserved?* notes, is, in other terms, the instituting of *another world of social imaginary significations* (not the *impact of other worlds,* e.g. migrants' world) de-presenting the critical potential of representation taken for granted in post-colonial critique. In contrast to e.g. the classic position of the 'orientalist-paradigm' (Edward Said),[92] self-assertion wants nothing of the foreign. Edward Said's famous paraphrase on Marx, that the other cultures of the West "cannot represent themselves; they must be represented",[93] is turned upside down in a crisis of de-presentation: the others are neither capable of presentation nor of being represented, they become the effect of creative articulation without any dedicated position in the system. The circularity – the tautology – of the party's argument is thus well founded, that is, in self-creation as a social and historical form.

The type of representational signification taken for granted in postcolonial critique is 'set out of work' due to a factor not accounted for. Here we may gain a more comprehensive view of what a crisis of critique may entail. The Other and the others are de-presented by the appearance of something, an articulation, what we, on the conditions specified below,

may term a "presentation" (Castoriadis) 'before' system, antepredicating the diasporic alterity, and with it, the 'gap', 'supplement' etc. In plain language, the self-assertionist constellation of superiority and inferiority is a vision with no residence of the alien, with nothing but Danishness as a whole way of life. With a paraphrase of Roland Barthes's famous analysis of the representational signification of mythology at work implied by a Black saluting the French flag:[94] in the world of the Danish People's Party the flag is blowing over a safe Danish haven, and nowhere is the migrant to salute.

3. Constraints: De-presentation and Presentation

It is important to understand that creativity for Castoriadis does not imply boundless freedom, e.g. as indicated and assumed in various ways in notions of 'creativity', creative genius etc., even if it follows from his position that social-historical instituting is open in principle. Creativity is an ontological condition of the human strata of the real, and as such it is bound to a number of specificities, as Castoriadis argues, "it creates *ex nihilo* (not *in nihilo* or *cum nihilo*)".[95] "Ontological conversion" amounts to questioning not only how "the social-historical … create, once and for all, a new ontological type of order characteristic of the genus "society".[96] It also implies a question of how this "type" of order is "each time 'materialized' through different *forms*, each of which embodies a *creation*, a new *eidos* of society …",[97] and moreover, he emphasizes, the 'fact' that "creation, as the work of the social imaginary, of the *instituting* society … is the mode of being of the social-historical field, by means of which this field *is*. Society is self-creation deployed as history".[98]

This leads to one of the most important aspects of Castoriadis's thought: the issue of "constraints" for the creative.[99] Radical imagination is constitutive in psycho-somatic and social-historical forms, but it is not unbounded: it is a *specific* creation of a "complete system of the world" and is, as such, prone to constraints. In the text "Radical Imagination and Social Instituting Imaginary" this issue is schematically presented as "external" (e.g. nature), "internal" (e.g. dispositions of subjects), "historical" (e.g. forms of sociality) and, finally, "intrinsic" constraints[100] relating in particular to how the specificity of the imaginary institution is made "coherent" and "complete".[101]

The issue of completion points furthermore to an important question

of how imagination, creativity, may stand forward as a specific heterono-
my or closure. In fact, closure is in the known history the almost over-
whelming form of "sedimentation" of "norm systems:"

> ...institutions and social imaginary significations have to be *complete*.
> This is clearly and absolutely so in *heteronomous* societies, where *clo-
> sure of meaning* prevails. The term *closure* has to be taken here in its
> strict, mathematical sense. Mathematics say that an algebraic field
> is *closed* if its roots of any polynomial of the field are elements of the
> field. Likewise, in any closed society, any 'question' which can be for-
> mulated at all in the language of this society must find its answer
> within the magma of the social imaginary significations of the soci-
> ety. This entails, in particular, that questions concerning the *valid-
> ity* of the social institutions and significations cannot be posed. This
> exclusion of such questions is ensured by the position of a *transcend-
> ent* extrasocial, source of the institutions and significations, that is,
> religion.[102]

Castoriadis' argument here appears to me to be extremely important for
understanding self-assertion *cum* de-presentation. What self-assertion
posits is a specific *de-presentation by way of presentation*.[103] The issue of
constraint is a 'boundary' effect of creation which gives the creative fig-
uring an institutional shape by constraint. Thus Castoriadis argues that it
is necessary to show how the symbolic field is generated 'from within' by
self-creation, how "the specificity and the unity" of the symbolic "remain
incomplete and finally incomprehensible"[104] without an "essential supple-
ment".[105] The notion of presentation refers to the inescapable element of
imaginary creation ex nihilo, presenting figures, co-figuring a field of
representation in its various ways and relata.

The creation of a "complete system of the world" is thus a presenta-
tion, that is, imaginary constituting, and, moreover, in the case of de-
presentation, of closure. This may not be a religious closure, although
it may be aligned to such. Put differently: when self-assertion focus-
es on globalization as a substantial reflex of being Danish, it also posits
globalization as closure. What self-assertion does is to transform globali-
zation into a Danish issue, to make Danishness the 'blind spot' of the sys-
temic, so to speak, the point from which all 'distinctions' are made. Of
course it follows from the working program of the Danish People's Party
quoted above that globalization is not really an issue: what is at issue is

homeostasis of the Danish culture as a whole way of life. Nevertheless it is impossible to conceive of the conjecture without the need for "agitation" (Kjærsgaard) against "mass-immigration", that is, migration, large scale movement etc. In this sense, globalization is the point of departure for closure: a paradoxical *denial* of heightened global interdependence, but, importantly, *from* the *state* – or positioning, of this interdependence.

In *Globalisation and the Postcolonial World* (1997),[106] Ankie Hoogvelt questions the assumption that globalization is equal to an expanding world system. On the contrary, Hoogvelt argues, the current dynamic of globalization may in fact break with the understanding of an expansive political economy transforming the world, worldwide. Both liberals and neo-marxists assume that capitalism is driven by a need to incorporate ever-larger areas of the world in an "inexorable" expansion, a process whereby a "relentless search for raw materials, for cheap labour and for market outlets, time and again [drives] capitalism *either* into fresh geographic regions, *or* when these [are] no longer available, into upgrading existing ones".[107] However, the world system has since the end of the 1970s experienced a change which breaks with the dogma of economic expansion, and the structure of the system has been transformed from a "classic" expansionist mode to what Hoogvelt claims is a state of "implosion" with a new deepening internal logic, thus reframing the relation between what world system theory called core and periphery.[108]

The periphery of world system theory is going from being submitted to capitalist exploitation (or underdevelopment) to "structural irrelevance", says Hoogvelt,[109] creating a relative, selective, withdrawal of linkages between core and periphery. While large or perhaps even increasing parts of the world may still be, or become, irrelevant to the world system, the remaining parts are exposed to a quantitative as well as a qualitative deepening of relations. Despite globalization and gigantic increases in economic activity, the global economy does not necessarily become more global (in the sense of expansive world system), "*not any more!*",[110] Hoogvelt argues.

The mode of a world system in implosion may very well be liaisoned with a de-presentation of the kind argued for above. Culture conjectured as coherent and complete in Castoriadis's sense of closure may stipulate the creation of a "complete system of the world" as an implosive state, redefining the entire 'disposition' of the system. Put differently: such a state may circumscribe 'proper' morphologies of a system, and culture may become impetus for instituting such, not bluntly "anti-systemic" (Waller-

stein)[111] but, importantly, pointing to an altogether different constitutive problematic.

Can this really be the case in present-day globalization which apparantly produces endless evidence of interdependency or, with an often used term, "connectivity"? For one thing one should be aware that connectionist visions of globalization may be hiding a de facto substantive qualification, which inscribes the idea of connection and connectionism in new morphologies of territory and systemization, for that matter in terms like network, which for all its comprehension and assumed 'seamlessness' stipulates specific modalities[112] emerging on distinctions (one may think of Niklas Luhmann's systems theory) or become situated in a "complexification" of inherited reductionism.[113] Manuel Castells thus argues for structural irrelevance as an integral, albeit adjunct aspect of the network society.[114]

In the following I put my argument in perspective by a closing look at de-presentation in a more principal exposure of self-assertion in Denmark, Søren Krarup's *Dansen om Menneskerettighederne* [The Dance around the Human Rights] (2000).[115] Krarup, MP for the Danish People's Party, minister in the national Danish church, and editor of the journal Tidehverv (literally: the task of times), may be seen as one of the intellectual originators of the party's ideology. I emphasize, however, that the text dealt with here is seen as a statement by a wholly independent author, which relates to antimigration sentiments in the capacity of being a creative element of a larger imaginary.

Krarup's main point is that the ethnicity of the Danes is constitutively grounded in (Protestant) Christianity, primarily in the overarching constitution of God, accessible to humans in the teachings of the Bible and through the believers' faith, thus making attempts to establish overarching principles of Being by humans an aberration. In the West, he argues, an *absolute* justice set by God reigns as indiscernible to humans, as contrasted with a *relative* form of justice established by the unfolding of God's peoples, in the sense of earthly lineages within the Occident, where Christianity historically unfolds and becomes co-creative of countries, societies, and peoples;[116] "... the Occident, which has Christianity as origin, is handed the assignment of building country and society".[117] Of course, this view must create a clash with migrants predicated on a non-Christian and non-Western 'norm system', e.g. Islam. But equally important, and the main focus in the book, is the clash it produces with the secular establishment of universal human rights, which to Krarup becomes an aberration

of God's justice and an attack on the concrete human, its kin and lineage: "Human rights are the attack by abstraction on the concrete human being of flesh and blood, with a father and a mother and history and people".[118]

Human rights can be equalled to pharisaic intrusion (in biblical terms) in God's indiscernible realm appearing with the Enlightenment and its abstraction of the human as universal, established in the 20th century as a "new heaven",[119] by an overly secular UN, following upon the WW2 – "the crusade of World War II"[120] (or by Marxism, in another version), to become a new form of fundamentalism, "the human rights-fundamentalism"[121] relegating the historically sedimented Western Christianity of *family*, *people* and *nation* to prohibition:

> It is contrary to the human rights! And so there has been no more to speak about. If it is contrary to human rights to defend oneself and ones homeland, then it is prohibited. If it is contrary to human rights to care more for one's family than for human rights, then this is prohibited. If it is contrary to human rights to be a single sinful, earthly human being of flesh and blood with a given historical reality, then this is prohibited. The human rights became in the end of the 20th century a fundamentalism, which annulled any discussion.[122]

Krarup attempts, it appears to me, to refute the prospect of universal human rights by positing 'sedimented' Christian historicity as constituted *beyond any human capacity*. To him any form of thought, of reasoning, any form of representation is justified by devotion to a constituted 'principle beyond principles'. Put differently: imagination – creation – is ultimately an issue for God and de-presentation is qualified by an indiscernible principle beyond principles. To Castoriadis this is of course a closure wholly in compliance with his idea of social imaginary significations, implicating "that questions concerning the *validity* of the social institutions and significations cannot be posed".[123] Additionally Krarup appears quite unconcerned with the non-Western world except for indicating that decolonization was yet another reason for letting the abstractions of the human rights serve as a pharasaic attack on the Christian West[124] (the war itself must be seen as a secular aberration, he argues, e.g. in the biologization of race society in Nazi Germany or in the American government's attempt at establishing universal values in the postwar scenario).[125]

162 However, while closure may be the strength of Krarup's argument, it

is also its Achillean heel. While the 'proof' of God's chosen people is ultimately indiscernible and thus unquestionable (only to be approached in the Protestant sense of Sin, Faith and Holy Writ), the realm of historical lineage is open to deliberations as the *relative* product of an *absolute* justice. Here things may be made to fit pragmatically by humans, not by means of a universal right but by law 'given', or law emerging, as Krarup indicates in a longer debate on Magna Charta and the Danish "Jyske Lov" [The Jutland Law].[126]

Nevertheless, this historicity may also become dangerous. It may in practice be difficult to define the border between absolute and relative, since this border is to the one side a question of an indiscernible – absolute – principle beyond principles, which can only be taken into account by way of Sin, Faith, and Holy Writ, and to the other a question of meddling through – relatively – step by step, building kin, lineage, people and country on the basis of the Christian Occident given. In the realm of the absolute, Krarup may not be challenged, but in the realm of the relative, in writing, of imagining by way of presentation, the question of how far one can go may appear. Of course Krarup repeatedly emphasizes his preference for "the concrete human of flesh and blood" and so forth and repeatedly distances himself from any abstractions of the universal.

Nevertheless, one may conceive of a predicament wherein God may be challenged by way of the relative, so to speak, because of the imagination to be employed creatively by Krarup, who in the end has nothing but Sin, Faith and Holy Writ to secure the all-important boundary between relative and absolute, between devotion and aberration. In other words, he cannot really know if, whether and when he is taking measures that go to far, because in terms of (his own) writing Krarup is in charge to such an extent that aberration becomes possible *not in the absolute but in the relative*. Put differently: to secure the relativity of human imagination implies a reflection of the imagination *per se*, as Castoriadis advocates, which becomes a contradiction in terms in Krarup's argument, since creativity is ultimatively a question for God. In contrast, to Castoriadis creativity is an ontological given and must be treated in order to become mendable by the humans that have to carry its burden. Imagination is an inherently meta-instable condition of the social-historical, primarily given the magma, but also mendable by humans through reflection, e.g. in democratic institutions.

Put in concrete terms: what is Krarup to do when relative justice is challenged by other alleged forms of justice e.g. within Islam? Krarup

can, of course, resort to God, but that will – apparently – only make a certain way against the intruders (despite being a *conditio sine qva non* of course). Judging from Krarup's activities it is not the option chosen. He must therefore imagine, invent arguments, create a system of the relative, so to speak, *but this he is only allowed within the relative.*

Here, I think, Krarup's predicament becomes quite clear. If for instance his argument is not immediately accepted, which may be probable (one may think of a cleric of Islamist conviction), he must resort to one of two positions: *either* he carries on, but then he comes in danger of establishing what will *de facto* become a missionary and aberrative attitude, invoking the rejected universalism of abstraction (his book can be said to play on the margin of such), *or* he resorts to de-presentation within self-assertion, simply presenting a system of emphatic non-concern for the migrant, reinforced by repeated concerns for Christian kin, lineage, people, and country.

In the first case he is on a dangerous road given his reproach of the pharasaic, leading, in his language, to fundamentalism (due to its lingering and in fact inherent universalism). The second road, however, is not much better, since he is forced along the same track: for every new challenge, for every new islamist in the country, for every new migrant, to put it impertinently, he must re-emphasize a self-assertion by way of de-presentation, risking increased stakes so to speak, ultimately circumscribing a new form of universalism in the shape of fundamentalism (his book can be reviewed as such an increased stake).

Thus Krarup must, as also the programs of the Danish People's Party indicate, renounce any real dialogue, what to many others would be the options of a 'relativist' stance. Since his particular form of relativism is substantiated by Sin, Faith, and Holy Writ conditioned by something ultimately indiscernible, Krarup is threatened by or caught in heightened self-assertion leading to universal closure. The relative is no secured ground. The relative is only possible once de-presentation is enacted.[127] That is, when self-assertion is aggravated, *it may become itself a threatening fundamentalism.* Not only, we may argue, is a process of implosion building for each new act of de-presentation by way of presentation, leading, as an option – to some observers at least, notably the Danish Supreme Court – to problems of e.g. racism which the Danish People's Party wants to avoid. To live in ones 'homeland', 'oneself' with ones 'family' in 'flesh and blood' becomes a question of the universal reversed *but not abolished* in the relative.

By his own rules so to speak, Krarup is condemned to lose the feud for the relative in fundamentalism. The Bible contains no explicit passages on the muddled relative ways of contemporary and concrete globalization, of the EU, of migrants, of refugees from strange wars in the distance, and so on. That is why Krarup must write by himself, threatened by imaginary aberration. This may seem intellectually pleasing to some, surely – a narrative gap perhaps, to follow Bhabha, but what I want to indicate is the contrary: the game of Krarup is a *game of heightened self-assertion by way of de-presentation*, closure of dialogue, that is, of migration, of active human exchange across the globe. And we may add – pondering Krarup's fundamentalism – whether the alleged universal human rights after all appear somewhat less universal, or in any case, mendable, for instance by the democratic institutions serving the Danish People's Party and its constituency (and Krarup). They are, to read Castoriadis with Winston Churchill's (who Krarup is happy to invoke) remark on democracy, *the least unreflected form of imaginary institution.*

The possible intellectual lure of Krarup (and the Danish People's Party) notwithstanding – a protection of culture – it cannot live up to its own principles: it cannot stay within the relativities of the realm where it has to be played out. Bluntly: it cannot play by its own rules – for all we know without playing on the brink.

In Closing

The analysis of this paper indicates that one may plausibly debate antimigration sentiments as a social form of signification liaisoned with globalization processes under the heading de-presentation, which is clearly at play in central documents of the Danish People's Party. Moreover, it is rendered plausible to conceive of this in a theoretical framework relying on Castoriadis' notions of a creative imaginary focused by an issue of "self-creation". Furthermore, the prospect of re-definitory critique is affected by this. This implies in the context of the present book, for instance, a re-assessment of the regime of post-colonial critique on display in the statements of the Documenta 11-catalogue (e.g. framed by Jean Fisher as trickster", "the carnivalesque" and "bricolage").[128] If the Danish experience is valid, this regime of critique is not really a precondition for e.g. a "cultural contestation" emerging as a "(...) 'difference' of cultural knowledge that 'adds to' but does not 'add up' (...)".[129] On the contrary, the prospect of 'in-

terstice' may become 'occupied' by a force not of the alien, but wholly alien to post-colonial critique.

In a larger perspective I have argued for the appearance of a schisma *between* apparently globally stretched organizations *and* their constitution: fundamentalism of a new order, so to speak, of various dispositions distributed across "one global environment with a huge number of ecological, economic, social, and political pressures"[130] but constituted within universalism reversed but not abolished. My analysis of Danish self-assertion should be read as a critical entry into this. As such it is obviously different from others, e.g. Islamic or Hindu forms. It should be emphasized that the Danish form is for instance firmly anchored in parliamentary democracy. The issue of religious affiliation should not be overdone either. To many Danes self-assertion is wholly on a par with everything 'good' in the country and not necessarily religious, and the Danish People's Party makes nothing in particular of religion in their day-to-day politics.

Perhaps the most interesting conclusion pertains to what Ankie Hoogvelt succinctly terms the "implosive" state of the world system. Antimigration sentiments render the migrant un-representable because of a specific form of implosive imaginary at play in the instituting of globalization. One may ponder whether the view of 'transformationalism' today most often accepted as indicative of globalization is not in some capacity the 'other' of such fundamentalism: the former (self-assertion), indicating what Maurice Merleau-Ponty termed the 'bad dialectic' featuring a moment of opposition, the latter (transformationalism), indicative of a 'good dialectic', featuring a moment of process.[131] Of course, to many such a reading would be caught in an American debate between Fukuyama and Huntington, and in any case, subscribing to dialectics will not fit into the idea of social-historical constitution focused by Castoriadis's theory relying on the impetus of self-creation.

All in all, my argument points to a number of qualifications in understanding cultural aspects of globalization. Moreover, it emphasizes that even if antimigration sentiments are "toxic but containable" we should not underestimate their constitutive dynamic. Phrased somewhat differently: the present era of globalized 'systemicity' is neither a system of emphatic 'difference' debated at length here, but nor is it the option of a 'system of the multiple'[132] dear to other strains of contemporary radical art and culture (e.g. as mirrored in the hopes for Multitude in Michael Hardt's and Antonio Negri's Deleuzean *Empire* (2000))[133] but a question of culture

referring to the imaginary institution of specific, biased and contested multiplicity, that is, to a variety of guarded positionings liaisoned somehow with a state of implosion.

Moreover, the association of critique with culture – e.g. in notions of 'whole way of life' – should be throughly qualified. In so far culture is circumscribing a 'whole way' and is thus somehow foundational, whether in relations to notions of representation or not, one should see this fact as an occasion for researching how the universal becomes reversed but not abolished in the relative. One may see Castoriadis's theory as one attempt of this: to investigate how cultural worlds, with their 'localized' and 'immanent' conventions, meanings and values, are constituted in the sense of a reflection upon ontological universals.

The predicament of migrants – and, for that matter, the native informant taken in Spivak's comprehensive sense – confronted with depresentation points to a different critical perspective appearing from the investigation of the *creation* of "complete system[s] of the world". There is no gap, no differance, no multitude, from where a given critique may be '(auto)-erected'. The predicament of "toxic but containable" presentation has, in less academic language, ultimately to do with a crisis *for global coexistence as a democratic form* in some capacity. However difficult, democracy in this important sense, the democracy of the future, so to speak, is ultimately the victim of the present shake up by way of transformationalism *vis-a-vis* fundamentalism of a new order, leaning in the case I have debated here on cultural self-assertion.

1 Bhabha, "Dissemination. Time, narrative, and the margins of the modern nation", in Homi K. Bhabha: *The Location of Culture*, London: Routledge 1994, pp. 139ff. Here cited, p. 161.

2 "The beyond is neither a new horizon, nor a leaving behind of the past (...) Beginning and endings may be sustaining myths of the middle years; but in the *fin de siècle*, we find ourselves in the moment of transit where space and time come cross to produce complex figures of difference and identity, past and present, inside and outside, inclusion and exclusion. For there is a sense of disorientation, a disturbance of direction, in the 'beyond': an explanatory, restless movement caught so well in the French rendition of the words *au-delà* – here and there, on all sides, *fort/ da*, hither and thither, back and forth". Bhabha, *Op.cit.*, p. 1.

3 "The concept of the people emerges within a range of discourses as a double narrative movement. The people are not simply historical events or parts of a patriotic body politic. They are also a complex rhetorical strategy of social reference: their claim to be representative provokes a crisis within the process of signification and discursive address. We then have a contested conceptual territory where the nation's people must be thought in double-time; the people are the historical objects of a nationalist pedagogy, giving the discourse an authority that is based on the pregiven or constituted historical origin *in the past*; the people are also the 'subjects' of a process of signification that must erase any prior or originary presence of the nation-people to demonstrate the prodigious, living principle of the people as contemporaneity: as that sign of the *present* through which national life is redeemed and iterated as a reproductive process". *Ibid.*, p. 145.

4 *Ibid.*, pp. 139ff.

5 *Ibid.*, p. 162f.

6 "The 'difference' of cultural knowledge that 'adds to' but does not 'add up' is the enemy of the *implicit* generalization of knowledge or the implicit homogenization of experience (...) the major strategies of containment and closure in modern bourgeois ideology". *Ibid.*, p. 163,

7 Gayatri Spivak, "Resident Alien", in David Theo Goldberg & Ato Quayson (eds), *Relocating Postcolonialism*. Oxford: Blackwell Publishers 2002, pp. 47ff.

8 *Ibid.*, p. 46.

9 *Ibid.*

10 David Held & Anthony McGrew, David Goldblatt & Jonathon Perraton, *Global Transformations. Politics, Economics and Culture*. Cambridge: Polity Press 1999. Held et.al. divide the globalization-debate according to three theses, (a) a "hyperglobalist thesis" emphasizing the pressures and prospect of economic globalization as a unilateral and uniform development pointing to a new world order and expanding global governance based on acceptance of Western democracy and market economy (pp. 3ff.), (b) "the skeptical thesis" which sees globalization as a mere example of "heightened levels of ... interaction between predominantly national economies" (pp. 5ff.), positioned in dominant relations to each other, and predicated on nation-

al and international economic blocs such as EU and NAFTA reinforcing patterns of inequality and imperialism, (c) "the transformationalist thesis" acknowledging the claim of fundamental change, although without any predictions of the outcome: Globalization is seen as a dynamic and open option, a powerful transformative force which "… is responsible for a 'massive shake-out' of societies, economies, institutions of governance and world order". (p. 7).

11 C.f. Spivak, "Can the Subaltern Speak?", in Patrick Williams & Laura Chrisman (eds), *Colonial Discourse and Post-Colonial Theory. A Reader.* Harvester Wheatsheaf 1994, pp. 66ff. In *A Critique of Postcolonial Reason* she writes on "the native informant", "a name for the mark of expulsion from the name of Man – a mark crossing out the impossibility of the ethical relation". Gayatri Spivak *A Critique of Postcolonial Reason. Toward a History of the Vanishing Present.* Cambridge, Mass.: Harward University Press 1999, p. 6.

12 "I have proposed in this book that a different standard of literary evaluation, necessarily provisional, can emerge if we work at the (im)possible perspective of the native informant as a reminder of alterity, rather than remain caught in some identity forever". *Ibid.*, pp. 351–352.

13 To be sure one should not underestimate the differences within the post-structuralist academy. However, one should not overlook, either, similarities in relation to ideas of e.g. language, represention, system etc.

14 Quoted from Les Back and Vibeke Quaade, "Dream Utopias, Nightmare Realities", in *Third Text* 22 1993, p. 80.

15 For instance, what Aaron David Gresson terms a "white recovery" predicated on the "rhetoric reversal" of victim and victimizer in new forms of negotiation of meaning, "The Recovery of Race in America", in Ellis Cashmore & James Jennings (eds), *Racism: Essential Readings.* London: Sage Publications 2001, pp. 386–407.

16 Samuel P. Huntington, *The Clash of Civilizations and the Remaking of World Order.* London: Touchstone Books 1998, in particular sections I & V. See also Spivaks critique of Huntington and similar positions, e.g. in writings of Richard Rorty, in *A Critique of Postcolonial Reason*, pp. 354ff.

17 Stuart Hall (ed), *Representation. Cultural Representations and Signifying Practices.* London: Sage Publications 1997. He cites Foucault, "nothing has meaning outside of discourse", and argues, "representation through language is … central to the processes by which meaning is produced" (p. 1). He sets up a 'genealogy' from Saussurean linguistics over semiotics to discourse theory, emphasizing power-truth-knowledge relations. Moreover, Hall relates discourse theory to the notions of a 'whole way of life' from Anglo-American cultural studies: "In the semiotic approach, representation was understood on the basis of the way words functioned as signs within language. But for a start, in a culture, meaning often depends on larger units of analysis – narratives, statements, groups of images, whole discourses which operate across a variety of texts, areas of knowledge about a subject which have acquired widespread authority". (p. 42). See also Hall's classic "Encoding/decoding" in

Culture, Media, Language. Working Papers in Cultural Studies, 1972–79. London: Hutchinson in association with the Centre for Contemporary Cultural Studies, University of Birmingham 1980, pp. 128ff.

18 Rasheed Araeen, "What's wrong with multiculturalism?" in *Under [De]construction – Perspectives on Cultural Diversity in Visual and Performing Arts.* Nordic Institute for Contemporary Art. Helsinki. 2002.

19 C.f. Cornelius Castoriadis, *The Imaginary Institution of Society.* Polity Press 1987. See below for detailed definitions and discussion. See also Arjun Appadurai, *Modernity at Large. Cultural Dimensions of Globalization.* Minneapolis: University of Minnesota Press 1996 for an application of notions of the imagination closer to post-colonial critique and globalization debates.

20 Representational signification may be defined historically and systematically as relating variously to e.g. a reality reflected (realism), cognitive schemas (transcendentality), discursive praxis (immanence) and reflexive modernity (e.g. in aesthetic form). See for instance, Richard Eldridge (ed) *Beyond Representation. Philosophy and Poetic Imagination.* Cambridge: Cambridge University Press 1996. Castoriadis's philosophy introduces, however, a different interpretation of the problem of imaginary signification pertaining to creation and creative articulation of valorized meaning, which is not recursive to representation but to "(...) self-creation deployed as history". C.f. Castoriadis, "The Imaginary: Creation in the Social-Historical Domain", in Cornelius Castoriadis, *World in Fragments. Writings on Politics, Society, Psychoanalysis, and the Imagination* (David Ames Curtis (ed)). Stanford: Stanford University Press, pp. 3ff. (p. 12).

21 *Ibid.,* p. 12.

22 C.f. J. Ørstrøm Møller, "Model Europa. Økonomisk internationalisering og kulturel decentralisering i fremtidens Europa" [Model Europe. Economic internationalization and cultural decentralization in future Europe] in *Politiken 17-7 1991:* "In these years, European cooperation is formed around two strong principles: economic centralization and cultural decentralization. From these principles, or these trends, a European social model will appear. Europe will teach itself and the world how deep economical and social integration can evolve hand in hand with cultural autonomy for the different nationalities". [Det europæiske samarbejde udformes i disse år omkring to stærke principper: økonomisk centralisering og kulturel decentralisering. Ud fra disse to principper eller strømninger vil der udvikle sig en egentlig europæisk samfundsmodel. Europa vil lære sig selv og verden, hvorledes en dybtgående økonomisk og samfundsmæssig integration kan gå hånd i hånd med kulturel selvbestemmelse for de enkelte nationaliteter]. In this text, from the early 90s, Ørstrøm Møller walks an interesting yet thin line between policing and forecast, which in subsequent years has proved correct, although with quite different implications: that is, in the metamorphosis of cultural decentralization into self-assertionism. See also, Jørgen Ørstrøm Møller, *The future European Model. Economic*

Internationalization and Cultural Decentralization. Westport, Conn.: Praeger Publishers. See also note 85 below.

23 Where nothing else is noted *all translations of Danish sources in the following are mine.* When quotations cited from an original in Danish figures in the following, the original Danish text figures in [], except note 44 where the original Danish text is part of a graphic illustration in *Politiken.* When the source is a World Wide Web page, full address and time of access is noted.

24 For information on the Danish People's Party see e.g. http://www.dansk-folkeparti.dk.

25 [Landet bygger på den danske kulturarv, og dansk kultur skal derfor bevares og styrkes], http://www.danskfolkeparti.dk/sw/frontend/show.asp?parent=3380& layout=0 (Accessed 2004-01-16:13.52).

26 [Kulturen består af summen af det danske folks historie, erfaringer, tro, sprog og sædvaner], http://www.danskfolkeparti.dk/sw/frontend/show.asp?parent=3380& layout=0 (Accessed 2004-01-16:13.52).

27 [Dansk Folkeparti vil arbejde for at øge forståelsen for, at ethvert samfunds udvikling er bestemt af det samlede indhold af dets kultur, og vi vil modarbejde et-hvert forsøg på at skabe et multikulturelt eller multietnisk samfund i Danmark, dvs. et samfund, hvor en betydelig befolkningsgruppe er tilhængere af en anden kultur end vores. At gøre Danmark multietnisk indebærer, at udviklingsfjendtlige, reak-tionære kulturer vil nedbryde vores hidtil stabile, homogene samfund.] C.f. http://www.danskfolkeparti.dk/sw/frontend/show.asp?parent=4269&menu_parent=& layout=0 (Accessed 2004-01-16:14.32).

28 *Dancing to a new tune. A survey of the Nordic region.* June 14th 2003. The Econo-mist June 14th–20th 2003.

29 *Ibid.*, p. 9.

30 *Ibid.*

31 *Ibid.*

32 It must be emphasized that the ruling only related to a concrete statement of Kjærsgaard in a given situation and an accusation made by another Danish politi-cian in relation to that. It is thus not allowed to call Kjærsgaard racist in general but only within the thus given – and historical – problematic. See for instance, "Pia Kjærsgaard's words are racist" [Pia Kjærsgaards ord er racistiske], in *Politiken* 19-6 2003, 2nd section, p. 5 (Accessed through Infomedia: 2003-07-15: 13.00); "Pia K. An-griber Højesteret" [Pia K. attacks the Supreme Court], in *Politiken* 24-6 2003, 1st sec-tion, p. 5 (Accessed through Infomedia: 2003-07-15: 13.01); "Dommere vrede på Pia K." [Judges upset by Pia K.], in *Politiken* 26-6 2003, 1st section, p. 2 (Accessed through Infomedia: 2003-07-15: 13.02).

33 [hamrende forkert, hamrende uretfærdig og hamrende politisk], Pia Kjærs-gaard, "Højesteretsdom om racisme er politisk" [The Supreme Courts Ruling on Racism is Political], in *Politiken* 26-6 2003, 2. sektion, p. 7 (Infomedia: 2003-07-15:12.59).

34 *Ibid.*

35 Thomas Rørdam, Marie-Louise Andreasen, Peter Birger Blok, Lene Pagter Kristensen, Poul Sørensen. Ibid.

36 "Nok tager jeg dommen til efterretning, men jeg kan altså ikke tage den alvorligt". *Ibid.*

37 [I forhold til tidligere er det politiske arbejde blevet nemmere, fordi der er synspunkter, som er trængt tilbage i debatten. Vi kan mere uforstyrret arbejde i retning af de ting vi gerne vil], in "Experts fear the government" [Eksperter frygter regeringen], in *Politiken 29-6 2003*, 1st section, p. 1.

38 See for instance "Rønn: Wake Up, Fogh" [Rønn: Vågn så op, Fogh], in *Politiken 2-7 2003*, 1st section, p. 1 (Accessed through Infomedia 2003-07-15: 13.23). A senior politician from Anders Fogh Rasmussen's Liberal Party, Birthe Rønn Hornbech, distanced herself from Kjærsgaard after her attack on the Supreme Court. Rønn Hornbech emphasized that there exists fundamental differences between the Liberal Party and the Danish People's Party, since the latter is predicated on a religious cleavage between Muslims and Christians. Nevertheless, Rønn Hornbech fully supports the reforms of Fogh Rasmussen's government.

39 Cf. Amnesty International, Dansk Center for Menneskerettigheder & Dansk Flygtningehjælp [Amnesty International, the Danish Center for Human Rights & the Danish Refugee Council, *De seneste års ændringer af udlændingeloven* [The last Years Changes of Migration Law]. København: Dansk Center for Menneskerettigheder 1999.

40 "Toxic but containable", in *Economist Apr. 25th 2002* (print edition) (Accessed through http://www.economist.com 2003-07-16:14.50).

41 See overview in *News from the Rockwool Foundation Research Unit, March 2002*, p. 3. Downloaded on http://www.rff.dk/ukhome.htm – link to newsletters.

42 See for instance Ralf Pittelkow, *Efter September. Vesten og Islam* [After September. The West and Islam]. Satellit 2002. Pittelkow, a former ideologue of the left, sees the liaison between Enlightenment and Islam as crucial. Islamic fundamentalism is at odds with the Enlightenment, and so, he argues, is the migration of Muslims into the West. Thus he argues for an inherent connection between Enlightenment and Westerness. To relate present Westerness with the Enlightenment is of course fully compatible with many aspects of its history and, so to speak, with the 'program' of the Enlightenment as also foregrounded in post-colonial critique (see e.g. Spivak's debate in *A Critique of Postcolonial Reason*, and Bhabha, *op.cit.*). Yet it differs from another impetus, underwriting e.g the UN-system, conditioning a principle of universal Human equality. C.f. "The Universal Declaration of Human Rights" completed by The United Nations Commision on Human Rights in 1948. See "Universal Declaration of Human Rights" *Encyclopædia Britannica* from Encyclopædia Britannica Online. http://search.eb.com/eb/article?eu=127116 (Accessed June 5, 2003).

43 See, for instance, "A tight success – which continues" [En stram succes – der

bliver ved], in *Politiken 2-8 2003*, 1st section, p. 2. The article refers to polls by the newspaper Berlingske Tidende late June 2003.

44 C.f. "Voters flunk Fogh on economy" [Vælgere dumper Fogh på økonomi], in *Politiken 16-11-2003* (Accessed through http://www.politiken.dk 2003-11-17:14.53). Additional graphics, http://www.politiken.dk/media/grafik/1639GIF (Accessed through http://www.politiken.dk 2003-11-17:14.59)

45 Bülent Diken, *Strangers, Ambivalence and Social Theory*. Aldershot etc.: Ashgate 1998, pp. 2f.

46 Hans Jørgen Nielsen, "Are Danes less tolerant of foreigners than other people", in *News from the Rockwool Foundation Research Unit, March 2002*, pp. 3ff. Download on http://www.rff.dk/ukhome.htm – link to newsletters.

47 *Ibid.*, p. 3.

48 *Ibid.*

49 *Ibid.*, pp. 4f., pp. 5f.

50 *Ibid.*, p. 4.

51 *Ibid.*, p.8.

52 *Ibid.*

53 *Ibid.*

54 *Ibid.*

55 *Ibid.*

56 Hans Mouritzen (ed), *Er vi så forbeholdne? Danmark over for globaliseringen, EU og det nære* [Are we so reserved? Denmark facing globalization, EU and what is close]. Århus: Aarhus Universitetsforlag 2003.

57 Hans Mouritzen, "Introduktion med særligt henblik på globalisering" [Introduction – with a focus on globalization], in Mouritzen (ed), *Op.cit*, pp. 11ff.

58 *Ibid.*, pp. 32f., pp. 34f.

59 [*Danmark som stat har, presset af det historisk aflejrede normsystem i befolkningen, overvejende valgt en defensiv strategi over for globaliseringen (...)*] *Ibid.*, p. 33.

60 [Et kvalitativt merværd kombineret med et kvantitativt – styrkemæssigt – mindreværd har historisk aflejret sig i befolkningens dominerende normsystem]. *Ibid.*, p. 32.

61 *Ibid.*, pp. 34f.

62 C.f. his statement in Marc Guignard's movie (on Cornelius Castoriadis): "... c'est le elaboration du toute un systeme du monde (...)". Clip of movie, http://www.agorainternational.orhg/ccvideo.html (no titel).

63 Even though he explicitly distances himself from the ethical turn of recent years, to him "the ethicists' new clothes". Cornelius Castoriadis, "The ethicists' New Clothes" in Cornelius Castoriadis: *World in Fragments. Writings on Politics, Society, Psychoanalysis, and the Imagination* (David Ames Curtis (ed)). Stanford: Stanford University Press, pp. 108ff.

64 Cf. Cornelius Castoriadis, "Radical Imagination and the Social Instituting Im-

aginary", in Cornelius Castoriadis, *The Castoriadis Reader* (David Ames Curtis (ed)). Oxford: Blackwell Publishers Ltd. 1997.

65 Marc Guignard's movie, http://www.agorainternational.orhg/ccvideo.html (no title).

66 Castoriadis, "Radical Imagination and the Social Instituting Imaginary", p. 336.

67 Castoriadis, "The Imaginary: Creation in the Social-Historical Domain", pp. 13–14.

68 Se for instance, Castoriadis, "The Logic of Magmas and the Question of Autonomy" in Cornelius Castoriadis, *The Castoriadis Reader* (David Ames Curtis (ed)). Oxford: Blackwell Publishers Ltd. 1997, pp. 290ff.

69 C.f. Cornelius Castoriadis, "Radical Imagination and the Social Instituting Imaginary" in Cornelius Castoriadis, *The Castoriadis Reader* (David Ames Curtis (ed)). Oxford: Blackwell Publishers Ltd. 1997.

70 Castoriadis, "Radical Imagination and the Social Instituting Imaginary", pp. 319ff., p. 321.

71 At least four themes should be noted: (1) Thinking the social-historical beyond functionalist and organic schemata, (2) The imagination viewed as a constitutive vis formandi related to the symbolic, i.e. social imaginary significations, (3) Issues of science and technology, including what Castoriadis terms the identitary-ensemblistic dimension pertaining to the role of the rational in Being and to doing and determination in inherited ontology, (4) The problem of the human organism and subjectivity, in part theorized as 'Freudo-cognitive' theory of the "psychism". Moreover, Castoriadis understands the imagination as predicated on a schisma between heteronomy and autonomy leading to ideas of revolutionary "elucidation" of the imaginary institution of society. See my article "The Network Society: Organization and Constitution – beyond the Network's Innocence" [Netværkssamfundet: organisation og konstituering – hinsides netværkets uskyld] in *Grus Nr. 66, 2002. IT, Magt og Demokrati.* [IT, Power, and Democracy].

72 Castoriadis, "The Imaginary: Creation in the Social-Historical Domain", p. 8.

73 *Ibid.*

74 *Ibid.*, p. 12.

75 C.f Paul Dumouchel & Jean-Pierre Dupuy (dir.) *Colloque de Cerisy: L'auto-organisation. De la physique au politique.* Paris: Éditions du Seuil 1983. Dupuy & Dumouchel situate Castoriadis's notion of self-organization as a specific open modality of the 'paradigm', liaisoned with, yet distinctive from e.g. Henry Atlan's and Francisco Varela's notions.

76 See, for instance, Castoriadis, "Logic, Imagination, Reflection" in Castoriadis: *World in Fragments. Writings on Politics, Society, Psychoanalysis, and the Imagination,* pp. 246ff.

77 Castoriadis uses the term the "ensemblistic-identitary" or "ensidic" to debate the role of the rational in inherited thought: the received heritage in the West focus-

ing on the 'act' of etablishing sets, ensembles, predicated on identification, uniting, and demarcating as same/other, as such. Castoriadis criticizes on this background what he terms the "pseudorationality" of beliefs in technology, science and progress. However, he, nevertheless, takes great care to accomodate rationality etc. in his theory, thus distancing himself from the general relativism of science and rationality critique in discourse theory, science and tecnology studies etc. See in general, Castoriadis: *The Imaginary Institution of Society*, Polity Press 1987, and Castoriadis, *Les carrefours du labyrinthe*. Paris: Éditions du Seuil 1978. See also Castoriadis, "The Ontological Import of the History of Science", in Castoriadis: *World in Fragments. Writings on Politics, Society, Psychoanalysis, and the Imagination*, pp. 342ff. See also my article "Afirmación Technológica Postmoderna/Postmodern Technology-Affirmation", in *En Reconocimiento de la Historia/ In Recognition of History. Atlantica Revista de Arte y Pensamiento, Numéro 30 Otõno 2001*. Las Palmas (Gran Canaria): Centro Atlantico de Arte Moderno (CAAM). Webversion on http://www.caam.net/en/atlantica.htm – search on title or author.

78 Cf. my article on the computational heritage and the imaginary, "The imaginary of the artificial: automata, models, machinics. Remarks on promiscuous modeling as precondition for poststructuralist ontology", in Thomas W. Keenan & Wendy Hui Kyong Chun (eds), *New Media, Ole Media. Interrogating the Digital Revolution*. New York: Routledge 2005.

79 According to Kjærsgaard, the Supreme Court has altered the definition of racism to fit its needs.The Court considers three definitions of "racism" of which the third is applied, "a definition that aims at differentiation and oppression or mere distancing from groups of people that may well be of the same race as oneself" [en betydning, som sigter til forskelsbehandling og undertrykkelse af eller blot afstandtagen fra grupper af mennesker, som godt kan være af samme race som én selv]. Kjærsgaard, *op.cit.* She argues "With complete naivety the Supreme Court has used statements from the Danish Language Council as a basis for the decisions made. Naive, merely for the reason that the Danish Language Council is known to be a completely populistic organization, which accepts and furthers any vulgarization of the Danish language" [Helt naivt har Højesteret lagt udtalelser fra Dansk Sprognævn til grund for den beslutning, man har truffet. Naivt alene af den grund, at Dansk Sprognævn er kendt som et populistisk foretagende, som accepterer og giver frit spil for enhver forfladigelse af det danske sprog]. *Ibid.*

80 [hvis man agiterer imod masseinvandringen til Danmark og dens følger]. *Ibid.*

81 "Thus the Danish Language Council – now rubber-stamped by the Supreme Court – has totally watered down the meaning of the word racism – allowing for one to exert racism towards a person of the same race as oneself ... a total vulgarization of the Danish language". [Således har Dansk Sprognævn – og nu altså blåtstemplet af Højesteret – totalt udvandet betydningen af ordet racisme – så man altså godt må udøve racisme over for en person, som er af samme race som én selv ... en total forfladigelse af det danske sprog]. *Ibid.*

82 [De synspunkter, jeg fremfører, har intet med racisme at gøre, selvfølgelig ikke; derimod er der tale om ganske almindelige dagligdags synspunkter, som de fleste danskere giver udtryk for]. *Ibid.*

83 See for instance the section in the party's working program on "Danish Foreign Policy" [Dansk Udenrigspolitik]: http://www.danskfolkeparti.dk/sw/frontend/ show.asp?parent=4260&menu_parent=&layout=0 (Accessed 2004-01-16:13.59).

84 He argues in a critique of functionalism in sociology and anthropology: "Beyond the conscious activity of institutionalization, institutions have drawn their source from the *social imaginary*. This imaginary must be interwoven with the symbolic, otherwise society could not have 'come together'; and have linked up with the economic-functional component, otherwise it could not have survived. It can be placed, and it must be placed, in their service as well: there is, of course, a *function* of the institutional imaginary, although here, too, we observe that the effect of the imaginary *outstrips* its function; it is not the 'ultimate factor' (we are not looking for one anyway) – but without it any determination of both the symbolic and the functional, the specificity and the unity of the former, the orientation and the finality of the latter, remain incomplete and finally incomprehensible". Castoriadis, *The Imaginary Institution of Society*, p. 131.

85 In *The end of Internationalism. Or World Governance* (2000) Ørstrøm Møller replaces the hopeful connotations of a "Model Europe" with a somewhat dystopic account of the predicaments of world governance. In the "Prelude", to the book, Ørstrøm Møller discerns three trends which presently hinder the formation of world governance, (a) forces of culture questioning whether the world system – internationalism – 'can deliver', (b) the tendency to mount spectacular "manifestations of the nation state" on an international level, and (c) "criticism of the nation-state by ethnic and religious minorities, with the inevitable consequence that a part of the majority ... turns against them, producing some form of xenophobia" (p. 6). Ørstrøm Møller does not see, however, the connection between his deliberate investment in culture in the 90s and what he by 2000 judges as an overly focus on cultural conflicts, e.g. in Huntington's views. In comparison with e.g. *Are we so reserved?* he remains dedicated to a functionalist policing of an 'advanced' view, in 1991 within the framework of internationalization/decentralization, in 2000 within the agenda of internationalization/world governance. Jørgen Ørstrøm Møller, *The End of Internationalism. Or World Governance*. Westport, Conn.: Praeger Publishers 2000.

86 "... a name for the mark of expulsion from the name of Man – a mark crossing out the impossibility of the ethical relation". Spivak, *A Critique of Postcolonial Reason*, p. 6.

87 Cf. [Principprogram], http://www.danskfolkeparti.dk/sw/frontend/show.asp? parent=3380&layout=0 (Accessed 2004-01-16: 14.13)

88 "Danish Foreign Politics" [Dansk udenrigspolitik], http://www.danskfolkeparti.dk/sw/frontend/show.asp?parent=4260&menu_ parent=&layout=0 (Accessed 2004-01-16:14.14)

89 Cf. "Working Programme" [Arbejdsprogram]. In the introduction of the "Working Programme", "Common values – common responsability" [Fælles værdier – fælles ansvar], the party states: "Despite globalization of production and capital the forms of co-existence and production today demand, even more than previously, a depth and quality in a mutual community, which cannot be attained through political governance and moral indoctrination. Interdependency and community in Denmark and a number of small countries are today under threat from several sides. Internally by closed and intolerant minorities and externally from the worship of globalization and the international power of capital". [Trods globaliseringen af varefremstilling og kapital kræver nutidens samlivs- og produktionsformer endnu mere end fortidens en dybde og kvalitet i samhørigheden, der ikke kan opfyldes gennem politisk styring og moralsk indoktrinering. Samhørigheden og fællesskabet i Danmark og andre små lande trues i dag fra flere sider. Indefra af lukkede og intolerante mindretal og udefra gennem dyrkelsen af globalisering og international kapitalmagt], http://www.danskfolkeparti.dk/sw/frontend/show. asp?parent=4252&menu_parent=&layout=0 (Accessed 2004-01-16:14.13)

90 Cf. "Denmark and the poor world" [Danmark og den fattige verden]; [Dansk Folkeparti finder, at såvel EUs som de fleste europæiske landes indsats for at forbedre udviklingslandenes vilkår er helt utilstrækkelig. Det nytter ikke blot at tilføre landene økonomiske ressourcer, for de går i vidt omfang til spilde, hvis ikke landenes kultur og hele samfundsmæssige organisation ændres. En målrettet indsats for at ændre udviklingslandenes kultur er en forudsætning for at forhindre en masseindvandring, som de europæiske lande ikke kan bære. Dansk Folkeparti anser en omfattende plan for bistand til institutionsudvikling, demokratisering og børnebegrænsning i udviklingslandene for bydende nødvendig.] http://www.danskfolkeparti.dk/sw/frontend/show.asp?parent=4262&menu_parent=22669&layout=0 (Accessed 2006-11-03:11.32)

91 Castoriadis, "Radical Imagination and the Social Instituting Imaginary", p. 336.

92 Edward Said, *Orientalism. Western Conceptions of the Orient*. Penguin Books 1991 (1978).

93 *Ibid.*, p. xiii.

94 Roland Barthes, *Mythologies*. London: Vintage Books 1993, pp. 109ff., p. 116.

95 Castoriadis, "Radical Imagination and the Social Instituting Imaginary", in *The Castoriadis Reader*. Oxford: Blackwell Publishers Ltd. 1997, p. 321.

96 Castoriadis, "The Imaginary: Creation in the Social-Historical Domain", p. 13.

97 *Ibid.*

98 *Ibid.*, pp.331–336.

99 Castoriadis, "Radical Imagination and the Social Instituting Imaginary", p. 333ff. The issue of constraint pertains, as well, to the problem of what Castoriadis terms "elucidation". Since the imagination is an ontological condition and conditioning, the problem of alienation, of non-reflectedness of imaginary form must be posed, in its utmost consequence leading to revolutionary alterations of the "com-

plete system of the world". This aspect will, however, be left out of the debate here, since the primary object is an outline of fundamentalisms of the new order.

100 *Ibid.*, pp. 335–336.

101 *Ibid.*

102 *Ibid.*

103 See for instance Cornelius Castoriadis, "Merleau-Ponty and the Ontological Tradition", in *World in Fragments. Writings on Politics, Society, Psychoanalysis, and the Imagination* (David Ames Curtis, ed.). Stanford, California: Stanford University Press 1997, pp. 273ff.

104 Castoriadis, *The Imaginary Institution of Society*, p. 131.

105 *Ibid.*, p. 127.

106 Ankie Hoogvelt: *Globalisation and the Postcolonial World*. London: Macmillan Press 1997.

107 *Ibid.*, p. 65, pp. 65ff.

108 *Ibid.*, pp. 68ff.

109 *Ibid.*, p. 84.

110 *Ibid.*, p. 76. See also my paper "Cyberculture in globalization. Globalization, culture and technology". Forthcoming in Katya Sander & Simon Sheikh (eds), *Here and Elsewhere. OE readers in visual cultures #6.* (Berlin) b_books 2007.

111 Immanuel Wallerstein: "Culture as the Ideological Batttleground of the Modern World System", in Mike Featherstone (ed): *Global Culture. Nationalism, Globalization and Modernity.* SAGE Publications 1990, pp. 35ff.

112 The idea of 'network' points to a comprehensive, yet 'complex' form of ratio with a specific history and geneaology, and specific modalities of rationality, functionality and dynamic, relying on a number of conditions, which conversely make it highly versatile. Cf. Daniel Parrochia, *Philosophie des réseaux.* Paris: Presses Universitaires de France 1993.

113 Cf. John L. Casti, *Complexification.* New York: HarperPerennial 1994.

114 Cf. Manuel Castells, *The Information Age: Economy, Society and Culture Vol. I: The rise of the Network Society,* Blackwell Publishers 1996.

115 Søren Krarup, *The Dance around the Human Rights* [Dansen om menneskerettighederne]. Gyldendal 2000.

116 *Ibid.*, pp. 40–41.

117 "… får Vesterlandet, der har kristendommen som udgangspunkt, til opgave at bygge landet og samfundet op", *Ibid.*, p.41.

118 "Menneskerettighederne er abstraktionens angreb på det konkrete menneske af kød og blod, med far og mor og historie og folk", *Ibid.*, p. 16.

119 "En ny himmel", *Ibid.*, p. 116, pp. 116ff.

120 "'The Crusade of World War II'", *Ibid.*, p. 124. Krarup here adopts the American metaphor.

121 "Menneskerettigheds-fundamentalismen", *Ibid.*, pp. 117ff.

122 [Det er i strid med menneskerettighederne! Så har der ikke været mere at

tale om. Hvis det er i strid med menneskerettighederne at ville værge sig selv og sit fædreland, så er dette forbudt. Hvis det er i strid med menneskerettighederne at holde mere af sin familie end af menneskeheden, så er dette forbudt. Hvis det er i strid med menneskerettighederne at være et enkelt syndigt, jordisk menneske af kød og blod med en given historisk virkelighed, så er dette forbudt. Mennesk-erettighederne blev i slutningen af 20. århundrede til den fundamentalisme, der ophævede enhver diskussion.] *Ibid.*, p. 141.

123 Castoriadis, "Radical Imagination and the Social Instituting Imaginary", p. 336.

124 Cf. *Ibid.*, pp. 124ff., p. 130.

125 *Ibid.*, pp. 117ff.

126 *Ibid*, pp. 45ff.

127 For instance, once it is argued and accepted that it is possible to install an ar-gument pertaining only or mainly to the Christian West.

128 Jean Fisher, "Toward a Metaphysics of Shit" in *Documenta11_Platform 5:Exhibi-tion. Catalogue.* Ostfildern-Ruit: Hatje Cantz Publishers, pp. 63ff.

129 Bhabha, *Op.cit.*, p. 163.

130 Edward Said, *Op.cit.*, p. 21.

131 C.f. Maurice Merleau-Ponty, *The Visible and the Invisible.* Evanston: Northwest-ern University Press 1968, pp. 50ff.

132 Cf. Philippe Mengue, *Gilles Deleuze ou le système du multiple.* Paris Ilème: Édi-tions Kimé 1994.

133 Michael Hardt & Antonio Negri, *Empire.* Cambridge, Mass.: Harvard Univer-sity Press 2000.

FROM PRESERVATION
TO CONTEMPORARY ARTS

NASEEM KHAN

I have just come back from a night at the circus. That sounds as a very simple proposition. If you were to simply shut your eyes for an instant and think of the circus of your youth … your favourite performers … what pictures come to mind? Lion tamers? Trapeze artists? Clowns? Now here is a test. Am I right in my belief that all the (human) performers you have been picturing in your mind's eye were white?

Circus is a good example of the way in which cultural assumptions in Western Europe are shaped almost without our knowing it. Expectations tend to be more set than we realize, and stereotypes to hold sway even in the liberal areas of arts and leisure. Classical ballet, for instance, is still seen as a pursuit for white people. Opera now has a few high profile black opera singers, but comparatively few and comparatively recently. Circus, I am pretty sure, is another one of those 'white' territories.

Until this year, that is.* This year, Push, a determinedly sanctions-busting arts organization in London (two young black women and one young white woman), has taken on the stereotypes. They have just finished an audacious week in which they presented contemporary Black culture in Britain in which the usual products have been pointedly omitted. So it has been goodbye to reggae, hip hop and plays about oppression. It has been hello to a new look at Black opera, a mammoth reading of Homer's Odyssey by a gathering of the country's best known and best established Black actors, sessions of avant-garde film and video and, of course, the one-night circus.

Push's declared objective was to give the Black community a new image of itself. So it turned its back on the common manifestations of Black creativity and addressed itself very firmly to a work in which audacity pays and talent alone provides the entry fee. In the process, it showed not only the black community but also the white world how limiting the stereotypes have been.

A rousing week in itself, the Push week was more significant than the work alone. It signified a shift in the debate, a further move away from old definitions of diversity. It eschewed self-conscious dissections of 'hybridity' and was light-hearted about having a political message – the form indeed was the message rather than the direct content. Status, identity and location of the arts involving Black, Asian and Chinese artists have long been burning topics within the arts in Britain. Where do they belong? In

* The article was written in 2002

the so-called 'mainstream', or in the so-called 'community'? Where are artists' own loyalties? What is (or is not) 'Black arts'?

As the black women acrobats wove and twisted their way around the high trapeze, you could hear the sighs of delight rising from the hugely supportive audience, and you could sense a strange feeling of liberation. The circus literally rose above the debate and demanded to be taken on its own terms, as a display of elegance, style and talent.

The history of multiculturalism in Britain – a country with a long history in this area – is bumpy and uneven, and even now exists in an ambience of uncertainty and experiment.

Underlying its progress have been a series of tensions – is the artist in question an 'ethnic' artist or an artist simply of the country of settlement? Is there such a thing as 'Black arts'? Do they exist independently of their creators – is it, for example, as valid of a non-Asian to perform Indian classical dance or would that somehow be less 'authentic'? Is the polarization that arises from a focus on ethnicity unfortunate, but unavoidable?

As England's Year of Diversity approaches (it starts in June 2002), all these questions are certain to gain in sharpness. A number of other key factors have added strength to the urgency of the debate of which decentralization is a major one. The establishment of separate parliaments or assemblies for Wales, Scotland and Northern Ireland has generated strong feelings around the nature of a national culture, its relationship to so-called minorities' cultures, the latter's reflection in education, and the comparative allocation of resources. Multiculturalism has been seen by some as no friend in a fragmenting world, as an inducement to yet more ghettos, yet more separation, yet more no-go areas. A call to support cultural rights has led to an answering accusation of 'political correctness'. Inevitably, xenophobia and racism have stepped in.

But for all that, there has been distinct progress. The confidence of Push in itself is proof of that.

In the early days of policy formulation in the 1970s, the agenda seemed relatively simple. It had been demonstrated that significant quantities of cultural activity was being carried on within ethnic minority communities – African, Caribbean, Asian, Chinese, East Europeans, Cypriots and so on. By and large, this was essentially home-based and community-centred. It took place within private community gatherings – social and religious occasions in particular – and its ethos was essentially protectionist.

People wanted to preserve their culture and way of life in order to provide

continuity for their children and a sense of rootedness and pride. Caribbean folk groups like Gloria Cameron's were well established, and so, even more, were countless numbers of Polish and Ukrainian folk dance groups and choirs. By and large, these made no claim whatsoever on the overall arts funding system, and in many cases they were surprised to learn that they might even have been considered for support.

However, the 1970s were also a point of quiet change. Time had seen a new generation grow up largely in Britain as children to immigrant parents but with more knowledge of Britain than the so-called mother country. A growing university population also resulted in the emergence of increased student numbers and a booming alternative culture. The American civil rights and Black Power movements joined in spirit with the independence movements in Africa and the Caribbean, playing out their search for a new cultural voice on the streets of Britain too.

The impact on the old, contained world of nostalgic culture was marked. New black theatre groups started to mushroom. Indian cultural centres started to establish themselves. The Chinese business community perceived the value of visibility and sponsored the first Chinese New Year celebrations with large paper dragons parading though an area of central London that later became more commodified as Chinatown. The West Indian Carnival first put its cautious feet on to the road.

These manifestations posed some problems for the Arts Council of Great Britain. Frequently, they did not fit into the usual format and categories that the funding body operated. Although they had a fund for festivals, this was intended more for festivals of Early English Music or the Three Choirs festival than a robust and popular street carnival. How was the Arts Council to assess such a form? What were its criteria? More often than not, the activities were, strictly speaking, amateur: people knew they could not earn a living from their art, therefore they supported themselves in other ways. This also went against the rules, for at that time, the Arts Council defined its function as being to support professional arts rather than amateurs.

The pressure of new constituents – of which Black arts were only one, albeit highly important, – forced the funding bodies to rethink their role. But it still left the vexed issue of 'quality' over which approaches and attitudes differed. The improvisation-based nature of Indian music ("We waited", said one fan respectfully of his maestro, "for him to 'make his mood'") did not fit into strict time codes of concert halls, for instance.

Staff of some venues struggled to understand audiences who did not seem to mind their children running around in a performance or talking through the events.

New thinking about dance in education stressed personal creativity. Indian classical dance, on the other hand, stressed simple absorption of the teacher's experience and disapproved of personal expression at an early stage of training. A number of Black, Asian and Chinese visual artists felt passionately that their work was being seen through post-colonial spectacles. Had they conformed to stereotypes and turned out 'colourful', 'exotic' work, replete with eastern (or Caribbean) colour, they would have been taken on, they felt. But seeing themselves as they did, as contemporary artists on a world stage, they were denied space.

The arts funding system itself clearly was failing to respond significantly to the new arts. What could be done? Indubitably, the old, established arts were in a privileged position. With decades of history behind them, with assured status and ability to attract sponsorship, with rafts of professionals adept in fund-raising and financial management quite apart from the artistic aspects, they demanded and deserved support. So where was the space for the new arts and artists? Could ancient goal posts be shifted?

The strategy that the Arts Council adopted in the 1980s involved quotas. It asked all its departments and the organizations it funded – from theatre companies to arts centres to regional arts associations – to work towards spending a minimum of 4% of their outlay on 'ethnic arts'. The aim was to shift set patterns of funding, to create the window that was so absent. It seems generally accepted – by the way in which the strategy was quietly dropped, if nothing more – that the 4% rule did not work. It is true that it did free up some money, but on the other hand, the initiative was not regularly monitored, reviewed and acted on. Some organizations found it all too easy to get around the rule by engaging in one token activity, while the base line of regular activities and ongoing attitudes continued unchanged. Other organizations felt unfairly leaned on, and a number of Black artists themselves disliked the impression of being protected: they wanted their success to have been patently achieved as a result of their work's quality not their ethnicity.

However, the problem the bold 4% policy sought to tackle is serious and endemic. All Western countries with long-established cultural infrastructures and limited resources will recognize it. Cultural budgets are dominated by expensive clients – orchestras, large arts centres, opera and

ballet companies – in large buildings. They leave little slack for new work and new approaches.

The story of the recent phase of the Arts Capital Lottery Programme in England might sound like a dry tale. In fact, it is a very telling counter to the 1980s quota. The past five years have seen the presence of the Lottery, one of whose strands goes to support the arts. In the first round that took place in 1998, billions of pounds from Arts Lottery were handed out to major ventures – the Royal Opera House, Sadlers Wells Theatre and so on. Out of that largesse however, only 0.2% went to Black and Asian ventures. The fund was designed to give a significant boost to capital projects (i.e. buildings) and as such was of particular importance for major cities – where by and large Black and Asian communities make up some 25% of the population. In those cities, research has indicated that the audience profile of major mainstream buildings is not on a par with demography. So it is fair to conclude that a sizeable chunk of the population was not benefiting from a major fund.

In response to this, the Capital Lottery Panel of the Arts Council advised ring-fencing in the second round of the Fund. Out of £80 million, it was agreed to ring-fence £20 million minimum for Black, Asian and Chinese led projects.

Left on its own, it is possible that this might have met the same fate as the 4% rule. However, it was also decided to be proactive. Given the cynicism found in the Black and Asian arts sector (fed of course by the record of the 0.2%), remedial action was needed. An experienced arts administrator, the ex-head of a Black community arts centre, was hired to advocate and promote the scheme. She travelled the country, advocated, advised, made contacts and brokered partnerships. In the ultimate analysis, the proposals that came in would have totalled – had they all been supported – around £79 million. The ring-fenced figure of £20 million was exceeded, and £30 million were finally allocated to projects that ranged from flagships to young training ventures, from new technology to fine arts.

The next stage is the creation of a training programme for the successful applicants Black ventures included. Lottery proposals are weighty affairs in need of a great deal of highly specialized input: they have been seen to destabilize some untried and unprotected organizations. In short, they need to be treated as a development opportunity by applicants and funding bodies alike. The induction day held recently for over one hundred

successful applicants made no bones about the weight of the task ahead, but at the same – and for the first time – it insisted that the Arts Council would see its role proactively, as protector, advisor, counsellor, consolidator, guide. The scheme to be put in place will contain all those elements as well as action learning sets and mentoring as well as more formal skills enhancement.

There are a number of morals to be drawn from a story that is so far one of success. For a start, the role of the Lottery advocate was crucial. Regrettable but true, it acknowledges the fact that funding bodies like the Arts Council are distant from new constituencies, however unpalatable that fact may be. In the case of Black arts and artists, they have had disaffection to overcome and an inconsistent history of support that has convinced Black and Asian arts, artists and audiences of their poor faith.

In essence, the advocate is the communicator, the person creating channels of information between two sides. Institutions are increasingly coming to recognize the need for link people. Museums are reaping the benefit of employees who spend their time out in various communities. London's Victoria and Albert Museum created a vast worldwide project around Asian embroidery from the small seed of a community worker who activated Asian women firstly in London, then the country. The Mughal Tent project eventually attracted participants from a range of countries including Canada, India, Malaysia, USA and the Gulf States.

The Ambassadors Schemes that a number of arts marketing agencies have tried out in England also point to the prime importance of community connections. In this case, a number of individuals are enlisted whose job it is to interpret the activities of the theatre or arts centre to their own communities, to open out engagement and also to transmit views from the other side. It builds on the fact that the word of mouth and the endorsement of respected community members are by far the most potent factors within Black and Asian communities. The little Grange Museum in North London built its own home grown Advocates who played a role in determining exhibitions and in some case directly affected their character. The Grange's exhibition, 'The West Indian Front Room', brought energetic groups together to argue and debate the contents and placing of objects in a typical historic West Indian home. Those debates spread out like ripples and resulted in a wide awareness of this very popular exhibition.

The Arts Council's New Audiences scheme has gone further in allocating around £1 million to schemes that will create equal partnerships be-

tween community-based Black and Asian organizations and 'mainstream' arts institutions. The former would bring its knowledge of its own base and the latter would provide the building and operating mechanics.

The second lesson to be drawn from the history of the Lottery grants is the importance of commitment. Schemes in both the arts and museums worlds foundered in the past because they did not provide long-term support. A major exhibition at the Museum of London about the city's intensely ethnically diverse past succeeded in raising the Black and Asian visitor ratio to a very respectable 20%. But when the exhibition was over and the worker who had been making community contacts was dispensed with, the figure sank back to the low single figure that it was before.

Multiculturalism and Black and Asian arts in Britain are recent and without deep roots. There is little infrastructure to support them, and the scales are still weighted against them. The playing field is by no means even.

It is this fact that overwhelmingly justifies a policy focus on 'cultural diversity'. There is lower administrative expertise within the Black arts sector: the immigrant imperative of training for a secure career still holds good and robs the field of potential managers. The funding level is lower. It is more difficult to get space for work, often due to lack of expertise, knowledge and sometimes laxity of white venue managers. Initial research has shown the existence of a glass ceiling for Black and Asian arts administrators in mainstream settings. There are virtually none at upper echelons of arts management.

These issues are light years away from the simple dilemmas of the 1970s, when the question was seen as just a matter of opening doors to previously uninvited guests and strangers. Nowadays it concerns tussling with equality – a far more fundamental, serious and far-reaching affair. It entails looking deeply – far more deeply than many people maybe would like – into old values, systems, conditions and ways of working. This can be arcane language (the director of one theatre recounts how baffled a Black employee had been by the term 'Box Office Manager': a throwback to Victorian theatrical language). Or, it can be a greater emphasis on 'integrated casting' in which Black and Asian actors are cast in non-racially specific roles. Or, it can mean a searching look at staff profiles and boards of management to see how they reflect local demography and then acting on any inadequacies.

In whatever way, the steps carry with them the opportunity to revive cultural practice. The steps touched upon above are not, as the phrase goes, 'rocket science'. They are not special or extraordinary. They relate to the very basic activities of an institution that is in touch with its audience, where the bloodlines are clear and active. Reaching new audiences means that old communication process has to be reviewed; it has to be re-defined imaginatively in terms of new conditions, new peoples and new times. Viewed properly, we are talking about an act of regeneration.

The arts that exist within Britain demonstrate the gains that have been made. The spectrum has been expanded. New forms have married with settled ones and created their own second generation. Music and multi-media have been hugely energized by the confident use of multicultural perspectives. Literature reflects the distinctiveness of New Britain. The short-list for the prestigious fine arts prize, the Turner Prize, has regularly featured artists from 'diverse' backgrounds, from Aneesh Kapoor to Chris Ofili. English culture is being stretched.

These are the pioneers and the bright outriders. They signal how important it is to look at vision, first and foremost. The function of Ofili, and the young performers of Push, is to remind us of the ultimate aim – a world in which race is ancillary, quality is primary.

As things stand, sadly, we are not there yet. Expectations are unequal; barriers are higher for some than others; there are signs of glass ceilings. If more young Ofilis are to follow in his footsteps, we still need a focus on levelling the playing field.

However, the energy of Push, with its forthright slogans urging Black artists to accept no boundaries, signals a view that it lays claim, correctly, not to a corner but to the whole of the cultural spectrum. This is a huge step: twenty years ago and less, the talk was of culture at the margins. But while the barometer of change reads Fair, it still needs adjustments if it is to deal with everybody on terms of real equality. Riots in the north of England and cases of discrimination as well as statistics of unemployment carry their own messages. Ignoring difference – as some advocate – will only perpetuate difference.

APPROACHING TOMORROW

GAVIN JANTJES

To think of the visual arts as a tool able to show and tell one something significant about the world is to assume that art can communicate and educate. It gives art a role in culture that is much more than visual gratification. It also recognizes art's ubiquity; that it can operate at both ends of time. The past and the present, yesterday and tomorrow. One's formal education teaches one that the world is revealed through facts. We learn by gathering concrete information that provides proof of something or allows a logical conclusion to be drawn. Visual art remains a domain in which we do not learn about the world in this way. Making art is to say something about the world in an un-theorized or indirect manner. The visual experience of art allows one to draw conclusions based more or less on intuition and instinct rather than facts alone. Art is not logo-centric. It reveals the world through the re-assessment of personal experience, emotion and one's ability to imagine the impossible. By this definition, the contemporary exhibition is more than the consumption of visual images. It is not only an aesthetic experience but also an intellectual exercise and a means of communication with others and the self.

Art was once the illustration of literary narratives. Today it is more the translation of experience. An exhibition invites its viewers to work with the ideas, emotions and facts that arise from what is on view and from the aura of invisible traces of each image. If artists have done their jobs well, the viewer will find that looking can be an exciting encounter. Looking at art is a form of extra-sensory perception. The visual experience may allow one to recall something from deep in the vaults of one's memory. The smell or movement of a work of art may do the same. Sometimes, it quietly touches the emotions, at other times, it hammers them into outrage. To approach any exhibition with one's senses programmed to respond only to what one knows would presume knowledge of what new art should be. The journey into any exhibition requires one to keep an open mind and to trust that the way art teaches is as relevant today as it has always been.

When artists want to show and tell us what is on their minds, they do it using the working strategies and technologies of their time. They are engaged accomplices of change. Most of them will agree with Buckminster-Fuller's axiom "I seem to be a verb", a working word in the grammar of change. Artists will not allow time to pass from one epoch to the next without them actively participating in its progression. Their daunting task is to make abstract and new ideas become objects in the world. Their success is gauged by how good they are at fashioning these objects.

We began the 21st century by looking back at the past. We are in the age of jet lag. Our bodies are in one space and time zone while our minds are in another. The world we live in looks and feels different to that of our parents. Yet we are still trying to solve today's problems with yesterday's solutions. Science, technology, trade and industry clearly reflect change and transition. Artists also reflect this difference through the materials used in the making of a work and the many different ways to frame what they do. Lifestyle and home decor set aesthetic trends for today's generation of artists. The supermarket or the bus stop offers a potentially greater audience than some art galleries. Newspapers and the marketing methods of advertisers provide opportunities to address issues of our time that the exhibition catalogue cannot. Artists have learnt to use the strategies of contemporary media not only for its style but to emphasize what lay at the heart of the digital age – the need to communicate. The Internet and World Wide Web have introduced us to virtual presentations of art. In short, the art of tomorrow will look different and appear in unexpected places. It will use technologies in ways their inventors never foresaw. But the significant difference of tomorrow's art will be how it reflects attitudes and opinions to the issues of our time.

Tradition has settled our identities and our relationship to others. Tomorrow's moral, religious and sexual attitudes will rub up against fixed, ethical notions. Just who we are and what we are becoming as individuals or as a group will therefore remain significant areas for artistic research. Art will enter one's visual domain from unexpected geographic locations as its discourse broadens and new voices from around the globe follow this 21st century urge to communicate their particular vision of the world. Artists from here will put down new roots in strange lands over there, changing our definition of internationalism and making art more trans-national. They will take greater charge of defining themselves, rather than allowing someone else to say who or what they are. One has to learn to accept this self-definition of the other. It will help to break open the mould that shapes one's identity.

If contemporary art reflects reality, the mirrors artists hold up for us to see are fragmented, cracked and full of holes. This is how they experience the world today. Contemporary images are distorted, disrupted, and not immediately discernible. The viewer has to be willing to put it all together, to play with the puzzle and not expect it to be complete. The notion of a grand artwork, complete or absolute in itself, is a rare thing in

our time. We no longer interact with the world this way. Complete, absolute or grandiose are concepts of an imperial past, practised by men with megalomaniac egos. Artists today are more inclined to address an issue via a number of strategies, using a variety of technologies or producing work in series. They have learnt to place the shifting prefix 'post-' before all 20th century -isms. Post-colonialism, post-feminism, post-modernism have made artists moderate their vision in line with contemporary expectation that the (male) artist genius was a mythological invention of 20th century Modernity. "We don't need another hero", said Barbara Kruger's untitled billboard work as early as 1985.

One of the doctrines of the last century was the belief in the ideal of progress. Nothing remained static, every thing moved forward. One entered the modern age, became a modern person, by believing in the future, not the past. The notion of modern progress required one to criticize what had gone before and move on, rather than accepting it unquestioningly. Over the past century, modern man's desire for perpetual progress made him a passenger on a vehicle with fixed steering, four forward gears, no reverse and no breaks. One became a projectile fired from the canon of modern history. With head pointing forward, eyes transfixed, focused on an inevitable future, one observed the past in the rear view mirror. Now that we have left the 20th century, it will occupy our thoughts more vigorously than before, as it becomes the reference for where we go and what we do tomorrow. It is our rear view mirror. The young try to run away from it at break neck speed to break this dichotomy. It never happens.

A century ago, traditions that revoked change were challenged by new ideas and modes of working. This radical approach to tradition, to question and to deny fixity, to discard the irrelevant and move on, was particularly true in the visual arts of the 20th century. One continues to believe that the ability to change makes us and keeps us modern. When one says as artist or as viewer, that "times change", one does not express a movement observed from a fixed position. One is surely not just watching change occur but actively partaking in it. Art like life is not about missing the bus and watching it disappear over the horizon into the future. One is enmeshed in change and carried along every little step of its perpetual journey. Most people want to be passengers. Artists want to be in the driving seat or instruct the driver where to go. They want to be more than witnesses to change. They want to reflect and predict its movement. Their vision is a critical enquiry and may even be the thing that initiates change.

Art driven by these desires becomes a kinetic activity within culture. Different tomorrow than it was yesterday, it invites its viewers to become engaged witnesses to its ever-changing events.

Over the past millennium, our specialist approach to the presentation of art has made us forget that art once was made in an 'appropriate' place and for an appropriate place. That could have been the riverside, the forest, the walls of a dwelling, a cave, or cut into a landscape over many miles. As the new millennium begins, we are returning to that early understanding of the 'appropriate' place for art. Today, art can speak from a location whose site is more specific to the content of the work than the gallery could ever be. A work presented on a video monitor in a supermarket may grab one's attention for only a moment. Yet this brief disruption to the routine use of a commercial market place is more than that. In a matter of nanoseconds, the work communicates some of its content into the subconscious where, like a virus, it replicates itself into the idea banks of morality, ethics, good, and evil etc., threatening to corrupt normal thought patterns. The viewer may only understand the work of art after the fact, when emotions are stirred to the level of outrage or the sublime. The work would then have done its job. It would have put one in touch with one's emotions and heightened one's awareness to the subliminal way visual stimuli work. Where, when and by whom art is seen, will change radically over the next century. Viewers should be invited to look upon the gallery as more than just a larg- scale vitrine for art. The art gallery has a context before any work is placed inside it. An empty gallery is full of the history of art, the walls are inscribed with the ideas and achievements of what has gone before. One reads all gallery exhibitions against this invisible background of the history and the traditions of art. If one agrees that the critical revision of tradition implies change, then the contemporary exhibition is the site in which artists can show and tell us how to lay aside this portmanteau of history. The gallery may become the site where art's history and traditions undergo their critical inquiry and where alternatives for tomorrow are found. The gallery could become the site for new contexts. Artists will not provide answers but, more importantly, ask questions that help to shape possible answers.

One of the challenges facing the contemporary artist is the establishment of reference points other than the generalities of dominant art history. Cultural, sexual, language contexts applicable to the here and now. In a

new century born under the sign of globalism, and a world wide web of information exchange, these references distinguish and trace the rhizomatic make up of the art of our time. Mapping the visible and invisible connections of image references will be part of the fun of discovering again our relationship to others. Discovering the world as a differentiated yet inter-connected entity via the visual arts is a fascinating prospect.

An endearing image of the past millennium is the view of planet earth from outer space. It is the view of ourselves from the position of the 'alien' other, the outsider's view. It provided a unique visual reference that allowed us to recognize our difference and particularity in a vast solar system. At a time when the world was divided along the lines of politics, race, language, culture and history, it returned us to a notion of humanity that is all inclusive. It became a reference for a world, inter-linked by geography, inter-dependant on ecology, inter-connected by economy. A fashionable attitude arising from postmodern theory in Europe and the West was that art could and should loose its social dynamic within culture. That artist should take the position of a non-entity rather than play the role of the avant-garde. It was hip for artists to prop up technical and intellectually facile works with the cool crutches of meaninglessness and aimlessness. Stupidity became a new sublime inviting US TV networks to transmit Renn and Stimpy, Bevis and Buthead, and Hollywood to produce "Dumber and Dumber". With Europe reeling from the recent fascist war in the Balkans, and the new right wing in Austria entering democratic European politics, social realities need some reflection. Irresponsible laughter cannot be the subliminal response to the issues of our time. If visual art is to provide new meaning in people's lives, if it is to be more than shock treatment for the eyes, but also a challenge for the intellect, then artists have a grand stage on which to play.

CULTURAL DIFFERENCE
AND THE ETHICS OF
CULTURAL PARTICIPATION

RIA LAVRIJSEN

> Universality can never come except through writing about what one knows thoroughly. ... And, though it is only too easy for a writer to be local without being universal, I doubt whether a poet or novelist can be universal without being local too.
> *T.S. Eliot*[1]

In March 1995, I published an article in the *Boekmancahier* (a Dutch quarterly on cultural policy and research) on "cultural diversity and audience participation". In fact, this article was a critical reaction to a survey carried out by the Amsterdam Office for Research and Statistics on the issue of: Participation in the performing arts by immigrant/ethnic minority 18–30 year-olds in 1994 and 2005. This survey tells us that the participation percentage for immigrants in 2005 will remain virtually the same. The researchers state that over the last ten years the level of education within the migrant communities has not increased, and that it is expected that it will not increase over the coming ten years. So nothing really is to be expected in terms of participation. This simplistic conclusion drawn by the O&S survey stigmatizes immigrants/ethnic minority groups and may have a paralysing effect on the arts sector. Only when we cease to consider immigrants as a statistical average and instead view them as richly varied groups influenced by generation, background and social structure, can creative ideas emerge for an updated cultural and arts policy.

In the survey, there is a lack of differentiated figures on the educational standard of immigrants/ethnic minorities. The researchers only consider average percentages and ignore the fact that over the next ten years the total number (in an absolute sense) of better-educated Surinamese, Antillians, Turks and Moroccans will rise. They ignore the fact that there is a social mobility taking place within these migrant communities. That the 'average' educational standard is not increasing is, among others, the result of an ongoing influx of sometimes illiterate or not very highly educated migrants. But the researchers in fact consider the migrant community as a "homogenous" badly educated community. The researchers have worked with generalized concepts such as 'immigrants' and 'market', and have overlooked intrinsic issues such as programming and the public's diverse frames of references. Participation in art appears to have a chance of success if a connection with people's frame of reference is sought. And it is the challenge of our time to gain more understanding of people's contemporary frame of reference, which may be complex and ambiguous at

the same time. Nowadays there is no such thing as a typical concert- or theatre-goer. Some people may visit concerts of world music and may have an interest as well in avant-garde theatre. Some people may visit baroque concerts as well as classical Indian or Arab music. Some people may like to go to so-called 'intercultural' productions with Dutch performers and actors of an Afro-Caribbean background because their frame of reference relates to themes touched on in this kind of hybrid productions.

We know that the standard of education plays a role in arts participation. A large part of audiences in the performing arts has a higher educational training. But we have to recognize that other factors are relevant as well: factors connected with family environment, social background, geographical location and affinity for the range of performing arts on offer. It would be silly not to recognize that audiences from various cultures have different histories and possess different kinds of 'cultural capital'. However, it would be even more silly to suggest that 'ethnicity' or 'race' is the essence of a person's 'cultural identity'.

The great challenge for the new millennium is: are art and cultural institutions prepared to engage themselves with the environment and the people, are they willing to make new connections, are they willing to make an effort to reach both native citizens and people of migrant communities or the so-called 'other'? Are they willing to encourage the arts sector and cultural sector to deal in a creative way with diversity and difference rather than continuing to work in an elitist and exclusionist way? The single greatest challenge for all of us is to make a thorough investigation of the complexity of the varied migrant and autochthonous communities and the social and cultural differences within as well as between these communities. Dealing with 'cultural difference' is not only dealing with race and ethnicity but also with social, cultural, economic and historical 'differences'.

Differentiation

In Amsterdam, about 30 % of the population is in one way or another of a culturally diverse or foreign background. Which means that almost a third of the people are first generation guestworkers and their children from Turkish and Moroccan background, or people from the former Dutch colony Surinam, a small country in the northern part of South-America or from the Dutch Antilles, a few Caribbean islands that are still part of the Kingdom of the Netherlands or from Indonesia. It is important, then, to

realize that, for instance, the Surinamese are a very heterogeneous community made up of people of African, Indian, Amerindian, Chinese, Indonesian, Portuguese-Jewish descent, not to forget the people of mixed race. It is also crucial to know that quite a few young black "Surinamese" or Antilleans are in fact Dutch and have never even been in Surinam or the Antilles. One can therefore imagine how complex the issues of 'cultural identity' and 'belonging' are.

Besides these so-called 'ethnic minorities', there are refugees from South Africa, Somalia, Iran, Chili, Vietnam, China, Algeria, Russia or the former Soviet Union, former Yugoslavia etc. In terms of the level of education, there are great differences. Within the migrant communities, there is a small group of intellectuals and well-educated people and a large group of less-educated people. Sadly enough, we then face the problem of too many second-generation youngsters of Moroccan, Turkish, Surinamese and Antillian background dropping out of schools. These young people have to mediate between the sometimes traditional, rural culture of their sometimes illiterate parents and Dutch modern urban life. We should not be too pessimistic however: the level of education in these minorities is increasing.

Communicating and working together, in the city as well as in neighbourhoods, is rather difficult because of all these different histories and cultures. When thinking and talking about 'cultural diversity' and 'multiculturalism' in relation to art, culture and neighbourhoods, it is crucial to make a distinction between various 'fields'. The first 'field' is the international art world: the world of international performing art festivals, international culturally diverse programming in theatres and concert halls, new internationalism within the museum world etc. This world is now slowly discovering that art, and especially contemporary or modern art, is not only being produced in Europe or the USA by white Europeans but also by 'black' Europeans and African-Americans as well as by artists and great masters in African, Arab and Asian countries. Some arts institutions are at least going beyond the stereotypical folkloristic approach.

The second field is both the field of the local culturally diverse communities in cities and neighbourhoods and the local migrant and culturally diverse communities in various cities in Europe. To recognize differentiation within these communities is crucial. In the cities, are the well-educated intellectuals and artists of non-Western descent who were in universities and art schools in their former mother country or in the

new homeland as well as great 'masters' with a long experience. Among them are also refugees. How are these people participating in art production, presentation and in attending art events?

The other group is the first, second and third generation migrants from poor and socially disadvantaged culturally diverse communities. Among these are refugees as well. How are these people participating in art production, presentation and in attending art events?

Different Truths

In 1961, in his essay on "Universal Civilisation and National Cultures", the French philosopher Paul Ricoeur posed himself the question, "What would happen to our civilisation when contact between peoples of different cultures would no longer be based on domination and subjugation?"[2] In 1961, the process of de-colonization was well under way, but Ricoeur felt that this confrontation had not yet taken place. A real dialogue on an equal level between people of different cultures had not yet occurred. Ricoeur considers the era of the sixties as a "silence before the storm", a sort of interim period where we know that the dogma of "one truth" is no longer valid, but where we do not yet know how to deal with our doubts. That was in 1961.

How true are Ricoeur's words in 2006! In this post-modern era, we all know that there is not 'one truth'. And we know as well that we have a lot of doubts. However, the difference between 1961 and today is the fact that we are not in a period *before* the storm, but that we often find ourselves *in* the storm itself. Stormy weather may not be very pleasant and may cause feelings of anxiety. There is, however, no way out, and, in one way or another, we have to deal with it and try to survive. We will have to learn to deal with 'difference' and 'diversity', we have to discover different 'truths' if we want to be in touch with our reality.

Beauty and Ethical Criteria

One of the people in the world of art who tries to deal in a creative and sensitive way with this 'storm' is the French curator Catherine David. She was curating the tenth *Documenta* in Kassel which took place in 1997. She was the first woman in the history of the Documenta to curate this visual arts

show of global significance, which incidently in itself is no mean achievement. But what is most interesting about Catherine David is not that she is a woman, but that she is a curator with a challenging vision. In 1987, as director of the Jeu de Paume in Paris, she and some colleagues were curators of the thoroughly debated exhibition "L'Epoque, la mode, la morale, la passion". In English, this is translated into: "The time, the fashion, the moral, and the passion". In this exhibition, for which Catherine David used a line of Baudelaire's "Le Peintre de la vie moderne" – "The Painter of modern life", she wanted to pay attention to the fact that there exists, besides the 'eternal' and traditional values such as beauty, other considerations such as time-related and ethical values, fashion, moral and passion, all of which play a crucial part in the arts. The achievement of Modernism may have been the establishment of the autonomy of artistic criteria, yes. There is, however, in the modern world a debate acknowledging the fact that time-related, ethical and non-aesthetic criteria have been discarded in the arrogant moments of high Modernism.[3]

My personal opinion is that neither the exclusive and absolutist appreciation of autonomous aesthetic criteria nor the exclusive appreciation of the time-related and ethical criteria are fruitful approaches in the debates on art. Maybe a combination of the two is the way out. I feel it is about time that we start looking not only for beauty, but for new and urgent values emerging from our times as well. Let us in the fields of art and culture for instance think about new forms of engagement and of themes we did not yet consider as relevant for our ethical survival. Why not combine ethics with aesthetics instead of separating them. For some time, since the seventies, in the world of art in the Netherlands, it was almost a sin to plead for 'engagement'. Now the Dutch art world is slowly opening up to this idea. Fortunately, the word "commitment" is no longer a curse.

If we really observe our time and environment, what do we see in Western European cities? In this post-colonial decade in Europe, especially in urban areas, we see people of various countries, nations and cultures mixing and living together. We see artists from the North, the South, the East and West making contacts and learning from each other. The French-Martiniquan writer Patrick Chamoiseau (winner of the famous Prix de Goncourt) even holds the idea that the world is evolving in a state of Creoleness. This may be true for some people, but at the same time, we see an increasing fragmentation into nationalist movements and ethnocentrism within different communities.

Art and cultural institutions in Europe in the nineties indeed find themselves faced with a growing number of artists using styles and expressions such as fusion and hybridization, which are no longer purely Western or non-Western, as a result from this process of 'Creolization'. Those involved in the assessment of art in the nineties, whether they be of European, Asian, Arab, African, or Afro-Caribbean descent, will have to ask themselves whether they are equipped to judge the quality of culturally diverse art and the works of art produced by artists with various frames of reference. A diversity of new themes and forms is being introduced. Just think about 'new' literatures that are emerging: a literature with characters that face the consequences of migration and displacement, of belonging and not belonging, of being an outsider or an insider, of losing and gaining. A literature that is introducing us to new aesthetics, new ways of storytelling and new enriching languages. These literatures are contributing to national cultures in various European cities.

Various Modernities

In 1992, Catherine David gave a lecture entitled "A Reawakened Interest in Other Culture: Urgency or Alibi?" In her lecture, she focused on the crucial issue of "modernity": "I think it is very dangerous to go on claiming that modernity is a particularly western invention and story, and that it has affected the others only on the rebound or by borrowing or reproduction. I believe that modernity has touched everyone ..."[4]

Modernity has touched everyone, and Catherine David feels that it is crucial to acknowledge the very many different ways and manners in which it has touched people within the West itself as well as in Africa, Asia, the Middle East etc. This view may cause a small revolution because it means that she refuses to take the Western European and American canon as the only and exclusive criterion. Catherine David – who I strongly agree with in this matter – is pleading for a new sensitivity and approach by means of which we can observe how other communities have experienced modernity, even if those experiences originate from compulsion and traumatization. It is also crucial to try to understand the dynamics within the 'cultures' of migrant communities. One of the mistakes policymakers often make is to name these cultures as 'ethnic cultures'.

'Modernity' and 'modern aesthetics' in Eastern Europe were shaped somehow differently compared to those in other parts of the Western world

for historical, political and cultural reasons. We all know that Dutch, Danish, British, German and other European people of rural, working class or poor background have experienced other kinds of 'modernities' compared with people in cities and youngsters who grew up in intellectual enlightened environments. If we try to understand the various modernities of our parents and of ourselves, why should we then not try to understand the various modernities of migrant communities whose origins or whose parents' origins are outside Europe?

Exotism

For a long time, we as Western Europeans have been interested in non-western arts and cultures. However, very often in the west, we wanted to see the "other" cultures as exotic, traditional, tribal and pure. With the modernization of the world, we started worrying about the way non-western cultures would be influenced and how cultural traditions in Africa and Asia might be damaged, or even disappear, through this process of modernization. In the meantime, our own western cultures changed tremendously through industrialization and modernity. While we considered the cultural changes in our western culture as part of our progress and the dynamics of western culture, we asked the non-western cultures to preserve their pure and sacred traditions. Let us take a closer look at just two cases that occurred in the world of art in The Netherlands and Belgium.

Fra Fra Sound, a Dutch band that plays Afro-Caribbean jazz and consists of musicians of Surinamese, British, and Latin-American descent is, I think, an interesting band because of the hybrid and cross-cultural orientation and the search of a mixture of musical styles such as salsa, kaseko, jazz and South African kwela. I do not hesitate to characterize this band as a Dutch band because I consider their music as a very valuable contribution to the culturally diverse Dutch music life. It is part of the heterogeneous national music of the Netherlands. An advisory committee of the Fund for the Performing Arts (Fonds voor de Podiumkunsten) reacted to their application for subsidy with the following words:

> ... The importance of the band is primarily aimed at giving young Surinamese musicians a chance to be introduced to this kind of music. The commission regrets that there is increasingly less effort being made on the backgrounds of Surinamese music. The group is heading

203

too much into the direction of a Fusion band. It is therefore in danger of losing its original purpose, without having gained a new one".[5]

Vincent Henar, the Fra Fra Sound bandleader, who is a black Dutch from Surinamese background, regards this counsel as: "an attempt at limiting us, and Surinamese musicians in general, in our artistic choices and 'sending us back to the bush as it were'".[6]

The following is another example of 'exotism'. In March 1994, the Belgian newspaper De Standaard, published a review by music critic Vic De Donder about a performance of The Royal Philharmonic Orchestra of Flanders in The Concertgebouw in Amsterdam conducted by the Afro-American conductor Michael Morgan. "A black man can also conduct Mahler" read the headline of the Standaard. In his review, Vic De Donder wrote about the conductor: "His frail appearance and typically negroid mannerisms would sooner lead you to expect him to start singing (negro)spirituals, than to conduct a large symphonic orchestra. Notwithstanding he conducted the Flemish Philharmonic with a firm hand". When the director of The Royal Philharmonic of Flanders wrote to this music critic that he was shocked, De Donder was surprised about the perception of his review. He had only meant to describe the atmosphere.[7]

Rasheed Araeen, a British-Pakistani writer and visual artist in the UK, has been criticizing this attitude towards the 'other' for some time. He writes:

> By attributing a very different social and historical space to the non-European peoples, they are turned into the "others". First, the "other" is reduced to the level of a victim, then the West looks in the "other" for some kind of purity and authenticity; the result is the promotion and legitimisation of exotic cultures or art activities which are pre-modern or are removed from the discourse of modernism.[8]

If we do not want to locate the 'other' artist in a pre-modern world, if we do not want to push him/her into a space of "folkloristic expressions" or "ethnic arts" or a slot where only collective experiences count, and if we do not want to deny the 'other' artist his individual aspiration and ambition, we should create the same space for the so-called 'other' artist that we do for the so-called Western artist. If we manage to do so, new perspectives will open up. In the fields of arts and culture, there is no room for "ethnic chauvinism".

According to Nikos Papastergiadis, publicist and editor of the British magazine *Third Text*, it is important "to see the migrant artist's work not just as a representation of the place of origin and the place of arrival, but also as a metaphor for the processes of journeying".[9] As the cultural critic Kobena Mercer said: "... why not search for ROUTES, meaning the path from one place to another, instead of ROOTS".[10]

Faceless Universalism

There is another kind of attitude that is just as insensitive as the 'exotic' attitude. In the words of the Afro-American writer and thinker Cornel West, I would call this attitude the one of "faceless universalism".[11] However, before I continue to reflect on this phenomenon of "faceless universalism", I want to acknowledge the possibility of sharing certain values as universal values. I do believe that in many cases it is possible for people who have different histories and who come from different cultures to share, appreciate and understand each others' aesthetics and works of art. Therefore, I do not want to say that there are no universal values at all. Take for instance Toni Morrison, the Afro-American writer and Nobel Prize Winner. Her books can be read and understood by people who did not experience slavery and racism themselves. Morrison's characters are so fully human that she enables us as readers to share their emotions and to appreciate her work. Another example are the books of Kenyan writer Ngugi Wa Thiong'o. To appreciate his splendid description of a young girl's fear of circumcision in his book *The River between*, you do not have to be either an African or a woman. You can understand why she flees from her village: she must do so to get away from this act that is going to ruin her health and sexuality.

Sometimes, in heated debates, people shout to each other: "You are European and you do not know or understand black people" or "you are an immigrant and you do not understand Danish culture".

British-Indian writer and thinker Homi Bhabha says the following about the issue of sharing universal values:

> When a community enters into an act of representation, by making paintings and writing plays about their experience, you take that experience and you give it a public presence ... In that very act ... you deny the a-priori presence of yourself as belonging to a closed always

self-explanatory form of being. Only through that sense of alienation, by putting yourself in art, you produce a certain public image. At that point, you cannot claim to possess a unique inexplicable sense of experience which is not accessible to others. That act of public representation means that the very subject of oppression and of cultural specificity becomes, in the very process of representation, alienated to itself. That opens up within the act of representation an area which others are invited to identify with.[12]

I do acknowledge that certain universal values can be shared. But it would be rather naive to think that Western European people are always open and non-prejudiced towards art and cultural expressions of the 'other'. It would be rather naive to think that we can always understand and appreciate all signs and symbols of all cultures without being informed about the specificities of people's histories and cultures. It would be rather naive to think that we are all part of one harmonious global world, where the diversity of cultures is being shared through absolutist universal values and without any tension, competition or inequalities involved. As Homi Bhabha points out: "It is utopian to imagine that all the walls of all the great museums would somehow crumble and we could have festivals in the park or community arts centres, as if those would be free spaces or non-ideological spaces".[13]

For instance, one of the significant things is that we still find mainly white men over the age of fifty in positions of power in the arts in the Netherlands. Of course, I am not suggesting that the Dutch or international art world consists of a group of white chauvinistic males over the age of fifty who are in deliberate conspiracy to keep women and the 'other' out. It is, however, crucial to recognize that art and art institutions and the assessment of art are closely related to existing canons, decision-makers, and their power. According to French sociologist Bourdieu, intellectuals, scientists and artists ought not to strive for economic interest in the first place, but their activities are often not as unselfish as they want to make us believe.[14] In the arts, as well as everywhere else, you find competition, prestige battles, immaterial and material interests.

Absolutist Divisions

The absolutist and binary divisions between men/women, white/black, oppressed/oppressor and self/other are, in my opinion, not very fruitful. But we urgently need to rethink questions such as: to whose stories are we going to listen, whose books are we going to publish and read, whose works of art are we going to exhibit in our museums, which plays and concerts are we going to programme and which audiences are we going to serve, or what kind of students are we going to educate? Or, in the neighbourhoods of European cities, which communities are going to be served, who is going to receive the resources for artistic and cultural development? It is no longer possible to define national cultures in Denmark, France, the United Kingdom, and in the Netherlands as homogenous cultures; therefore we unavoidably have to think about how to approach the issues concerning the intercultural, the multicultural and the cross-cultural.

The Ethics of Participation and Cultural Democracy

As regards the demographics, let us take a look at the schools in Amsterdam. Here, between 50 and 60% of the pupils aged between 6 and 12 are of a culturally diverse background. Which means that more than half of the pupils have in one way or another a Surinamese, Antillian, Turkish, Moroccan or other background. Some of these kids will be the artists of the future, a bigger group will hopefully make up the arts audience of the future. Arts institutions will have to develop intelligent ways to include the diversity of histories and frames of reference of these kids in their programming. At this point, I want to introduce to you a very interesting example of a Young Peoples Theatre in Amsterdam, The Artisjok / 020 Foundation that engages in an innovative way with culturally diverse groups of young people (between 14 and 20) in various neighbourhoods throughout Amsterdam, Rotterdam and other cities. For each project, a professional team consisting of a director, a choreographer and a writer builds a close working relationship with the local social, cultural and educational organizations in the neighbourhoods as well as with the parents. That is a very special part of the "method": building new networks, making new alliances, dealing with competition, and breaking barriers between institutions in the interest of young people as well as building relationships with parents. In co-operation with these organizations, teachers and parents, young people of diverse backgrounds are being in-

vited and selected to take part in theatre workshops. Artistic, educational and social-pedagogical objectives are combined in the production process. Acting, dancing and singing are crucial in the workshops. The youngsters are happy to learn skills such as social responsibility and discipline because of the pleasure they gain from working together. In the process, they are also expected to gain motivation and the skill of working together. After each project, there are always a few of the youngsters who are keen on setting up a new production and who want to take part in more training and workshops. Few are always keen to gain more knowledge about themselves, to gain more self-confidence and artistic and social skills. Some of the youngsters of the Nultwintig Company are able to run workshops themselves after a few years of training. Some are studying to become professional dancers or actors within the formal art schools. It is this process of training and 'empowerment', this process of investing in 'human resources' that will offer the youngsters, as well as the city of Amsterdam, a 'new' culture.

Limited Resources

The limited space and resources in the fields of art and culture will, however, force us to define new priorities and new policies. This lack of resources unavoidably brings about tension and conflicts on local, regional and global levels, within, outside and between communities. And the world of art cannot escape from these tensions. If we are not able to think that our own history, our own frame of reference, however international or cosmopolitan it may be, may have its limitations, we may not discover what might be of great importance for the arts and culture of our time. It is very likely that we will miss out on 'truths' that exist besides the 'truths' we think we know. I passionately feel that the most interesting challenge lies in building new alliances and breaking institutional barriers. We know that the intellectual potency is there to develop a new attitude, and this is not mere flattery. What is at stake here is a willingness to change attitudes. The challenge of the future, I believe, is about crossing boundaries, searching for the 'other' inside ourselves, and being sensitive to 'difference' without essentializing it. It is about communicating with the 'other' without locating him or her in a fixed 'ethnic' identity. It is about moving into spaces you do not yet know, it is about talking to and sharing thoughts and resources with people you have not yet met,

it is about curiosity and respect. It is about breaking out of the existing 'cultural mafias' where all the members of the club know the rules of the game. It is about the reflection on ethical issues such as cultural democracy and participation of culturally diverse audiences and artists instead of promoting the fashionable rhetoric of box-office-income.

One of the positive characteristics of European culture is the critical attitude toward the mental basis of Europe and the refusal to consider everything our parents and grandparents did as 'good'. If we are able to consider the things our parents and grandparents did and said in a critical way, we may as well start considering our own practices and ideas in a critical way.

Martiniquan Patrick Chamoiseau is opening up a new and challenging perspective for a process of creolization. The quote comes from an essay entitled "In praise of Creoleness", which he wrote in co-operation with the writers Jean Bernabé and Raphael Confiant. "For a Creole poet or novelist, writing in an idolized French or Creole is like remaining motionless in a place of action, not taking a decision in a field of possibilities, being pointless in a place of potentialities, voiceless in the midst of the echoes of a mountain".[15] I truly hope that artists and professionals in the world of art, as well as the people in the neighbourhoods, have no intentions of embarking on idolized and pure national or ethnic cultures. I truly hope we will be able to oppose the ones who want to be motionless, voiceless and pointless.

1 T.S. Eliot 1965: p 55, 56. Quoted in "Toward the Decolonization of African Literature".

2 P. Ricoeur: "Civilisation universelle et cultures nationales". In *Esprit* 29 (1961), no. 10, October, pp. 439–453.

3 Sarat Maharaj: *Cultural Diversity in the Arts*, ed. Ria Lavrijsen, Royal Tropical Institute, Amsterdam, 1993, p. 89.

4 Catherine David: "A Reawakened Interest in Other Cultures: Urgency or Alibi?", in: *MED URBS VIE*, The authentic contemporary art from countries such as Egypt, Morocco and Turkey and its presentation in Europe. Rotterdam, Rotterdamse Kunstichting 1993, p. 46.

5 Fonds voor de Podiumkunsten d.d. 1994.

6 Vincent Henar's reaction d.d. 1994.

7 Vic De Donder, De Standaard quoted in 'de Volkskrant' of 1 April 1994.

8 Het Klimaat: buitenlandse beeldend kunstenaars in Nederland. Den Haag: Culturele Raad Zuid-Holland, 1991, p. 55.

9 Nikos Papastergiadis: "The South in the North", in: *Third Text*, Spring 1991, no. 14.

10 Kobena Mercer: "Back to my routes". In: TEN 8 Vol 2 No 3, Critical Decade, Black British Photography in the 80s.

11 Cornel West: "The new cultural politics of difference". In: Out There; marginalisation and contemporary cultures. Ed. by R. Ferguson, M. Gever, T.T. Minh-ha, C. West. New York: The New Museum of Contemporary Art, 1990, p. 36.

12 Homi Bhabha in a video interview I (Ria Lavrijsen) made at the ICA in London for the MED URBS VIE Conference, organized by The Rotterdam Arts Council and the City Council, December 1992 in Rotterdam.

13 Homi Bhabha, see note 11.

14 P. Bourdieu: *Opstellen over smaak, habitus en het veldbegrip*. Amsterdam: Van Gennep, 1989, pp. 34-37.

15 Patrick Chamoiseau, Jean Bernabé and Raphaël Confiant: *Eloge de la Créolité / In praise of Creoleness*. Gallimard, Paris, 1989.

REFLECTIONS OF A 'PERIPHERAL INSIDER'
Convictions and Dissonances

Y. Raj Isar[1]

By the autumn of 2000, when the "1+1=3" conference in Copenhagen sought to highlight the challenges of cultural diversity in contemporary Denmark, movements, unsettlings and settlings of peoples on a scale never before experienced were seriously challenging cultural and social policy makers right across Europe, as indeed throughout the world. Reinforced by post-colonial developments, human flows and interactions launched five centuries earlier (if not more) had grown exponentially in the 1990s under the impact of globalization. And as it had unfolded, this phenomenon had profoundly altered notions of culture, cultural identity, cultural difference, cultural hybridity and cultural relations. It had also contributed mightily to foregrounding the value of 'cultural diversity' that K. Anthony Appiah has called "one of the most pious of the pieties of our age".[2]

Today, this unprecedented mixing defies governments in hitherto unimagined ways and poses equally new existential questions to the 'peripheral insiders' themselves – particularly if they are artists and intellectual workers. It is as a member of this latter sodality that I offer the reflections that follow in two parts. The first and main part advocates some lines of cultural and social policy thinking for the culturally diverse futures of European societies. In the second part, more idiosyncratic, I raise some possibly dissonant questions.

I represented UNESCO at the Copenhagen conference, and was asked to contribute here by 'discussing the positive things that can emerge from being open to multiculturalism in art, and giving examples of similar experiences in other western countries'. The first bit of that brief has proved easy to tackle, since a commitment to cultural pluralism is as central to my personal philosophy as it is to my institutional role. But the second component, the request to cite European examples comparatively, was clearly a task one simply did not have the means to achieve – indeed no agency, to the best of my knowledge, keeps track of European developments relevant to so-called 'immigrant arts'.[3]

In an attempt to sidestep the difficulty, I requested and was given the unusual privilege of writing a contribution based on a reading of all the others. Since any international civil servant is necessarily somewhat removed from the ground realities, such a procedure, I thought, would help me find a useful counterpoint to the empirical reporting from other contributors. As a professional comparatist, I also reasoned that such a course would help me deliver an overview of sorts, one that might possibly draw together the diverse threads of argument.

The other contributions turned out to be too heterogeneous for this to be possible. What the special treatment did afford, however, was the opportunity to refine some of my viewpoints and revise others, in the light of panoply of forces, trends and settings that create the cultural conditions of existence for artists in Europe who hail from different geo-cultural areas. All this is directly linked to my experience, as a non-specialist in visual arts practice, on the Board of the London-based Institute for International Visual Arts (inIVA).[4] By providing important facts and insights on issues specific to artistic practice, the other authors are allowing me to 'dialogue' with them as it were, in terms that are analogous to the discussions we have at our Board meetings. One of the Institute's principal concerns, echoed in this volume, is to steer clear of the shoals of essentialization, or the valorization of artistic work on the basis of its ethnic/cultural provenance alone, rather than primarily for its quality *per se*. Of course, the very notion of 'quality' can be manipulated by any dominant monism, yet even greater is the risk that illiberal multiculturalism reduces creative individualities and confines them within a single, ascribed cultural identity.

First the Convictions

On the general policy level, i.e. the broader context in which pluralistic stances for and about arts practice should be taken, let me at the outset stress the salience of culture in the socio-economic transitions our generation is living through. Culture here is understood in the broad, anthropological sense – diverse patterns of human behaviours, values and meanings – as well as in the narrower sense of artistic and intellectual creativity. In both meanings, the emphasis is on culture as a process – often contested – of meaning making marked today by the empirically observed trend of differentiation as well as the ethically desired ideal of plurality based on freedom of choice for individuals and communities. In other words, it is not the 'old' sense of cultures as bounded wholes, relatively homogeneous across their members. "Cultures, in that anthropological sense of specifically defined ways of life, have been broken into and interrupted by cosmopolitan dispersals, by migration and displacement".[5] In the expanding complexity of peoples and ideas that is the shape of the future, culture will be increasingly a site of both contestation and negotiation.

If awareness has indeed emerged that culture in this sense matters – with regard to governance and citizenship, social cohesion and inclusion, quality of life and economic growth – it is still very hard to translate this awareness into actionable policy guidelines. For a start, the concept of culture, already so polysemic and elusive, has been over-exploited rhetorically, its edge blunted by the uncontrolled if not indiscriminate use people in all walks of life have made of it. To make things harder, the interactions between culture, society, economy and polity are under-researched; empirical data is sorely lacking.

A number of good practice examples are often cited, however, among them Community Music London, which has shown how a carefully coordinated programme of training trainers can transform music provision in an area and stimulate the setting up of autonomous music groups. During the 1990s, the organization ran a summer play scheme in the London Borough of Newham with 25 low achievers and school refusers. Two local youth workers were trained in fund-raising and two musicians in managing a music workshop. A number of young people, mainly beginners, formed their own music group. Some went on to study music at college, create further bands or get jobs in the arts. In another project in Newham, Community Music gave music workshops for a group of young Asian people, which in due course became the nationally known Asian Dub Foundation, which has played a major role in bringing Asian music into the rock and pop mainstream.[6]

This example illustrates the challenge of formulating and applying policy that is appropriate to "the network of perspectives created by the contemporary flow of culture between countries and continents, and with the conflictual relationships in multicultural settings, especially in cities".[7] Throughout the world, ethnic landscapes will continue to diversify across different existing regimes of citizenship: in nation-states such as Canada and the United States, which already have an established history of 'multiculturalism'; in others such as France, which have traditionally assimilated a variety of groups within a non-ethnic contractual model of citizenship based on shared values; in countries such as the United Kingdom and The Netherlands, which have absorbed major flows of immigrants from formerly colonized lands; or nations such as Japan or the Scandinavian countries in which the process is only beginning. There is little likelihood that the migratory flows will decrease, on the contrary. To be sure, the people involved will often be driven by the pragmatics of cultural adaptation. But they will also be caught up in the ongoing wave of cultural 'repluralization' that is a dialectical response to the homogenizing

thrust of globalization. The assertive affirmation of cultural distinctive-
ness has laid the 'melting pot' model to rest, at least for the foreseeable fu-
ture. However, this does not mean we have to resign ourselves to a world of
warring essences, with the egregious waste of social energy this implies.

Whatever their past – and current – positions regarding the cultural 'iden-
tity' of their nation, all societies are henceforth going to have to envision
it in the plural. In the process, however, they will have to reconcile two op-
posed political philosophies. On the one hand, the classic liberal position
that posits the primacy of the individual and her/his identity over col-
lective belonging and restricts the affirmation of the latter to the private
sphere. On the other, the communitarian approach that sees individual
identity as the product of community. There is likely to be continuous,
even mounting tension between the two positions. While an increasing
number of individuals are opting for the right and the responsibility to
choose for themselves the markers and roles they use to construct their
identities, the claims of equality will have to be reconciled with the claims
of difference. The challenge is to devise "novel ways of combining differ-
ence and identity, drawing together on the same terrain those formal in-
commensurables of political vocabularies – liberty and equality – *with*
difference, 'the good' *and* 'the right'".[8]

How then to arrive at inclusive visions of collective identity that can
keep pace with these volatile realities? The onus on policymakers will be
to create the kinds of environments that minimize the power of culture to
divide and maximize its power to bind, offering the potential of combin-
ing individual rights guaranteed by citizenship with respect for collec-
tive identities. As "formal equality of rights does not necessarily lead to
equality of respect, resources, opportunities or welfare … some differen-
tial treatment for groups with different characteristics, needs and wants
may be required in order to achieve equity of outcomes".[9] Societies will
need to invent structures, legal frameworks and institutions that cater to
this need, that recognize the cultural rights of a number of groups that
constitute the national community as a precondition for their successful
inclusion.

The task of finding ways to allow non-conflictual cultural distinc-
tions to flourish is already being pursued in many places and the immi-
grant groups themselves are performing much of the adaptive effort. In
other cases, such a task has been made superfluous by the hybridization
that is taking place quite naturally. Nevertheless, enabling all the groups

that henceforth constitute the national community to assume ownership of its composite cultural identity will remain a major challenge for policy-makers – how to build new forms of social capital that provide bonds within cultural groups as well as bridges between them?

Policy thinkers indeed suggest a range of concrete measures through which "societies can take a very strong stand against discrimination and inequality without promoting a racist backlash, and … achieve integration without assimilation".[10] But more is going to be required than publicly combating intolerance and exclusion. The broader challenge will be to give dignity, voice and recognition in the public sphere to different cultural groups while constructing – negotiating – a sense of national community. There appears to be only limited awareness of the inadequacies of existing policy and practice in making this possible. Overcoming these inadequacies is not a challenge for governments alone. Nevertheless, the latter can and must take the lead in creating a climate propitious to the emergence of a society-wide spirit of 'constructive pluralism'. Much of this climate will be a matter of subtly promoting symbols and structures of representation that are meaningful for 'minorities', recognizing them in constitutions, laws and electoral systems, and that also drive equitable funding patterns that cater to the needs of a culturally diverse community.[11]

Clearly, what is needed is "a more qualitative understanding of the different values, practices and interpretative frameworks that characterize culturally diverse societies at a time when the accent has shifted – not totally, but relatively, and to varying degrees in different countries from cultural policies with a nationalist and homogenizing cast to the acceptance and even active promotion of cultural differences".[12]

And, if and when that is achieved, what are the implications for arts and cultural expression? There is the important distinction between "cultural democratization" and "cultural democracy", between the spreading down of programmes through audience development, on the one hand, and the encouragement of multiple cultural values and forms, on the other. Both policies need to be pursued in order to support culturally diverse communities and to foster initiatives to create common ground for cross-cultural fertilization, by honouring and valorizing each heritage that contributes to a constantly evolving mix, recognizing each as a source of cultural vitality and innovation, of active participation rather than passive consumption.

Then some Dissonant Questions

When it comes to the here and now of immigrant artists in Europe and their key conditions of existence, there is little I can add to what other contributors to this volume have already provided. Therefore, what I want to do instead is cast a critical eye on the general discourse, whether it is produced by well-intentioned established insiders ready to broaden the policy paradigms or by the 'peripheral insiders' who want to become the mainstream. I shall do so by raising three possibly dissonant issues, each of which merit far more extensive treatment than I can give them here.

The first of these issues is the danger of identitarian reductionism. My own sense of this danger has led me, for example, as an Indian-born UNESCO official who lives in Europe, to determinedly avoid being bracketed as an 'expert' on my own country or region and equally consciously to seek recognition of my cross-cultural comparatist competences. In other words, as a professional, I seek to be recognized as someone who is as qualified to express a view or develop an action programme related to European, African or Latin American socio-cultural realities as I am qualified to do regarding South Asia, the region of my birth and ancestry. My claim is to judge in terms of a universal contemporary rationality (yes, it is a mainly Western 'paradigm' but what other one do any of us use?) and this in no way precludes the possibility of my bringing Indian sentiments, values, or attitudes to bear on what I perform, intellectually speaking that is, and how I do so. Hence my sense of identity could be declined very much in Stuart Hall's terms:

> Though they seem to invoke an origin in a historical past with which they continue to correspond, actually identities are about ... using the resources of history, language and culture in the process of becoming rather than being: not 'who we are' or 'where we came from', so much as 'what we might become', 'how we have been represented' and 'how that bears on how we might represent ourselves'. Identities are therefore constituted within, not outside, representation. They relate to the invention of tradition as much as to tradition itself, which they oblige us to read not as an endless reiteration but as 'the changing same' ... not the so-called return to roots but a coming-to-terms-with our 'routes'.[13]

To be sure, this is the language of the sociologist, not the artist. But is the vision different from the claim of an artist of non-European extraction

who seeks to be judged in her own terms, not as the representative of a single 'other' essence?

Immigrant artists, on the other hand, are not in the same situation as immigrant labourers. And if for some of them life centres on the struggle against poverty and discrimination (cf. Ramadan), surely there are many more whose lot resembles that of the educated, mobile, multicultural knowledge workers that Pico Iyer sees as a 'whole new race', a race as Salman Rushdie says, echoing Hall, of "people who root themselves in ideas rather than places, in memories as much as in material things; people who have been obliged to define themselves – because they are so defined by others – by their otherness; people in whose deepest selves strange fusions occur, unprecedented unions between what they were and where they find themselves".[14]

Edward Said said much the same thing a decade ago when he stressed the ways in which all artists, writers in particular, increasingly use intertwined and interdependent streams of historical experience, e.g. Adonis, the leading Arab poet; most of the dissenting writers in Eastern Europe; Caribbean writers who trace their heritage to C.L.R. James. It is in reference to such figures that Said argued that

> liberation as an intellectual mission ... has now shifted from the settled, established, and domesticated dynamics of culture to its unhoused, decentred, and exilic energies, energies whose incarnation today is the migrant, and whose consciousness is that of the intellectual and artist in exile, the political figure between domains, between forms, between homes, and between languages ...'[15]

What a bravura role that is! So can and should we actually think of the condition of the immigrant artist in the same way as we do regarding the conditions of social and economic exclusion faced by most of the immigrant working class?

My second line of thinking may seem surprising on the part of an acknowledged 'culturalist' such as myself. The claim for more inclusive patterns of support to immigrant artists rests on the preservation of cultural diversity is a higher collective principle, i.e. apart from the equitable treatment to which any citizen has the right. But is cultural diversity really what it is all about? Is it not more a question of diversity of identity? Appiah, in the article already cited, has made this distinction with regard to American society. He challenges the latter's 'cultural diversity' para-

digm on the basis of the extremely multifarious range of 'identities' that participate in Charles Taylor's 'politics of recognition': some groups that bear the names of the earlier ethnic cultures – Italian, Jewish, Polish; some that correspond to the old races – Black, Asian, Indian; some regional – Southern, Western, Puerto Rican; some new groups modelled on the old ethnicities – Hispanic, Asian-American; others that are social categories – woman, gay, disabled. It is not obvious that a distinct culture corresponds to each identity ... Yet the thinning of the real cultural content of many of these identities is matched by the rising stridency of their claims. The paradox is only apparent. The claim is not being made in the name of 'culture' but for respect, in a society inspired by its ideal of social equality.

Disrespect that leads to racism or xenophobia is not disrespect for culture. "It is not black culture that the racist disdains, but blacks. There is no conflict of visions between black and white cultures that is the source of racial discord ... No African-American is entitled to greater concern because he is descended from a people who created jazz or produced Toni Morrison. Culture is not the problem, and it is not the solution".[16]

Europe is not America, to be sure, but as far as the artist's 'unhoused, decentred, and exilic energies' are concerned, is the situation fundamentally different? I suspect that it is not ...

Finally, as they nowadays articulate the cultural responsibilities the postcolonial dispensation has thrust upon them, just how far are the right-minded and politically correct insiders prepared to go when they invoke 'intercultural' interaction, dialogue and exchange? Given that the dialogue must perforce be practised within Europe as the zone of interaction, to what extent are pre-existing local assumptions and patterns really being broken down or replaced? Is the 'interculturalism' that is offered to immigrant artists a truly balanced, mutual and dialogic process? How equal and open is the terrain on which such exchange and encounter takes place?

European societies certainly have a long record of interest in others, of aesthetic borrowings and adaptations. But a real awareness of what precisely cultural adapting and borrowing can and should mean today is still in short supply. The process we are looking for ought to transcend tolerance, accommodation and juxtaposition – all the virtues "multiculturalism" requires and sometimes achieves – and generate instead deeper interactions based on authentic exchange, lively creative conflict and real productive friction. As the theatre personality Lee Breuer expresses it:

I am desperately trying to develop an overview of what it means to be working interculturally in the theatre. There are a lot of underviews. They fall in the pattern of either I love the world and the world loves me, let's all get together and party interculturally, or, the notion of Western cultural imperialism – that we are ripping off every cultural icon we can get hold of, and then selling it … Why this thrust towards integration …? For whose benefit? To whose advantage? Who is saying, "let's integrate?"[17]

Does the merging of artistic languages actually provide a happy blending of specific and universal truths by virtue of performances and works that blend various cultural repertories? Or is this an illusion? Is a trans-cultural project that combines, fuses or blends the features of two or more cultures anything more than the use of the alien component as a "spicy sauce to make the same old gruel palatable again?" Do such projects really integrate the values, history and emotions of the other culture adequately? Perhaps, more often than not, the mix of foreign and native elements in the final analysis refuses to fuse, adding up to a sum that is not more than its separate parts, but less. Has the production of new alterities demolished boundaries, or is it reinforcing new insularities embedded in the rhetoric of cultural difference? Do we cross some borders only to close others?[18]

1 While the ideas and opinions expressed are informed by the author's professional experience at the United Nations Educational, Scientific and Cultural Organization (UNESCO), they in no way represent the official views of the latter.

2 K. Anthony Appiah, "The Multiculturalist Misunderstanding", in *The New York Review of Books*, October 9, 1997.

3 Indeed the lack of such a knowledge base is a major lacuna; may the combined impact of the conference, this volume and other cognate efforts bring about the creation of a mechanism or consortium of efforts across the continent that would fill the gap ...

4 The mission of inIVA is to create exhibitions, publications, multimedia, education and research projects designed to bring the work of artists from culturally diverse backgrounds to the attention of the widest possible public; engage with culturally diverse practices and ideas, both local and global; invite artists and audiences to question assumptions about contemporary art and ideas and act as a catalyst for making these debates and artworks part of mainstream culture.

5 Stuart Hall, "Museums of Modern Art and the End of History", in *Modernity and Difference*, Annotations, no. 6, Institute of International Visual Arts, London, 2001.

6 Anthony Everrit, "Culture and Citizenship" in *Citizenship: Towards a Citizenship Culture*, Bernard Crick, ed., 2001.

7 UNESCO, World Culture Report 2000 – Cultural Diversity, Conflict and Pluralism, UNESCO Publishing, 2000.

8 Stuart Hall, "Conclusion: the Multi-Cultural Question", in *Un/Settled Multiculturalisms: Diasporas, Entanglements, 'Transruptions'*, Barnor Hesse, ed., Zed Books, 2000.

9 Amareswar Galla, "Globalisation and Heritage Development in Multicultural Societies", paper presented at the "Living Heritage" conference organized by the French Commission for UNESCO and the *Maison des cultures du monde*, Paris, 8–9 June 2001.

10 Geoff Mulgan, "The Prospects for Social Renewal", in *The Creative Society of the 21st Century*, OECD, 2000.

11 A number of prescriptions may be found in *Towards a Constructive Pluralism* (report of a symposium jointly organized by UNESCO and the Commonwealth Secretariat in 1999), UNESCO, 2000.

12 Tony Bennett, presentation (unpublished) to a workshop entitled "Research in the Arts and Cultural Industries: Towards New Policy Alliances", co-organized by UNESCO, the National Arts Journalism Program at Columbia University and the Center for Arts and Cultural Policy Studies at Princeton University, Paris, 25–26 June 2001.

13 Stuart Hall, "Introduction: Who Needs Identity?" in Stuart Hall and Paul du Gay, eds. *Questions of Cultural Identity*, Sage, London, 1996.

14 Pico Iyer 'The Nowhere man' in Prospect, February 1997.

15 Edward Said, *Culture and Imperialism*, Chatto and Windus, London, 1993.

16 K. Anthony Appiah, *ibid.*

17 Quoted by Josette Féral in "Pluralism in Art or Interculturalism" reproduced in *The Power of Culture*, report on a conference of that title held in Amsterdam 8–9 November 1996, Development Cooperation Information Department, Minister of Foreign Affairs of The Netherlands, 1997.

18 Rustom Bharucha, The Politics of Cultural Practice, Thinking Through Theatre in an Age of Globalization, The Athlone Press, London, 2000.

OTHERED + MOTHERED = SMOTHERED

Tabish Khair

Not being an artist or even an art critic, I hesitate to contribute to a book of articles and papers on "the question of non-western artists living and working in the west and in Denmark in particular". And yet, as a writer, I remain interested in art; as an Indian in Denmark, I cannot avoid facing the issue of 'cultural others' living in Western countries; and, finally, as a scholar, I have to concern myself with questions of representation, hegemony and evaluation that lie at the core of such a book. However, I can only contribute to this fascinating enquiry at a personal level, for I do not claim expertise in the field.

Let me, then, begin with a personal conviction, put bluntly: *the non-Western artist in Denmark, like the average non-Western person in Denmark, lives in a state of 'visible invisibility'.*

This 'visible invisibility' can be highlighted in different ways. I have known of non-Western artists – and, for that matter, non-Western writers (including a serious Chinese candidate for the Nobel prize) – who have lived in Danish cities for years without attracting much attention as artists. Sometimes these artists and writers get some space in the popular media – though more often as 'immigrants' or commentators on 'immigrant issues' than as artists or writers – but the relatively closed world of Danish universities prefers to remain blissfully unaware of them. In any case, it is often the rule that their 'visibility' accrues from their 'otherness', while their art – as contemporary art, with claims to individuality and difference but not to a sweeping 'otherness' – remains largely invisible. It is not uncommon even today to find non-Western art exhibited in Danish museums on largely anthropological terms – something that would be a minor scandal in, say, England or Scotland. Recent art as 'anthropology' is obviously an indication of the 'otherness' that dominates most Danish perceptions of non-Western art. It is, actually, the scholarly counterpart of the social-journalistic tendency noted above. Just as the non-Western artist and writer is more likely to enter Danish society as an immigrant spokesperson of a different culture rather than as an *artist* or *writer* living in Denmark, non-Western art is more likely to enter Danish scholarly discourses in anthropological terms rather than, say, aesthetic ones[1]. In other words, one is more likely to find a non-Western artist or novelist writing about Bin Laden than about Michael Kvium in Danish papers. Even books by non-Western writers, such as Derek Walcott or Arundhati Roy, are given to Danes for review, while a Denmark-based Caribbean or Indian writer would almost never be asked to contribute a critical opinion on such mat-

ters. Similarly, non-Western artists in Denmark are almost never asked to review an art exhibition.

There is – as Rasheed Araeen, artist, critic and editor of the art and theory journal *Third Text* (Routledge, London), has pointed out in a number of articles – a tendency in the West to see non-Western art in terms of 'tradition' rather than within the complex continuity of, say, modernism. Hence, for instance, Picasso could incorporate non-Western aboriginal elements into his paintings and revolutionize modern art, but an Indian or African combining aboriginal elements with modern forms, techniques and material is, nevertheless, seen as 'restoring tradition' or 'exploring his tradition'. By definition, such an attempt by an Indian or African is pushed beyond the discourse of contemporary art and into that of 'anthropological' otherness. This tendency, it appears to me, is far more pronounced in Denmark than in the UK.

It appears that the non-Western artist can be accepted as an 'other' in many Danish circles, but not as a *different contemporary artist* with her own perception of art, aesthetics etc. And yet, one of the earliest objective books by a European on Hinduism and Hindu iconography (with its implicit relationship to Indian sculpture and art) was by a Dane. As Partha Mitter writes in *Much Maligned Monsters*:

> The most impressive work of this genre was written … in 1713 by the Royal Danish missionary, Bartholomaeus Ziegenbalg, at Tranquebar in south India … In Ziegenbalg we have a missionary who refused to go along with the prevailing attitudes and show how the Word of God had been distorted by the Hindus. Instead he wanted his readers to make up their own minds with the help of his straightforward, factual, and matter-of-fact presentation of Hinduism … Unfortunately, *Genealogy of the Malabar Gods*, a work of great usefulness even today was not welcomed in the eighteenth century. The hostility of Ziegenbalg's colleagues prevented its publication, for it was pointed out that the duty of the missionaries was to extirpate Hinduism and not to spread heathenish nonsense.[2]

As unfortunately (or perhaps significantly), Ziegenbalg – who, like most respectable Danes of the time, wrote in German – is available in an English translation but not in Danish.

The (obscured) presence of German in this short digression returns

us again to the ways in which a largely homogenous Danish identity has been created in recent decades. It is this creation of a homogenous Danish identity that explains why non-Western artists – and for that matter, non-Western immigrants in general – are both more tolerable and more repulsive to many Danes only in their essential 'otherness'. Depending on the political sympathies of the Dane in question, this 'otherness' can be seen as a threat or it can be seen as a colourful strength. At one extreme, you have priests and politicians who claim that one needs to be Christian in order to be a Dane; at the other, you have exotic festivals like 'Images of the World' in the year 2000 in Copenhagen. The former might wish to expel all 'otherness', the later might wish to 'mother' it. In both cases, however, there is a tendency to control and, in the longer run, assimilate the non-native, either forcibly (for the unmentioned purity of Denmark) or lovingly (for the good of the non-Westerner who decides to live on in Denmark). In both cases, the non-Westerner is seen as such an alien presence, that she and her art, literature etc. can only be spoken of in rather anthropological and sociological terms. In any case, an equation can be formulated to express the situation: othering + mothering = smothering.

The extremity and depth of the myths of coloured 'otherness' that pervade all aspects of Danish thinking can be, perhaps, best illustrated with reference to a popular children's book. In 1945 and 1948, Jørgen Clevin wrote and illustrated two books featuring an ostrich, Rasmus, who is captured in Africa and brought to Copenhagen Zoo. The books, which have been re-issued by the leading Danish publisher, Gyldendal, in 2002, are replete with stereotypes about Africans – "neger" – and the Danish state.[3] However, I am not concerned with most of these stereotypes in this essay. What interests me here is the complete otherness that informs the book's narrative of a generalized Africa and a specific Denmark. This can be best highlighted with the help of one innocuous-seeming example, though there are many other, more complex instances of it in the book. Rasmus has been captured and brought to Copenhagen Zoo, where he experiences rainy weather. This, we are told, Rasmus had *never* experienced before. Here you have a plausible fact, relative aridity in many parts of Africa, turned into an extreme myth of otherness: *no rain whatsoever* in 'Africa' versus regular, daylong showers in Denmark.

This otherness of the non-West in Denmark – the consequence of historical factors as well as the complex correspondence of the rightist-nationalist and social-democratic projects in recent years – often obscures

large stretches of Danish history. Not only the history of Danish colonies and slave trafficking, but also the history of many of the most redoubtable Danish buildings that were built or extensively renovated in exactly these periods of affluence. It strikes me as remarkable that Danish history books have almost nothing to say of the coloured presence in Denmark from the 17th to the early 20th century. Unlike, say, the UK, where much has been done over the last 20 years to recover the stories of coloured servants, slaves, sailors, mistresses, nurses, soldiers, traders etc, who lived in the UK at least as far back as the 17th century, Danish historians seem to dismiss the coloured presence in Denmark as completely unimportant. This is not a question of numbers, but of significance. After all, there are evidences of coloured slaves/servants being brought to Denmark and of Asian sailors being employed on Danish ships. British historians tell us, for instance, that in 1782, several lascars (South Asian sailors widely employed on European ships) "who had been hired by Danish ships arrived [in England] from Denmark"[4] – and that, in England, this was one of the factors that led to a rise of interest in the plight of lascars who were often fraudently discharged and abandoned by ships in Europe.

But such interesting and overlooked facts do not seem to have attracted the attention of at least mainstream Danish historians. Even in books by left-leaning and highly erudite historians, the coloured presence is relegated to Danish colonies – as if these colonies had nothing to do with the Danish 'mainland', as if masters could never bring coloured servants and slaves back 'home' with them, as if coloured sailors were not employed on Danish ships docking in Copenhagen, as if entire villages were not brought to Denmark for display etc. But let alone the *far* non-West in the shape of Caribbean families and Indian villages brought to Copenhagen to be exhibited as late as the 20th century, or teams of Chinese acrobats or groups of Asian lascars, even the *near* 'non-Western' presence of Greenlanders seems to be acknowledged only grudgingly in most Danish books about Denmark.

In short, with some honourable exceptions, scholars, journalists, critics and politicians in Denmark seem to show a great reluctance to acknowledge the coloured presence in its complexity. This reluctance extends back into time – Danish history is daily whitewashed – and into the present in which non-Western artists and writers are often reduced to representatives (or critics) of their own 'othered' cultures. While non-Westerners in Denmark in the past are rendered simply invisible, non-Westerners in

Denmark today have to be registered due to their somewhat greater numbers – but by being seen primarily as cultural others (to be expelled, assimilated or patronized), they are largely rendered invisible in their complexity as artists etc. Once one realizes this, it is not surprising to come across, say, books on the Cobra artists that do not mention Ernest Mancoba, a coloured artist who was an active member of the 'Danish' group.

Finally, the clientage system in official Denmark probably contributes to the (s)mothering of non-Western artists and writers in strange ways: for instance, someone writing in a language other than Danish can apply for a decent grant, provided her books are being published in that language in Denmark. So, in effect, you can write in English, Spanish, Chinese, Hindi or Arabic and be published by the biggest houses in the world without becoming eligible; but you can self-publish yourself in some obscure 'non-Danish' language in Denmark, and get the grant. This is another aspect of the 'othering-mothering' syndrome that reduces non-Western artists, writers etc. to a kind of 'visible invisibility' – in this case, by vesting power in the bureaucratic system rather than in any consideration of merit in the field.

The 'visible invisibility' of non-Western writers and artists, as I have tried to indicate, is an aspect and a consequence of a general discourse (or a complex of discourses) that pervades Danish society. It is a discourse that needs to be seriously questioned and examined by Danes not only for the sake of Danish art, but also for the sake of Danish society.

1 I must add here that, to some extent, the actual practice of Danish artists and sculptors (as contrasted to the popular or scholarly discourse on Danish art etc.) seems to differ from this: they remain more open to non-Western art as art.

2 Partha Mitter. *Much Maligned Monsters: A History of European Reactions to Indian Art*. Chicago and London: University of Chicago Press, 1992 (1977), p. 59.

3 Jørgen Clevin. *Rasmus & Rasmus Får Besøg*. Copenhagen: Gyldendals Bogklubber, 2002 (1945 and 1948).

4 Rozina Visram. *Asians in Britain: 400 Years of History*. London and Sterling, Virginia: Pluto Press, p. 18.

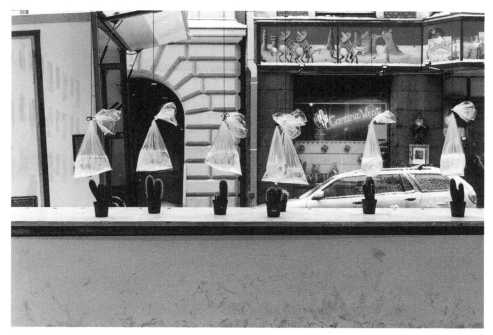

Title: Cactus. Year: 2001. Artist: Sofia Sundberg

Title: Installation view. Year: 2000. Artist: Wael Shawky

Title: The Toaster. Year: 2000. Artist: Gustavo Aguerre & Ingrid Falk

 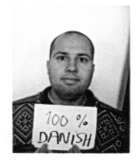

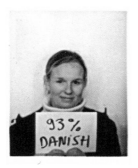 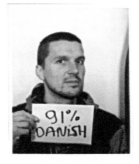 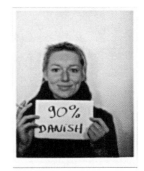

Title: Self measurement of Danishness. Year: 2000. Artist: Thierry Geoffroy-Colonel

Title: Grazyna
Year: 2005
Artist: Petra Bauer

Excerpt from the film Stories about Rana 2003–2005
A conversation with Grazyna Schultz, a social worker in Malmo

Grazyna: No as I was saying my experience is that I definitely do not think that 13-year-old girls should be parents, not 15 year olds either. It's not a good idea. On the other hand I think that it's very much to do with external circumstances that make people do certain things. If these guys who're often related, cousins of one sort or another, maybe this girl's mother is aunt to them on her sister's side or her brother's side. All these family ties that are there that are so strong and dominate everything else. If they had been able to stay where they wanted to, where they wanted to live, then they hadn't bloody well gone for 16 year olds, married them, got them pregnant, I don't think. That's from my experience, anyway. Because these guys aren't so happy about becoming parents either. The way I see it it's all connected; it's obviously to do with the political policy we have had in Sweden and in the rest of Europe. As a consequence of that policy, people have developed their own systems to get what they want, in other words to live in Europe.

It's incredibly two-sided. It's the usual old thing that, sure, they're villains, when it comes to these things, Muslim marriages, or it doesn't even matter if they marry or not, because it's that they become parents and are totally unprepared for it. And that little girls get pregnant. It's a bloody all-out catastrophe, and a human tragedy. But on the other hand I have to see it in context, see it as part of the societal system and relate it to how the world is. Then of course people say that we can't be held responsible for the policy of the entire world, but we bloody well are a part of the global world and that means you have to discuss these things. What I think is difficult with these issues in particular is that they are most often painted in black or white. I don't know how to say this, but my experience is that it's our Western and highly-developed system that criminalizes people that want to live here in Europe. The demands that are made are quite simply impossible to meet.

Title: Video still from the video "Performing the Border".
Year: 1999. Artist: Ursula Biemann

Title: Copywrong. Year: 2002. Artist: Serkan Ozkaya

Assuming a migrant woman identity

First, with "Illegal Border Crossing", I directly familiarized myself with border-crossing strategies that migrants have been using for decades. I trespassed the Slovenian-Austrian border, which at that time was the border of the European Union, and where approximately eight or nine 'illegalized beings' were captured per day. As a consequence, I went on exploring the topic in "Waiting For a Visa" (August 2000). The title refers to a queuing action in front of the Austrian consulate in Belgrade with no result: From 6:00 a.m. until noon, I lined up in the regular queue with hundreds of other people, with about 20 pages of documents and guaranty letters, in order to apply for a visa. At noon, the embassy closed, so I shared the destiny of failure with more than a hundred people who were "too late".

> While using her own body within different cultural and social contexts as a retort to various power games, Ostojic inevitably entered the realm of 'gender troubles'. Her reflection on gender issues is focused on the economic and political phenomena that accompany the phantasm of European Community that is shared by many Eastern European countries. In her project 'Looking for a Husband with EU Passport' she reveals and ironizes the truth about the traffic with women, prostitution, pragmatic marriages and all other 'side effects' of transition. Suzana Milevska

In August 2000 I started the "Looking for a Husband with EU Passport" project www.cac. org.mk/capital/ostojic. After publishing an ad with this title, I exchanged more than 500 letters with numerous applicants from around the world. After a correspondence of six months with a German man (artist K. Golf) I arranged our first meeting as a public performance (in the field in front of the Museum of Contemporary Art in Belgrade, 2001). One month later, we were officially married in New Belgrade. With the international marriage certificate and other required documents I applied for a visa. After two months I got an entrance visa for Germany, limited to three months, so I moved to Düsseldorf where I officially lived for three and a half years. This spring my three-year visa expired, and instead of granting me a permanent residence permit, the authorities granted me only a two-year visa. After that Golf and I got divorced, and on the occasion of my "Integration Project Office" installation opening (July 1, 2005) in *Gallery 35* in Berlin Friedrichshain, I organized the "Divorce Party".

In order to claim my own rights, which I have been deprived of by current EU laws, I explicitly applied the strategy of tricking or violating the law (as earlier with the "Illegal border crossing") to gain the right to move freely and live and work where I want.

The aspect of personal and direct speech, as opposed to abstract speech (such as the media machine uses), is an important element throughout my work. Thus the audience gets more chances to identify with a person with a particular problem rather than with an abstraction of a discriminatory law.

Title: Yes. Year: 2002. Artist: Tanja Ostojic

KHALED D. RAMADAN is a PhD candidate in Art History at the University of Copenhagen. He is an inter-media artist, curator and documentarist based in Copenhagen. He is member of the Danish Art Society and the International Association of Curators of Contemporary Art.

JESSICA WINEGAR, PhD, is an anthropologist whose work focuses on art and the culture industries in the Middle East. She is currently writing a book on the visual art world in Egypt, on which she has also published and lectured widely. She has been the recipient of numerous fellowships, including a National Endowmen for the Humanities grant. She is an Assistant Professor of Anthropology at Fordham University in New York.

STINE HØXBROE is a cultural geographer and editor specialized in Sociological and Ethnic Relations. She is also a lecturer in New Media and consultant in computer graphics. In addition to this she works as a freelance writer publishing in newspapers, magazines and anthologies.

STINE HØHOLT, PhD from Denmark's Design School and MA in Modern Culture from the University of Copenhagen. Inspector at ARKEN Museum of Modern Art. Has published in different catalogues, anthologies and magazines, among those several articles on post-colonialism and contemporary global art.

STAFFAN SCHMIDT is an art critic and curator. He lectures on art theory at the National Academy of Fine Arts, Oslo, Norway, and is a supervisor for the postgraduate program at the Valand Academy of Arts, Gothenburg University, Sweden. He spends a great deal of time in extensive cooperation with the artist Mike Bode. Lives in Malmö, Sweden.

BÜLENT DIKEN (b. 1964) senior lecturer at Department of Sociology, Lancaster University. Primary research areas are social theory, post structuralism, urbanism and immigration. Among his publications are the following monographs: *Strangers, Ambivalence and Social Theory* (1998); and with Carsten Bagge Laustsen: *I terrorens skygge* (2004), *The Culture of Exception* (2005) and *Sociology through the Projector* (forthcoming).

CARSTEN BAGGE LAUSTSEN (b. 1970) lecturer at Department of Political Science, the University of Aarhus. Primary research areas are terrorism, religion and security policies, and political and social theory. Among

his publications are the following monographs: *Subjektologi* (2004); with Bülent Diken: *I terrorens skygge* (2004), *The Culture of Exception* (2005) and *Sociology through the Projector* (forthcoming); and with Henrik Jøker Bjerre: *Slavoj Žižek*

ANDERS MICHELSEN is assistant professor and coordinator of visual culture studies at the Department of Cultural Studies and the Arts, the University of Copenhagen. He has published extensively in Denmark and elsewhere and is the editor and co-author of several books. He is a freelance curator of art and design exhibitions and advisory editor of Atlantica Revista de Arte y Pensamiento [Atlantic of Arts], CAAM, Gran Canaria

NASEEM KHAN is a writer, and a policy developer in the field of cultural diversity. Former Senior Policy Advisor to the Arts Council of England for this area of work.

GAVIN JANTJES was from 1986 to 1990 a council member of the Arts Council of Great Britain. In 1992, he was the Arts Council's consultant for the creation of the Institute of New International Visual Art (inIVA). He served as a trustee of the Whitechapel Gallery from 1986 to 1994, was an adviser to the Tate Gallery in Liverpool from 1992 to 95 and a trustee of the Serpentine Gallery, London, from 1995 to 98. He held a senior lectureship at Chelsea College of Art, The London Institute, from 1986 to 1998, when he was appointed Artistic Director of the Henie-Onstad Kunstsenter in Oslo, Norway.

RIA LAVRIJSEN is a writer and consultant specialized in Diversity and Intercultural Affairs. She is based in Amsterdam, The Netherlands.

Y. RAJ ISAR is President of European Forum for the Arts and Heritage. As a Jean Monnet Professor at The American University of Paris, he also lectures at many other universities in Europe and America. He is member of the boards of the Institute of International Visual Arts and Creative Exchange. Special Adviser to the World Monuments Fund, New York and Sanskriti Foundation, New Delhi. Consultant to the European Commission, the Organization of American States and the European Cultural Foundation. Previously, at UNESCO, he was Executive Secretary of the World Commission on Culture and Development, director of Cultural Policies and of the International Fund for the Promotion of Culture and

Editor-in-Chief of the quarterly *Museum*. In 1986–87 he was Executive Director of The Aga Khan Program for Islamic Architecture at Harvard University and the Massachusetts Institute of Technology. He has published extensively in the fields of cultural policy, cultural heritage and the arts. Born, raised and educated in India before settling in Paris in 1968, he has a Masters in sociology from the Sorbonne; post-graduate studies at the Ecole des Hautes Etudes en Sciences Sociales.

TABISH KHAIR, PhD, is associate professor in the Department of English at the University of Aarhus. He is also the author of several books, including the critically acclaimed poetry collection, *Where Parallel Lines Meet*, Penguin, 2000, *Babu Fictions: Alienation in Contemporary Indian English Fiction*, Oxford University Press, 2001, the novel *The Bus Stopped*, Picador (London, 2004), and has edited an anthology on Amitav Ghosh; *Amitav Ghosh: A Critical Reader*, Permanent Black, 2003. Tabish Khair has co-edited *OTHER ROUTES: 100 Years of African and Asian Travel Writing*, Signal Books and Indiana University Press, 2006, forthcoming, and his next novel, *FILMING*, will be out from Picador in April 2007. Tabish Khair is currently working on a book on Gothic fiction.